Letterhead & Logo Design

CREATING THE CORPORATE IMAGE

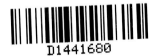

First published in the United States of America by:
Rockport Publishers, Inc.
33 Commercial Street
Gloucester, Massachusetts 01930-5089
Telephone: (978) 282-9590
Fax: (978) 283-2742
www.rockpub.com

ISBN 1-56496-398-5

10 9 8 7 6 5 4 3

Art Director: Lynne Havighurst
Design Firm: Carol Buchanan Design
Front Cover Images: From top left to right, credits appear on pages 136, 98, 68,
 13, 57, 172, 101, 14, 136, 53, and 59.
Back Cover Images: From top left to right, credits appear on pages121, 142, 48,
 121, 80, 17, and 72.
Additional Photography by: Doug Cannon

Printed in Hong Kong.

TABLE OF CONTENTS

No matter how attractive, elaborate, or expensively produced, the letterhead/logo can never be considered a success if it doesn't instantly and unavoidably convey the nature of the business. Every business is selling something, and business people usually come to the table wanting large, bright type; dark and sophisticated colors; or legibility above all else. Today's designer, on the other hand, often wants to work with broken or overlapping type, dark and sophisticated colors, or perhaps a 4-point body copy.

The designer's responsibility is to explain the artistic point of view, yet to make sure to understand the client's goals for pinpoint target marketing. The designer succeeds by creating a graphic "scream" that is ineluctable, ineradicable, and irresistible. For example, take the illustrations that go with this essay, a series of variations on Finished Art Inc.'s logo.

In conceiving the project, Donna Johnston, owner of the Atlanta, Georgia illustration and design studio, wanted to represent the diversity among the backgrounds and talents of her entire staff. Finished Art's studio personnel—designers, illustrators, cartoonists, paper sculptors, and three-dimensional graphic artists used both computer technology and traditional media to create their versions of the logo. The resulting forty-eight logo illustrations came rendered in watercolor, pastels, pencils, and ink, as well as digital files created in Adobe Photoshop and Illustrator, and Macromedia FreeHand.

Designer Kannex Fung took on the challenge to create a cohesive design base that would convey the studio's forward-looking and experimental image. The graphical representation of the studio's initials became the blank canvas for the illustrators and designers. Each artist was encouraged to work in any media

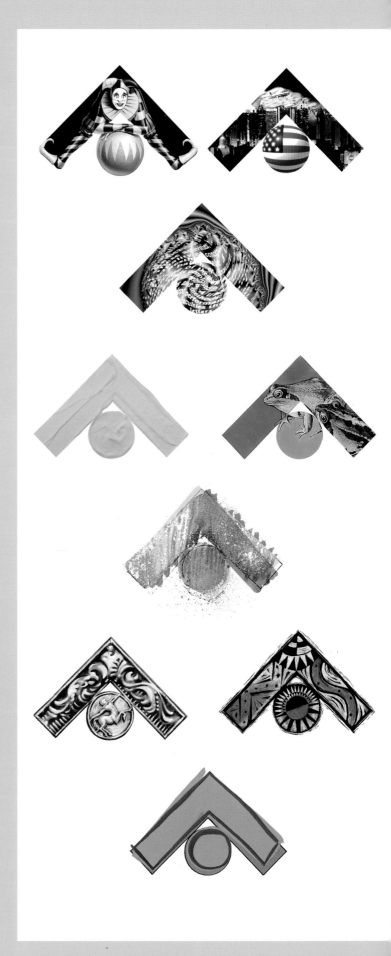

and to create his or her own variation of the logo. Thus came the iguana, a crunchy butter cookie, explosions of color, and the other individual expressions. A book such as *Letterhead & Logo Design 4* is of great value to both designers and their clients because it exposes the range of possibilities: Like any good resource, it inspires, but those ideas that are actually out there are the most convincing way of leading a client in a positive, contemporary direction.

The designer's favorite playground is the business card—there is almost no limitation as to what can be done, other than budget. The envelope and letterhead, however, have to work with the real message that is going out to clients. The body copy must be considered as an integral design element. It must balance within the letterhead, and the address on the envelope must merge with the design. Sometimes a simple design can become fabulous when it is completed with the body copy.

Rather than holding us back, though, this restrictive format merely creates a canvas for exploring creative vision. The pieces on the pages to follow—be they stark and conservative, wildly cutting edge, rich and sophisticated, or merely doing their job well—prove that the format allows enough freedom for excellent design work that satisfies both client and artist.

Illustration (left, facing page):*To produce these elements in full color for maximum impact and to stay within a budget that would make the entire program possible, designer Kannex Fung chose to use one color for the basic letterhead and logo. Since their original creation, the various logo illustrations have been used on stickers that are placed on company communications, T-shirts, and business cards for each employee. The graphic logo has recently been printed in stamped foil for labels that celebrate the 10th anniversary of the studio.*

Graphic Design
and Advertising

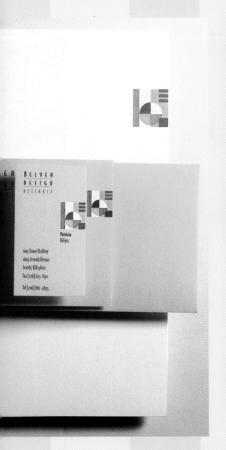

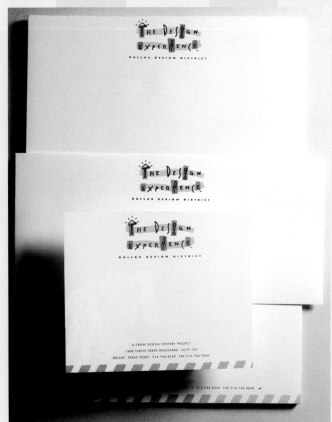

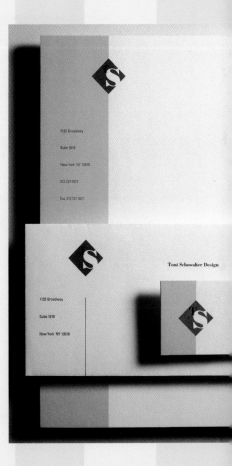

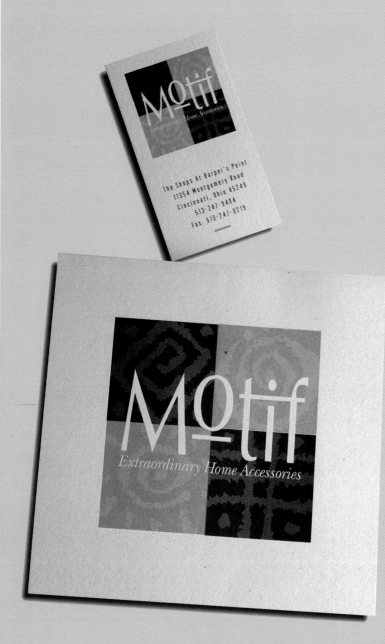

DESIGN FIRM Martiny and Company
ALL DESIGN Rick Conner
CLIENT Step By Step Packaging, Inc.
TOOL Adobe Illustrator

..

Initial thoughts were worked out on paper. After the concept
was conceived, mechanics were worked out on the computer.
Color tests were run on a 3M Rainbow proofing system.

DESIGN FIRM Martiny and Company
ART DIRECTOR/DESIGNER Nancy Andrew
CLIENT Motif Home Accessories
TOOLS Adobe Illustrator, QuarkXPress

..

A description was added to the name for clarification. The
funky illustrations reflect products sold in store.

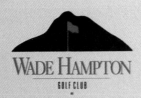

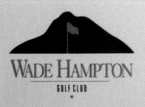

Hwy 107 South • P.O. Box 1920 • Cashiers, N.C. 28717 • (704) 743-5465 • FAX (704) 743-9752

Design Firm Logo Express
All Design Allison Edwards Cottrill
Client Austin Marketing, Wade Hampton G.C.

The mountain in the logo is indicative of the mountain on the
golf course, which is a well-known sight.

3152 PORTSMOUTH DRIVE CINCINNATI, OHIO 45208• 513.533.0997

DESIGN FIRM Logo Express
ALL DESIGN Allison Edwards Cottrill
CLIENT Logo Express

This freelance company needed something bold and full of energy.

40 E. McMicken Ave. Cincinnati, Ohio 45210 929.DUCK

DESIGN FIRM Martiny and Company
ART DIRECTOR/DESIGNER Allison Edwards Cottrill
ILLUSTRATOR Air Studios
CLIENT Free store / Food bank

The typefaces, Variator and Journal, were created in Illustrator and Quark. The illustration was done by hand by a local illustrator at Air Studios. Note Cincinnati skyline in the sunglasses.

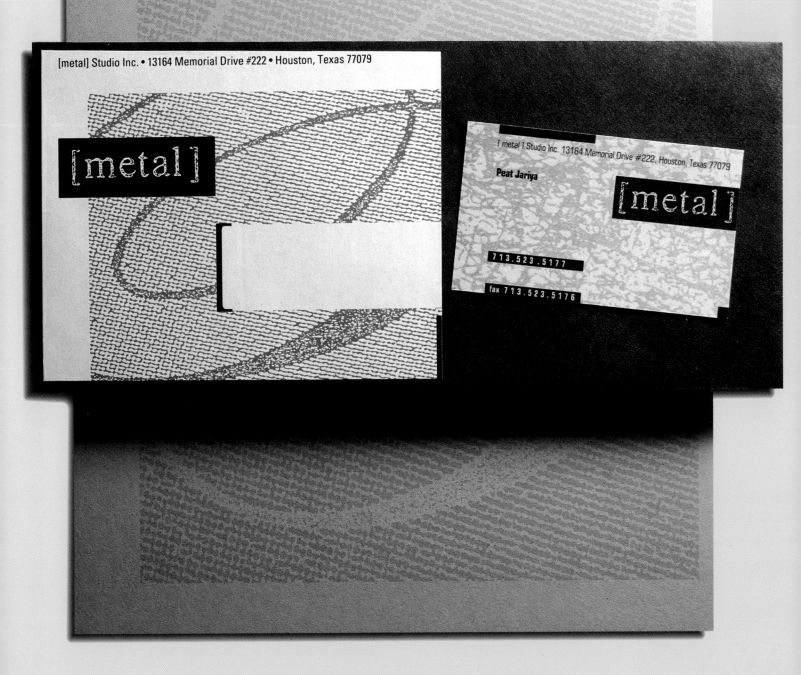

[metal] Studio Inc. 1210 W.Clay Suite 13 Houston TX 77019 713.523.5177

[metal]

[metal] Studio Inc. • 13164 Memorial Drive #222 • Houston, Texas 77079

[metal]

! metal ! Studio Inc. 13164 Memorial Drive #222, Houston, Texas 77079

Peat Jariya

[metal]

713.523.5177

fax 713.523.5176

DESIGN FIRM [Metal]
ART DIRECTOR Peat Jariya
PAPER/PRINTING Champion Benefit for letterhead, UV Ultra for
business cards, printing in black and a metallic ink.

DALLAS DESIGN DISTRICT

DALLAS DESIGN DISTRICT

DALLAS DESIGN DISTRICT

A CROW DESIGN CENTERS PROJECT
1400 TURTLE CREEK BOULEVARD, SUITE 100

DALLAS, TEXAS 75207 214.744.4250 FAX 214.744.9668

ROJECT

75207 • 214.744.4250 FAX 214.744.9668

Design Firm Jon Flaming Design
All Design Jon Flaming
Client The Design Experience
Paper/Printing Simpson Starwhite Vicksburg

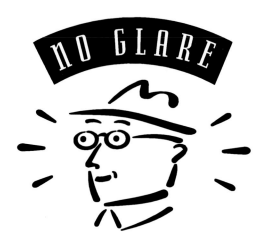

DESIGN FIRM Jon Flaming Design
ALL DESIGN Jon Flaming
CLIENT Eyemasters
TOOL Adobe Illustrator

This logo for no-glare eyewear was created using Illustrator's Brush tool and a Wacom graphics tablet and pen.

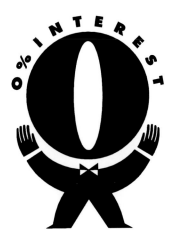

DESIGN FIRM Jon Flaming Design
ALL DESIGN Jon Flaming
CLIENT Computer City
TOOL Adobe Illustrator

This logo was used in a computer store's zero percent interest ad.

DESIGN FIRM Jon Flaming Design
ALL DESIGN Jon Flaming
CLIENT Eyemasters
TOOL Adobe Illustrator

This logo for Eyemasters's two-for-one sale was created using Illustrator's Brush tool and a Wacom graphics tablet and pen.

DESIGN FIRM Jon Flaming Design
ALL DESIGN Jon Flaming
CLIENT Blockbuster Video
TOOL Adobe Illustrator

Many logos and icons were produced for an elaborate and extensive new business pitch that was made to Blockbuster Video.

DESIGN FIRM Jon Flaming Design
ALL DESIGN Jon Flaming
CLIENT Objex Inc.
TOOL Adobe Illustrator

This logo was created for private-label coffees from
Objex Inc.

DESIGN FIRM Jon Flaming Design
ALL DESIGN Jon Flaming
TOOL Adobe Illustrator

This logo was created for a design and illustration studio
located in the industrial sector of downtown Dallas, next to
a huge power plant with tan smokestacks.

DESIGN FIRM Jon Flaming Design
ALL DESIGN Jon Flaming
CLIENT Blockbuster Video
TOOL Adobe Illustrator

Many logos and icons were produced for an elaborate
and extensive new business pitch that was made to
Blockbuster Video.

DESIGN FIRM Jon Flaming Design
ALL DESIGN Jon Flaming
CLIENT Target Music Research
TOOL Adobe Illustrator

This logo was created for a company that does target market
research for the music industry.

1133 Broadway

Suite 1610

New York NY 10010

212 727 0072

Fax 212 727 0071

Toni Schowalter Design

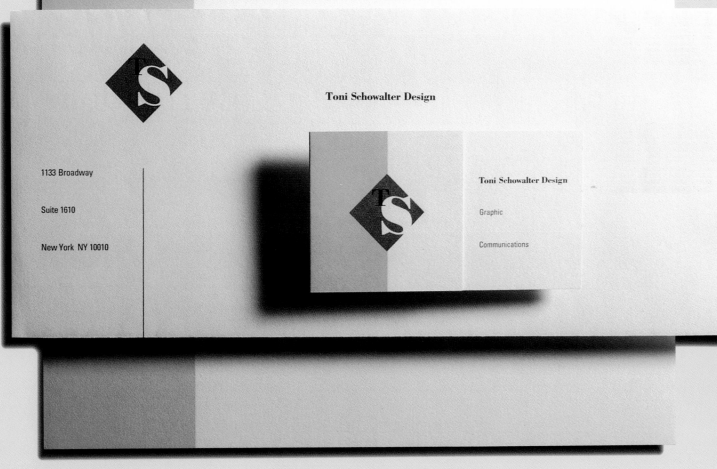

1133 Broadway

Suite 1610

New York NY 10010

Toni Schowalter Design

Toni Schowalter Design

Graphic

Communications

DESIGN FIRM Toni Schowalter Design
ART DIRECTOR/DESIGNER Toni Schowalter
PAPER/PRINTING Strathmore Natural White, Wove Finish, offset
..
The mark was created in QuarkXPress on the Macintosh.
Combining a unique color palette with unique layouts effectively
portrays this graphic design firm.

M A R S H A L L W A T S O N I N T E R I O R S

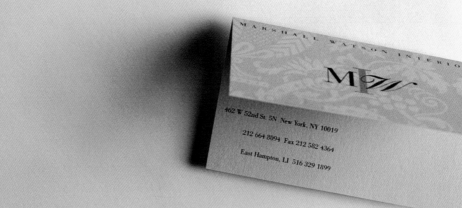

MARSHALL WATSON INTERIORS

462 W 52nd St. 5N New York, NY 10019

462 W 52nd St. 5N New York, NY 10019 212 664 8094 Fax 212 582 4364 East Hampton, LI 516 329 1899

462 W 52nd St. 5N New York, NY 10019

212 664 8094 Fax 212 582 4364

East Hampton, LI 516 329 1899

DESIGN FIRM Toni Schowalter Design

ART DIRECTOR/DESIGNER Toni Schowalter

CLIENT Marshall Watson Interiors

PAPER/PRINTING Strathmore Natural White, Wove Finish, offset

TOOL Adobe Illustrator

··

The logo was created to look both clean and decorated to reflect
the client's interior design styles. The background on the sta-
tionery matches the client's most common style of design.

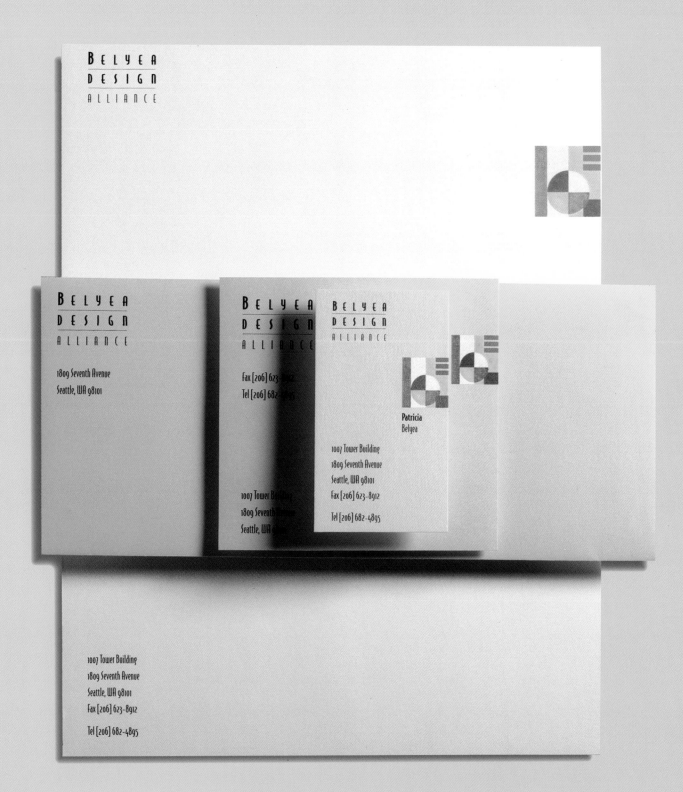

DESIGN FIRM Belyea Design Alliance
ART DIRECTOR Patricia Belyea
DESIGNERS Samantha Hunt, Adrianna Jumping Eagle
ILLUSTRATORS Jani Drewfs, Brian O'Neill
PAPER/PRINTING Simpson Protocol, Ruby Press, 4-color
TOOLS Adobe Photoshop, Aldus FreeHand, Fractal Design
Painter

The mark was rendered in FreeHand, colored in Painter and fil-
tered through Photoshop. The set is 4-color printed; a custom
match yellow replaces process yellow.

W D G C O M M U N I C A T I O N S

Concept-based Marketing Communications and Graphic Design

3011 Johnson Avenue NW Cedar Rapids, Iowa 52405

Telephone 319.396.1401 Facsimile 319.396.1647

W D G C O M M U N I C A T I O N S

Concept-based Marketing Communications and Graphic Design

3011 Johnson Avenue NW Cedar Rapids, Iowa 52405

Design Firm WDG Communications

Art Director/Designer Duane Wood

Illustrator Mark Jacobson

Client WDG Communications

Paper/Printing Neenah Classic Crest Sawgrass, 2-color

Tools Adobe Illustrator, QuarkXPress

The identity presents the firm's professionalism and the dynamic
synergy. The logo was scanned into and executed in Illustrator
and the identity was assembled in QuarkXPress.

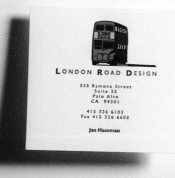

LONDON ROAD DESIGN
535 Ramona Street
Suite 33
Palo Alto
CA 94301

415 326 6103
Fax 415 326 6603

Jan Haseman

535 Ramona Street Suite 33 Palo Alto CA 94301 415 326 6103 Fax 415 326 6603

DESIGN FIRM London Road Design
ART DIRECTOR/DESIGNER Martin Haseman
ILLUSTRATOR Michael Schwab
PAPER/PRINTING Strathmore Bright White Wove,
letterpress printing
TOOLS Adobe Illustrator and Streamline

Michael Schwab supplied the flat art, which was scanned, vectorized with Streamline, and colored in Illustrator. Julie Holcomb, a letterpress printer in San Francisco, printed the work.

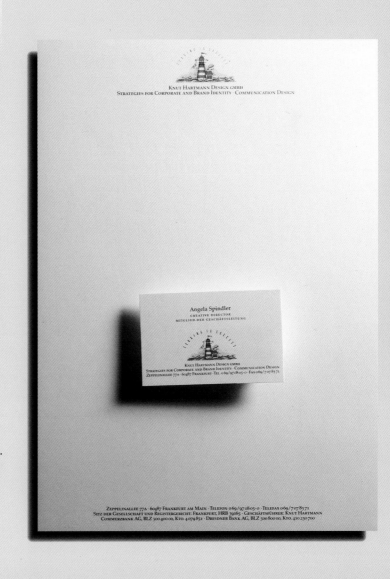

DESIGN FIRM Knut Hartmann Design
DESIGNER Angela Spindler
PAPER/PRINTING Croxley Heritage, 4-color

Letterhead and Logo of Knut Hartmann Design of Frankfurt. The lighthouse image leading the way confidently and reassuringly to success.

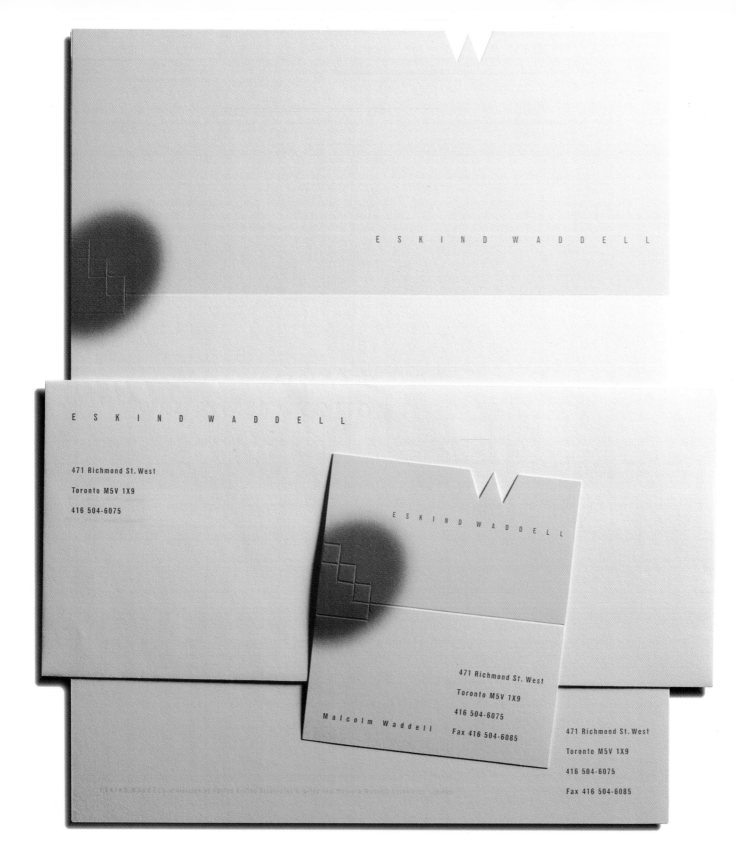

DESIGN FIRM Eskind Waddell
DESIGNERS Roslyn Eskind, Malcolm Waddell, Nicola Lyon
PAPER/PRINTING Strathmore Writing Recycled White Wove,
2-color and die cut

..

Eskind Waddell's distinctive die cut from the previous
stationery, was incorporated into a more contemporary layout.
Revising typography and color also gave the firm a fresh logo
without breaking entirely with the past.

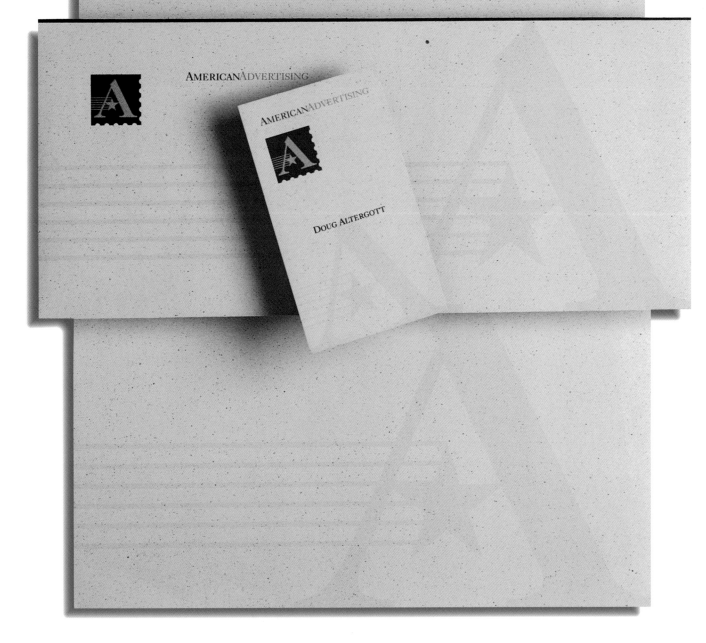

DESIGN FIRM Greteman Group
ART DIRECTORS Sonia Greteman, James Strange
DESIGNER James Strange
CLIENT American Advertising
PAPER/PRINTING Simpson Quest
TOOL Aldus FreeHand

This logo unifies the "A" and star of "American" with stripes
that turn into postage cancellation marks. The larger postage
stamp shape unites the entire concept.

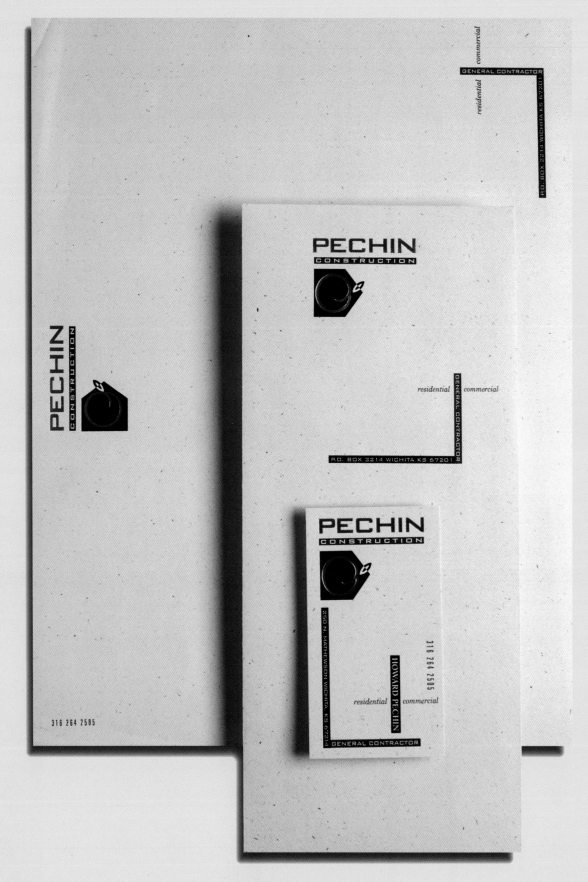

Design Firm Greteman Group
Art Director Sonia Greteman
Designers Sonia Greteman, Karen Hogan
Client Pechin Construction
Paper/Printing Benefit Flax, foil stamp

Since the client's name is often mispronounced, this mark helps
reinforce the correct pronunciation.

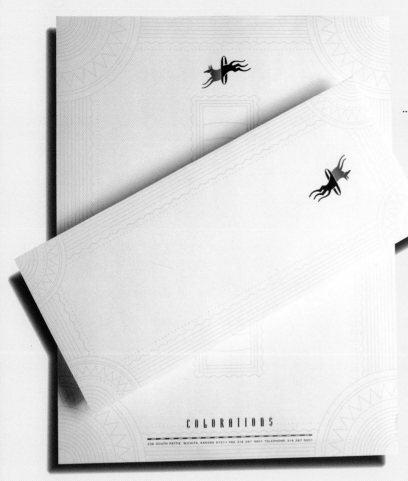

DESIGN FIRM Greteman Group
ART DIRECTOR Sonia Greteman
DESIGNERS Sonia Greteman, Bill Gardner
CLIENT Colorations
PAPER/PRINTING Classic Crest, 4-color process
TOOL Aldus FreeHand

This service bureau jumps through hoops for its clients. The big "C" changes color from black-and-white to magical color creating a circus-like atmosphere.

DESIGN FIRM Greteman Group
ART DIRECTOR Sonia Greteman
DESIGNERS Sonia Greteman, Karen Hogan
ILLUSTRATOR Sonia Greteman
CLIENT Jakes Attic Science Show
PAPER/PRINTING Benefit, 4-color process
TOOL Aldus FreeHand

This design displays a fun level of playfulness, curiosity, and excitement while developing a "character" with an attic hat, question-mark smoke, and a sparkle in his eye.

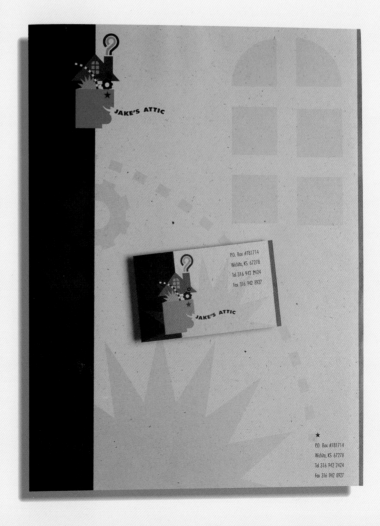

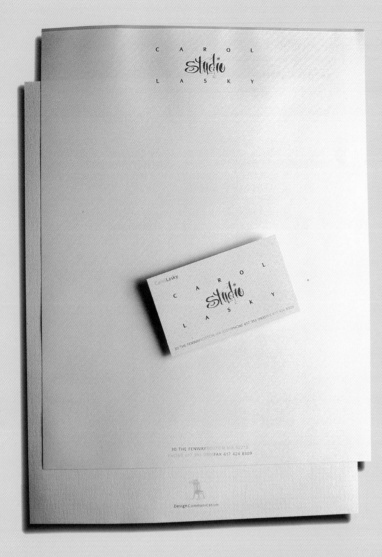

Design Firm Carol Lasky Studio
Art Director Carol Lasky
Designer Erin Donnellan
Illustrator Mark Allen
Client Carol Lasky Studio
Paper/Printing Curtis Brightwater, Strathmore Elements,
United Lithograph
Tools Aldus FreeHand, QuarkXPress

The system is a study in juxtapositions: calligraphy with a serif font; color against color. It juxtaposes bright white paper with diagonal ribs, polka dots, lush texture, and vertical grooves.

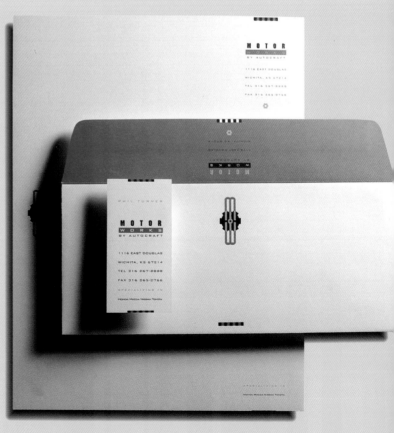

Design Firm Greteman Group
Art Directors Sonia Greteman, James Strange
Designer James Strange
Client Motorworks
Paper/Printing Classic Crest, 3-color
Tool Aldus FreeHand

The client wanted an image that appeared fast, racy and mechanical. Since the "M" and "W" mirror each other, a gear was added in the center.

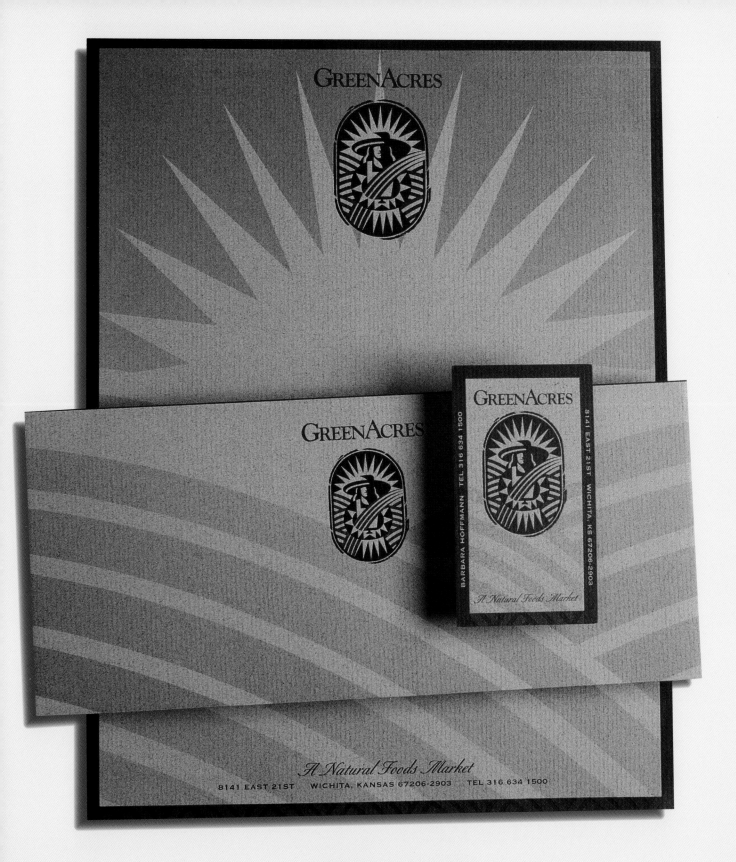

DESIGN FIRM Greteman Group
ART DIRECTOR Sonia Greteman
DESIGNERS Sonia Greteman, Karen Hogan
ILLUSTRATOR Sonia Greteman
CLIENT Green Acres
PAPER/PRINTING Peppered Bronze, 2-color
TOOL Aldus FreeHand

This earthy identity combines the simple pure image of a
farm girl with lush green fields and a warm sunny sky, to
communicate health and wellness.

DESIGN FIRM Pinto Design
DESIGNER John Pinto
TOOL Adobe Illustrator

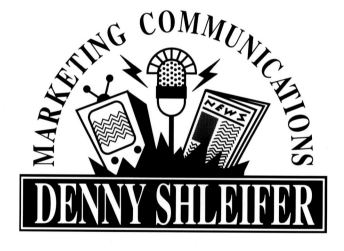

DESIGN FIRM Greteman Group
ART DIRECTOR/DESIGNER Sonia Greteman
CLIENT Winning Visions

...

In this logo for an advertising firm, the torch forms a "V," and the flame forms an eye.

IVIE & ASSOCIATES, INC.
MARKETING COMMUNICATIONS

DENNY SHLEIFER
MARKETING COMMUNICATIONS

DESIGN FIRM Jeff Fisher Design
ALL DESIGN Jeff Fisher
CLIENT Denny Shleifer Marketing Communications

...

The FreeHand illustrations of a television, radio mike and newspaper breaking through the surface convey enthusiasm and excitement.

DESIGN FIRM Ivie & Associates Inc.
ALL DESIGN Jeff Taylor
CLIENT Ivie & Associates, Inc.
TOOL QuarkXPress

...

The ivy leaf was hand-illustrated, then scanned and imported into a QuarkXPress document, where type was added.

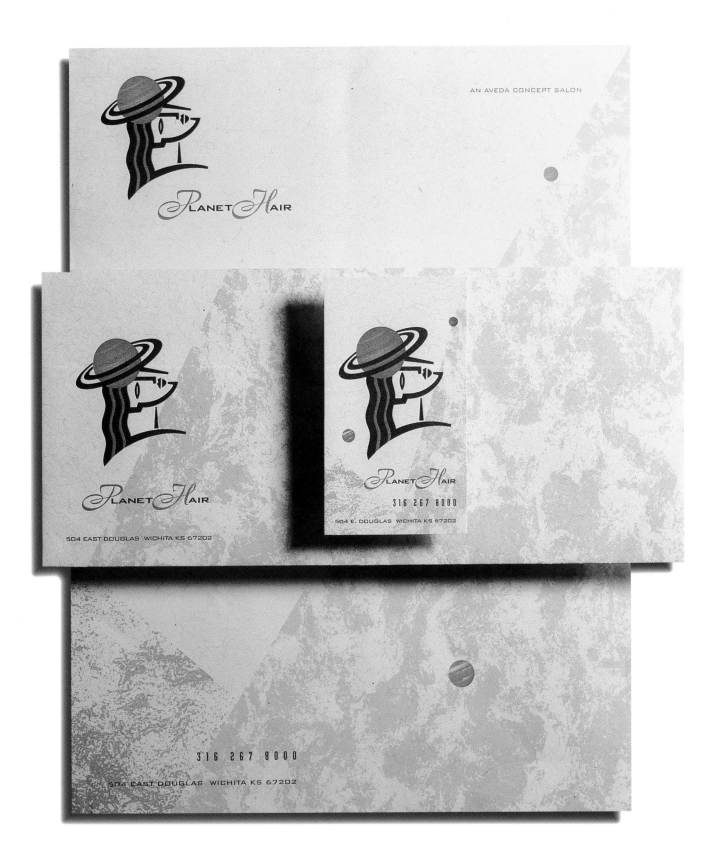

DESIGN FIRM Greteman Group

DESIGNERS Sonia Greteman, Karen Hogan

ILLUSTRATOR Sonia Greteman

CLIENT Planet Hair

PAPER/PRINTING French Rayon

TOOLS Adobe Photoshop, Aldus FreeHand

This unisex logo designed for a hip hair salon is androgynous,
suggesting a cubist feel.

mark duebner design

mark duebner design

176 horizon circle carol stream, illinois 60188

176 horizon circle carol stream, illinois 60188 phone/fax 708.871.9040

DESIGN FIRM Mark Duebner Design
ART DIRECTOR/DESIGNER Mark Duebner
PAPER/PRINTING Strathmore Elements (Lines, Squares
and Dots), 2-color
TOOLS Adobe Illustrator, QuarkXPress
..
The designer used his initials, which almost mimic the initials of
the company as the main visual element because it demands a
second look. The paper stock is engaging.

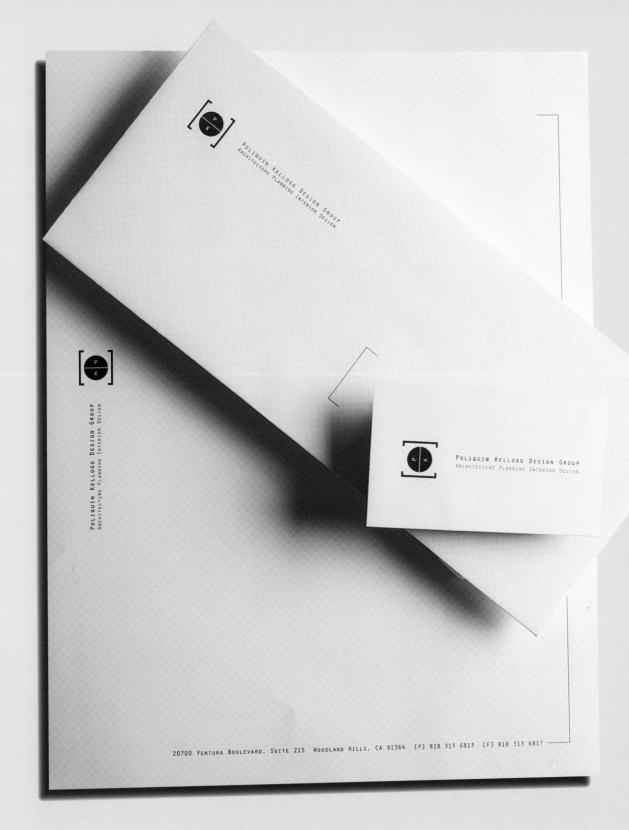

DESIGN FIRM Georgopoulos Design Associates
ART DIRECTOR John Georgopoulos
DESIGNER/ILLUSTRATOR Joe Doucet
CLIENT Poliquin Kellogg Design Group
PAPER/PRINTING Strathmore Elements Squares, Login Printing
TOOLS Adobe Illustrator, QuarkXPress

The logo reflects the architectural firm's focus on defining space.
The logo was created in Illustrator, saved as an EPS file, then
placed into QuarkXPress, where the layout was developed.

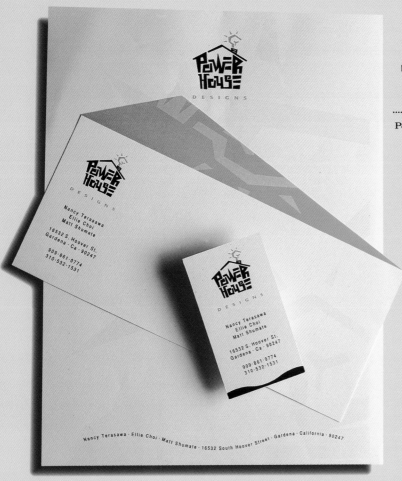

DESIGN FIRM California State Polytechnic University,
Pomona/Powerhouse Designs
DESIGNERS Nancy Terasawa, Ellie Choi, Matt Shumate
PAPER/PRINTING Concept Natural Surf Wove 24 lb. Writing,
Cyclone color output
TOOL Adobe Illustrator

Powerhouse Designs is a fictitious design firm created through a
group project for a class. This letterhead incorporates, into a
single corporate I.D. system, framing and building furniture.

DESIGN FIRM Mind's Eye Design
ART DIRECTOR/DESIGNER Stephen Brown
PAPER/PRINTING Hopper Proterra
TOOLS Adobe Photoshop and Streamline,
Macromedia FreeHand

Copper-metallic foil seals were designed to achieve
the foil-emboss look on a tight budget.

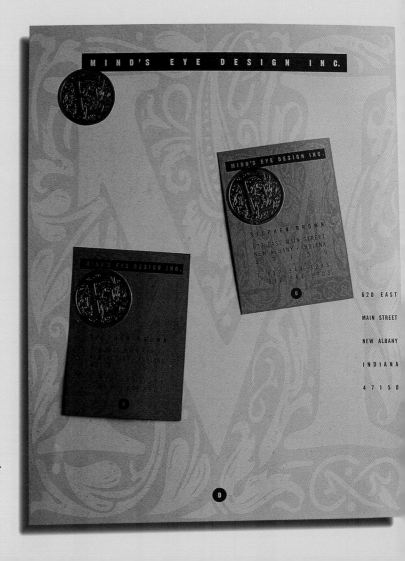

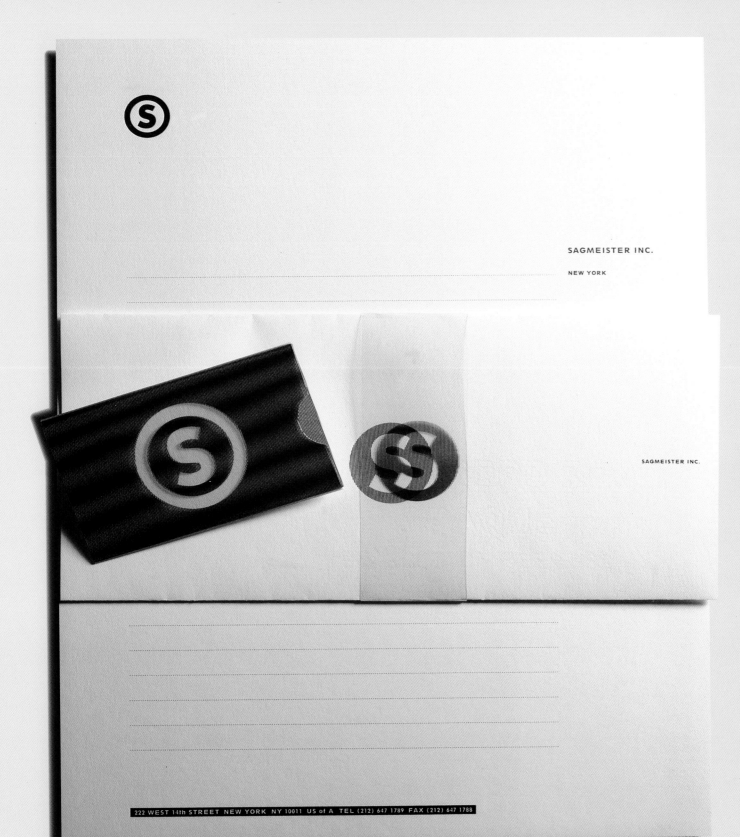

SAGMEISTER INC.

NEW YORK

SAGMEISTER INC.

222 WEST 14th STREET NEW YORK NY 10011 US of A TEL (212) 647 1789 FAX (212) 647 1788

DESIGN FIRM Sagmeister Inc.
ART DIRECTOR/DESIGNER Stefan Sagmeister
PAPER/PRINTING Strathmore Bond

The logo is as simple as possible. Since a New York restaurant/laundry service uses the same "S" in a circle, there are now napkins with the same logo.

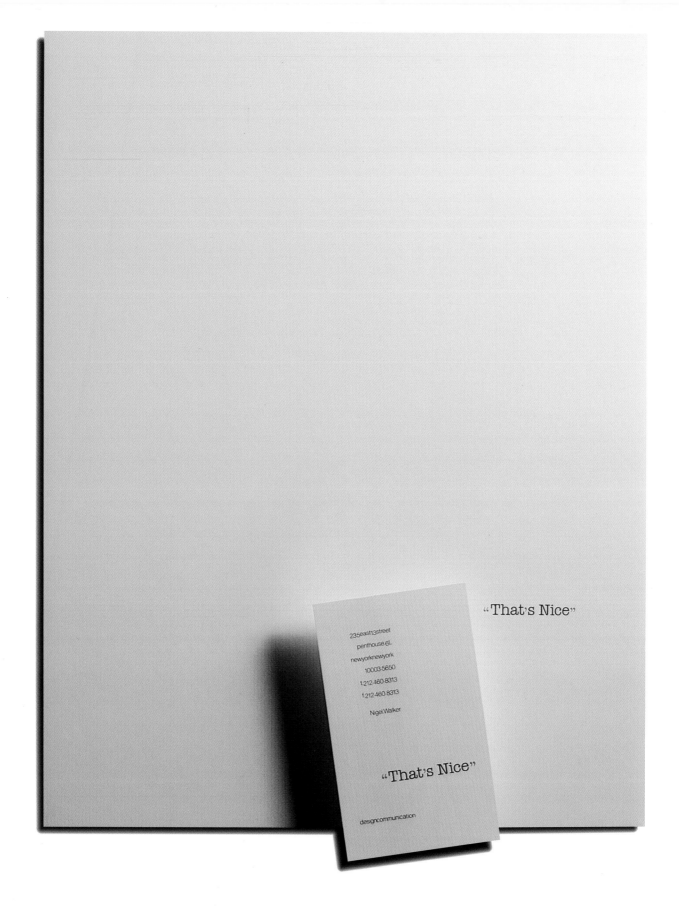

"That's Nice"

235east13street
penthouse.6L
newyorknewyork
10003-5650
t.212.460.8313
f.212.460.8313

Nigel.Walker

"That's Nice"

designcommunication

DESIGN FIRM "That's Nice"
ART DIRECTOR/DESIGNER Nigel Walker
PAPER/PRINTING Strathmore Elements, Anchor Engraving
TOOLS Adobe Illustrator, Aldus FreeHand, QuarkXPress
..
This logo uses old, roman-style numerals with a sans serif face,
no word spacing, and a rigid grid engraved on Strathmore's
Elements paper, double-warm red and reflex blue.

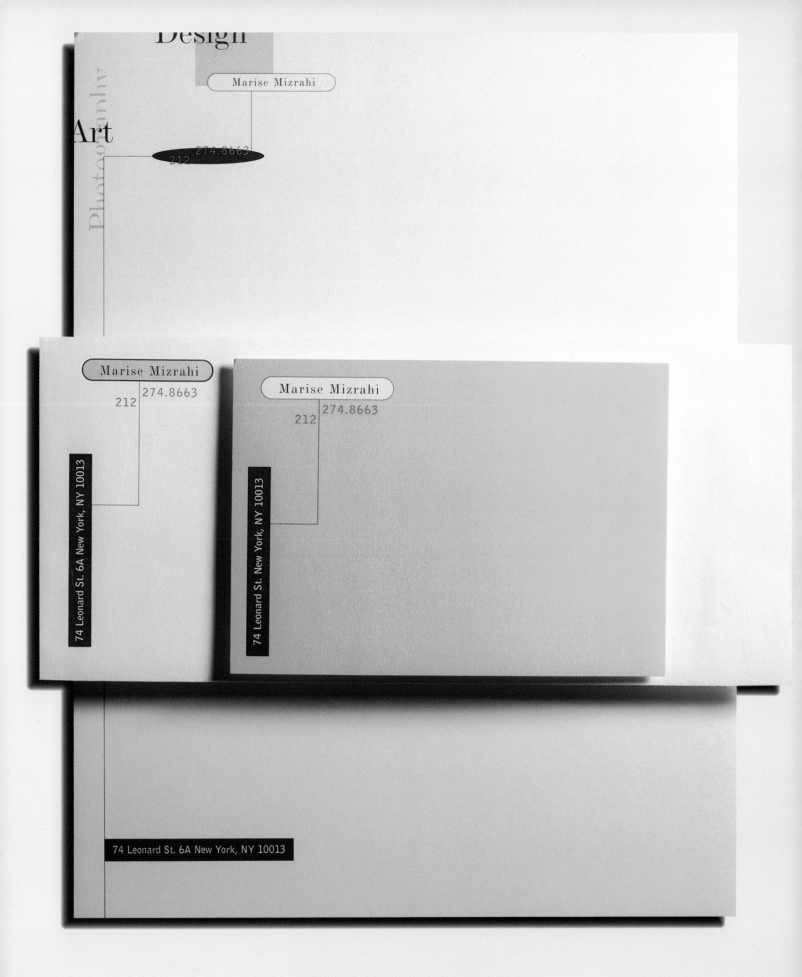

Design

Marise Mizrahi

Art

Photography

212 274.8663

Marise Mizrahi

212 274.8663

74 Leonard St. 6A New York, NY 10013

Marise Mizrahi

212 274.8663

74 Leonard St. New York, NY 10013

74 Leonard St. 6A New York, NY 10013

DESIGN FIRM Marise Mizrahi Design
ART DIRECTOR/DESIGNER Marise Mizrahi
PAPER/PRINTING Hammermill, 3-color, Sterling Bianco

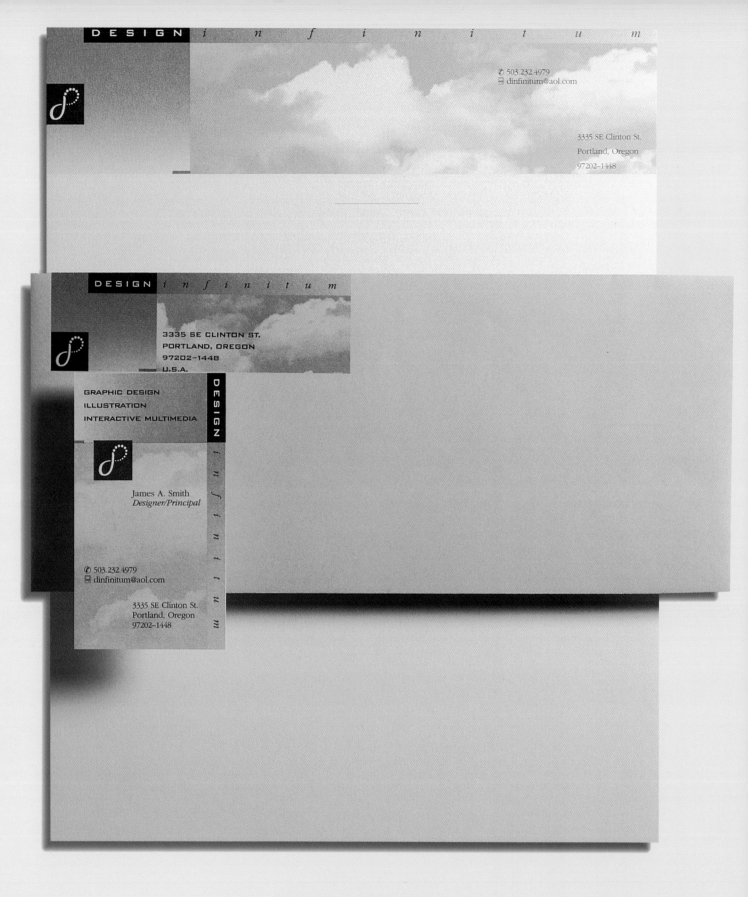

DESIGN FIRM Design Infinitum

ALL DESIGN James A. Smith

PAPER/PRINTING Neenah Classic Crest, Chromagraphics

TOOLS Adobe Photoshop, Aldus FreeHand, QuarkXPress

..

The logo was created in FreeHand; the cloud image was manip-
ulated in Photoshop; and the letterhead, envelope, and card were
designed in QuarkXPress. This package won a Neenah Paper
Silver Medal.

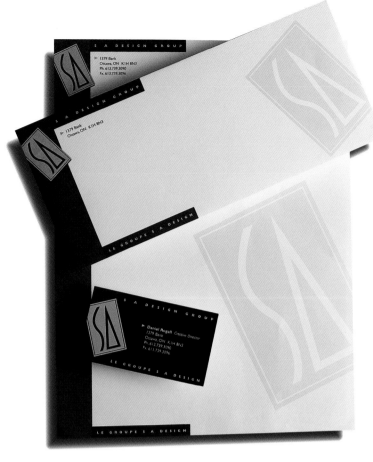

DESIGN FIRM S.A. Design Group
ART DIRECTOR/DESIGNER Daniel Rogall
PAPER/PRINTING Mohawk Superfine, 3-color (black, 2 PMS), envelopes—custom manufactured, Mohawk Superfine
TOOLS Adobe Illustrator, QuarkXPress

..

The pre-printed envelopes were custom manufactured after printing. Illustrator was used to create the logo, which was imported as an EPS into QuarkXPress.

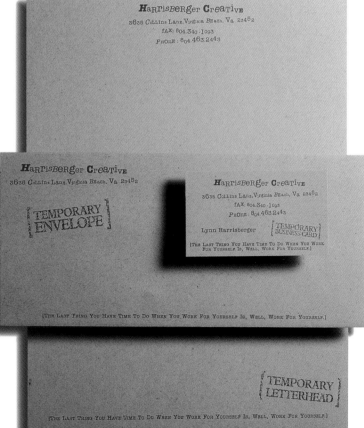

DESIGN FIRM Harrisberger Creative
ART DIRECTOR/DESIGNER Lynn Harrisberger
PAPER/PRINTING Environment Desert Storm, 1-color
TOOL QuarkXPress

..

This temporary letterhead, envelope, and business card was created with little time and a low budget.

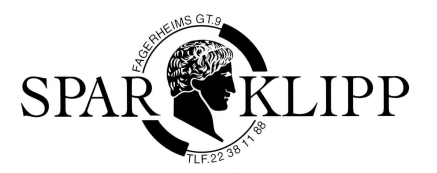

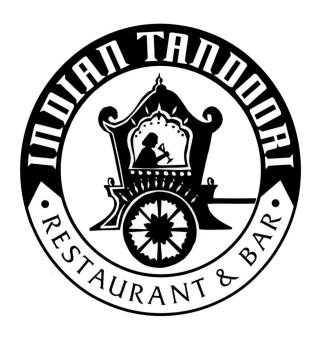 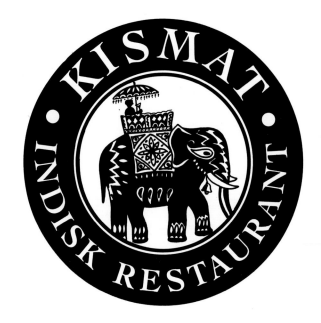

Design Firm Amar's Design
All Design Amar Aziz
Clients Spar Klipp, Indian Tandoori Restaurant & Bar, and
Kismat Indisk Restaurant
Tool QuarkXPress

All the logos were drawn by hand, and all the letters and headings were created in QuarkXPress.

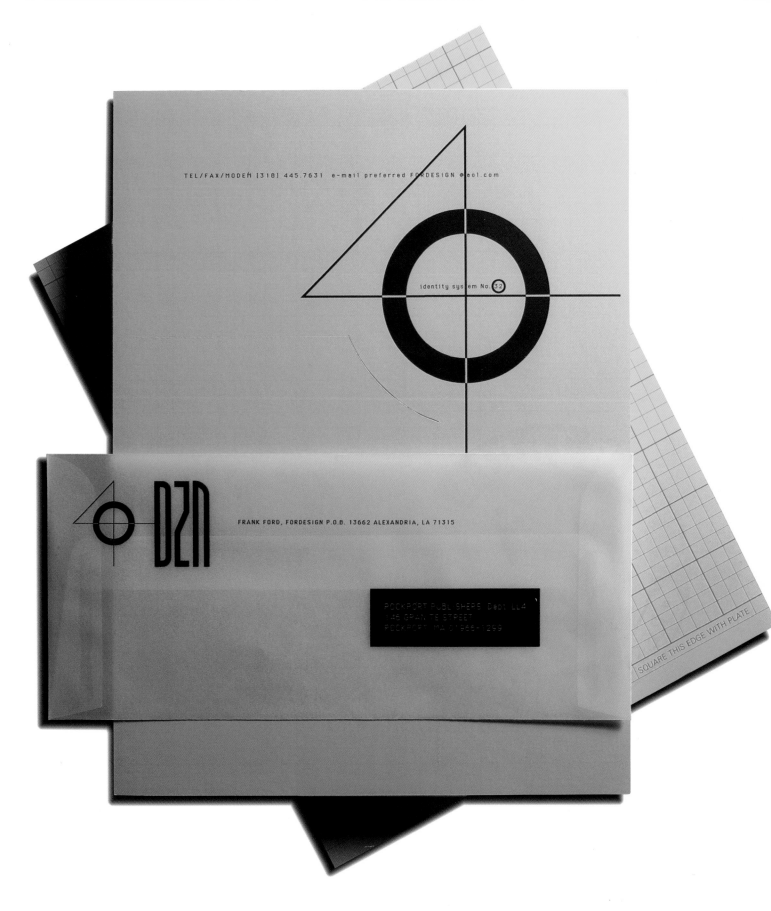

DESIGN FIRM FORDESIGN

ART DIRECTOR/DESIGNER Frank Ford

PAPER/PRINTING Masking sheets, vellum

..

The I.D. system, accomplished on the desktop on low budget
indicates specialization with print media. The masking sheets
indicate that the client follows the job from start to finish.

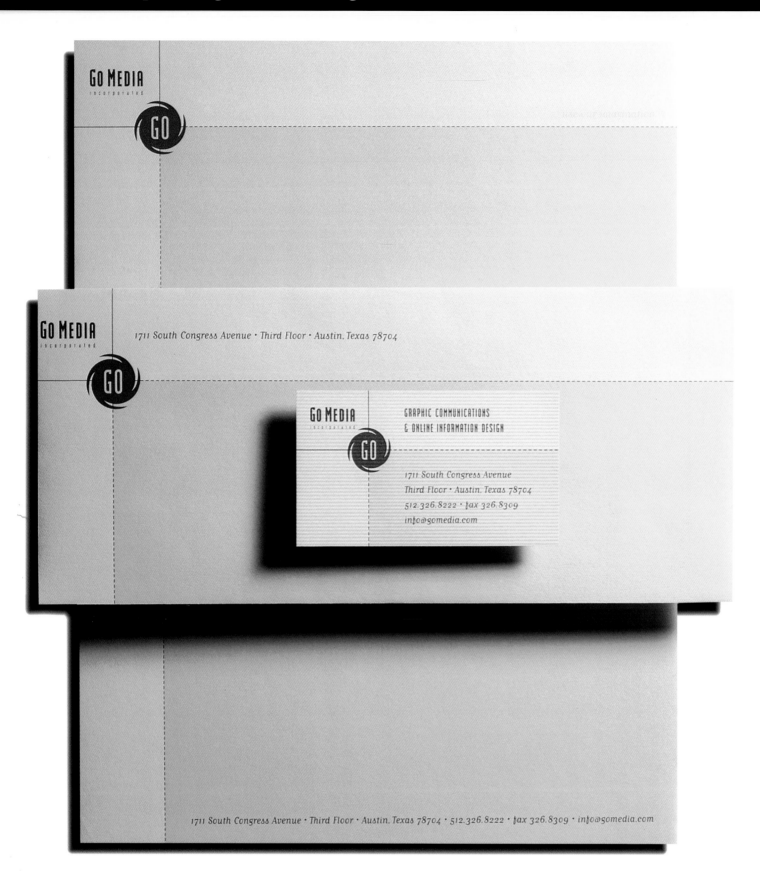

Design Firm Go Media Inc.

All Design Sonya Cohen

Paper/Printing Champion Benefit, Lithoprint

Tools Adobe Illustrator, QuarkXPress

The logo captures that sense of motion and the energy of "Go,"
while the layout, paper and color palette enjoy the more formal
and tactile qualities of traditional printed "Media."

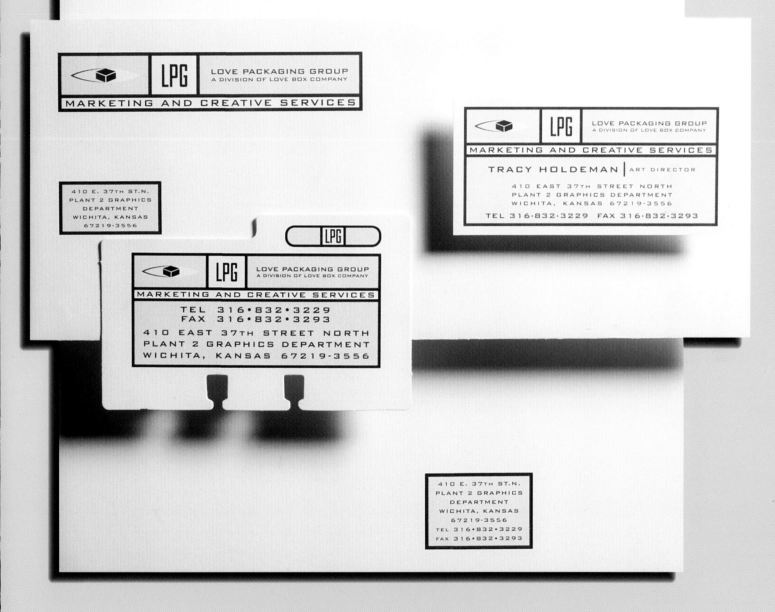

Design Firm Love Packaging Group
Art Director/Illustrator Tracy Holdeman
Designers Tracy Holdeman, Brian Miller
Paper/Printing Strathmore Elements
Tool Macromedia FreeHand

Love Packaging Group identity was created entirely in
FreeHand. The iris and pupil represent creative vision
in packaging.

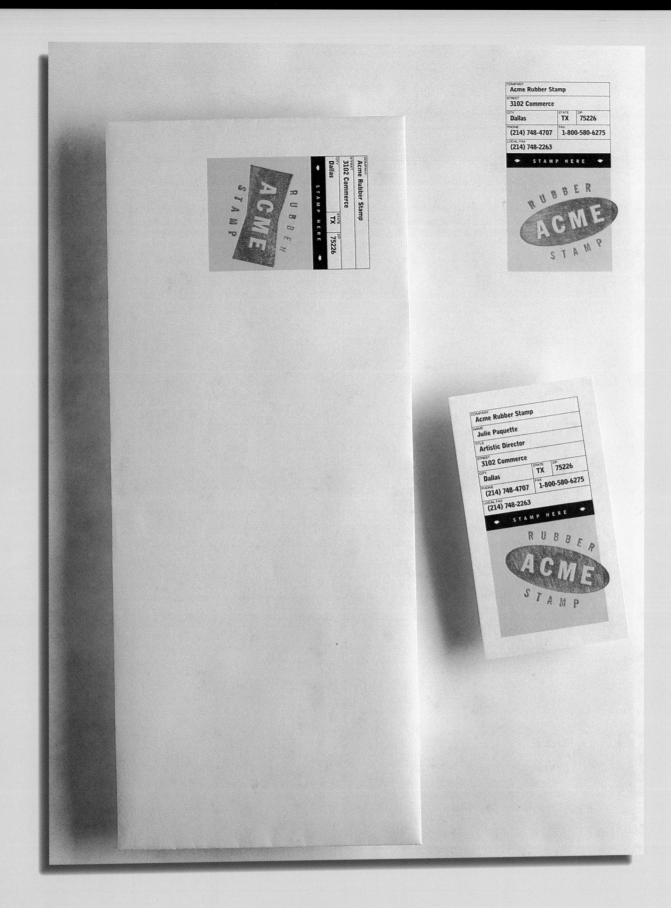

DESIGN FIRM Peterson & Company

ART DIRECTOR/DESIGNER Dave Eliason

CLIENT ACME Rubber Stamp Co.

PAPER/PRINTING French Duratone Butcher, Monarch Press

TOOLS Adobe Illustrator, QuarkXPress

This piece was printed offset, 2-color, on a mottled, industrial-looking paper. The logo was then rubber-stamped in red ink.

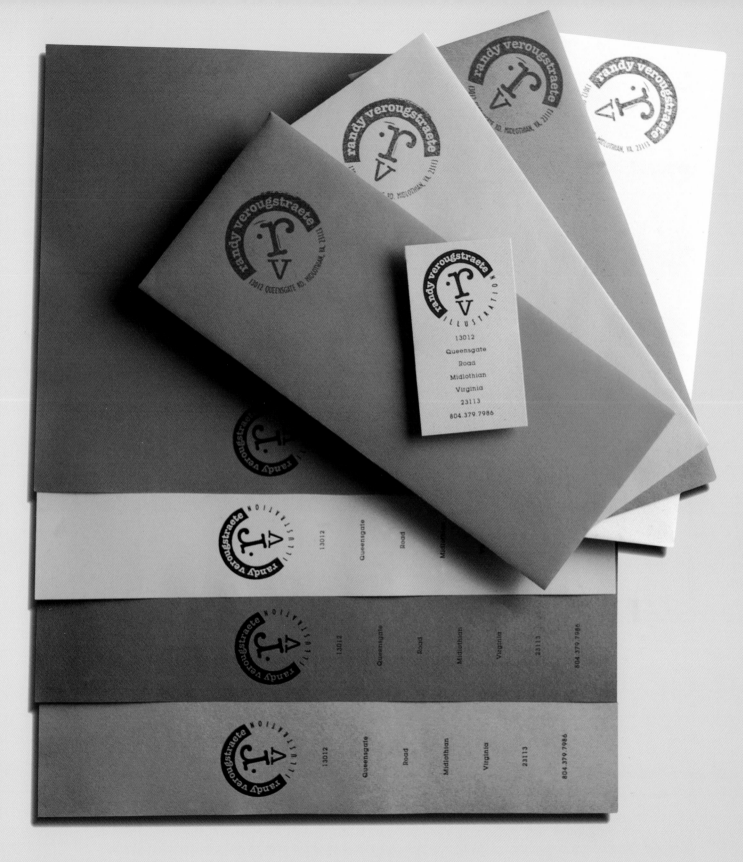

Design Firm Michelle·Farinella·Graphic·Design
Designer Michelle Farinella
Client Randy Verougstraete Illustration
Paper/Printing Canyon Terracotta, Cactus Green, Windswept
Ivory, Desert Beige, Kraft Paper Combos, 1-color
Tool Adobe Illustrator

The logo was reproduced as a rubber stamp for other compo-
nents and envelopes. The 1-color package was coupled with
recycled papers that are interchangeable and appropriate for the
versatile styles.

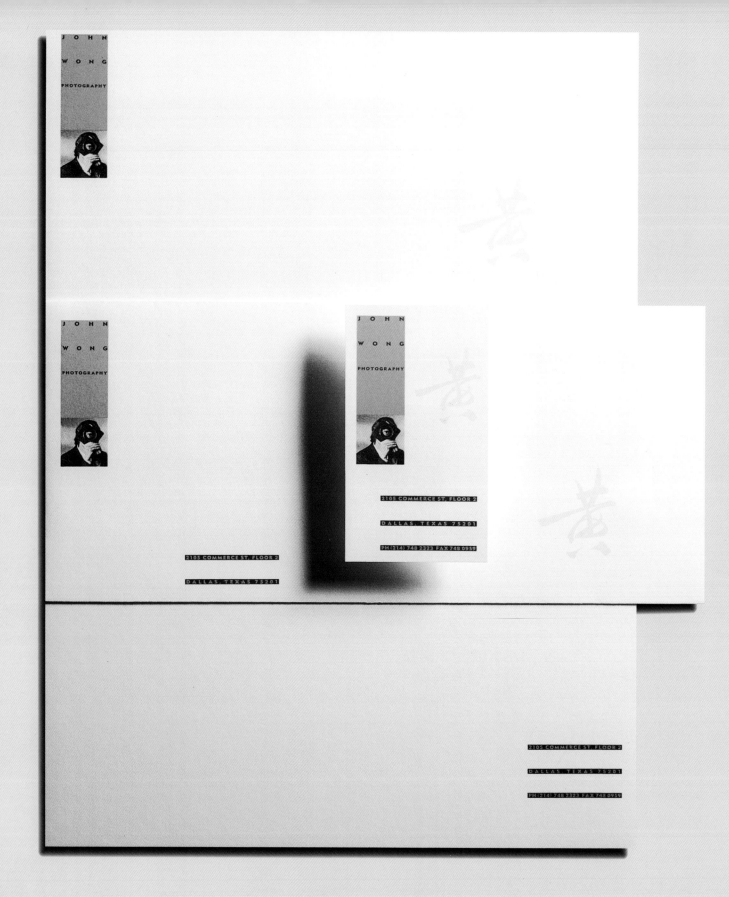

DESIGN FIRM Peterson & Company
ART DIRECTOR/DESIGNER Bryan L. Peterson
CLIENT John Wong Photography
PAPER/PRINTING Neenah Classic Crest, South Press
TOOL QuarkXPress

··

The photo was a halftone stripped in at the press. This package
was printed inexpensively on a small letterpress.

INFOFusion

Revolutionary institutional research methods
Rigorous audience identification and classification
Targeted copy, graphic design, and photography
Budget-sensitive print communications
Result-oriented distribution strategies
Exit analysis and product evaluation

1
Robert Topor
280 Easy Street
Suite 114
Mountain View, CA 94043-3736

2
Ann Granning Bennett
10634 Southwest Hedlund Avenue
Suite 193
Portland, OR 97219-7916

3
Bryan Peterson
2200 North Lamar Street
Suite 310
Dallas, TX 75202-1073

INFOFusion

1
Ann Granning Bennett
10634 Southwest Hedlund Avenue
Suite 193
Portland, OR 97219-7916

Call Ann at 503 635-6462

DESIGN FIRM Peterson & Company
ART DIRECTOR/DESIGNER Bryan L. Peterson
CLIENT Infofusion
PAPER/PRINTING Champion Benefit, South Press
TOOL Adobe Photoshop, QuarkXPress

The Polaroid photograph was shot in the design studio and
bitmapped using Photoshop. The columns were printed in an
opaque white on a small letterpress.

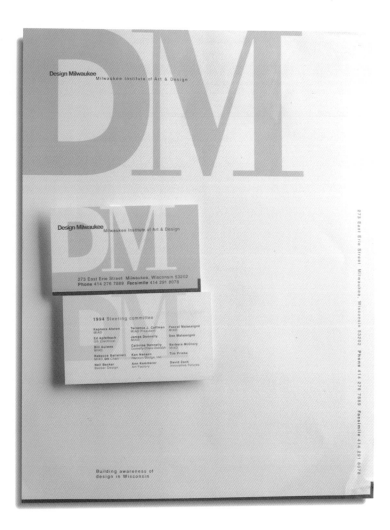

DESIGN FIRM Becker Design
ART DIRECTOR/DESIGNER Neil Becker
CLIENT Design Milwaukee
PAPER/PRINTING Neenah Classic Crest, 2-color, lithography
TOOLS Adobe Illustrator, QuarkXPress

Design Milwaukee, which reaches the entire design community of Milwaukee needed a look that would be appropriate for a wide range of disciplines. The logo was created with Illustrator and Quark Express.

DESIGN FIRM Duck Soup Graphics
ALL DESIGN William Doucette
PAPER/PRINTING French Speckletone, three match colors

The firm specializes in corporate identity, brochure, and packaging design. "Duck Soup" is a slang term that means something is easy to do. The logo was drawn in ink.

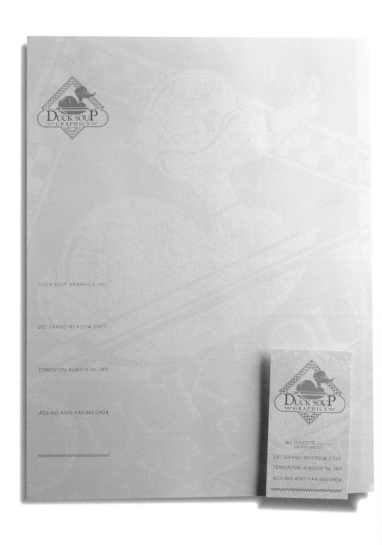

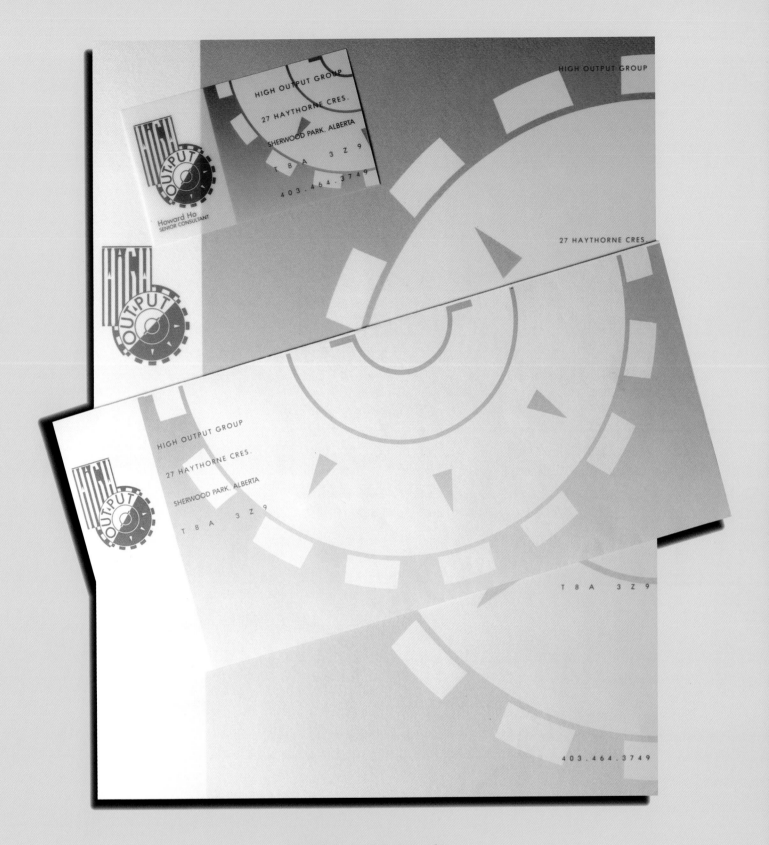

DESIGN FIRM Duck Soup Graphics
ART DIRECTOR William Doucette
DESIGNER/ILLUSTRATOR Sharon Phillips
CLIENT High Output Group
PAPER/PRINTING UV Ultra Opaque White, printed both sides,
two match colors

The hand-drawn letterhead and business card are printed both
sides on UV Ultra to achieve a highly unique image for this
start-up company.

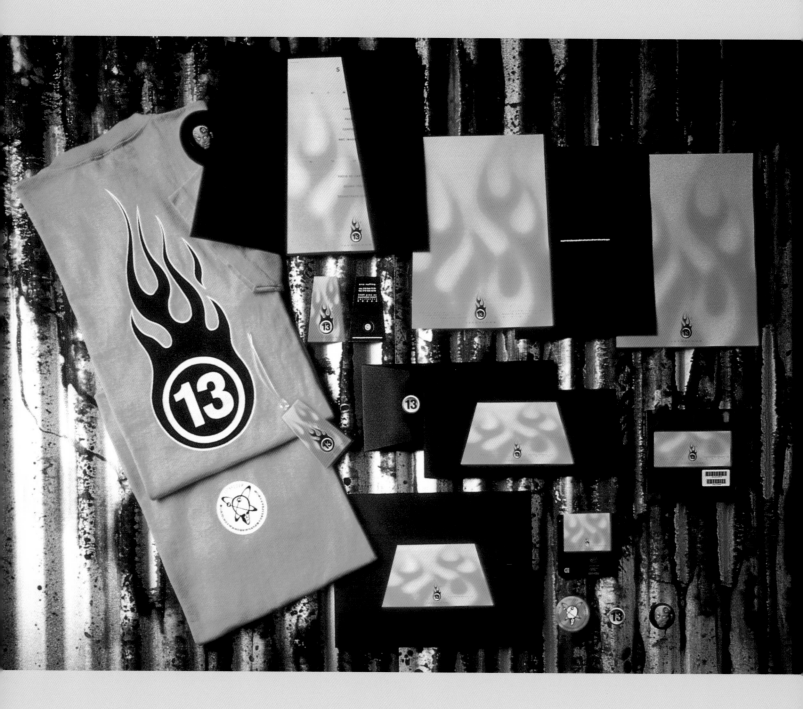

DESIGN FIRM 13TH FLOOR
ART DIRECTORS/DESIGNERS Eric Ruffing, Dave Parmley
ILLUSTRATOR Dave Parmley
PAPER/PRINTING Smith McKay Printing
TOOLS Adobe Photoshop, Aldus FreeHand, MetaTools,
Kai's Power Tools

This logo was hand-drawn and scanned into FreeHand where it
was traced. It was rasterized in Photoshop and repeated to get
the flame background used on all pieces.

56 Broad Street
Milford CT 06460

TEL 203 878 2600
FAX 203 876 0901

56 Broad Street
Milford CT 06460

METROPOLIS CORPORATION

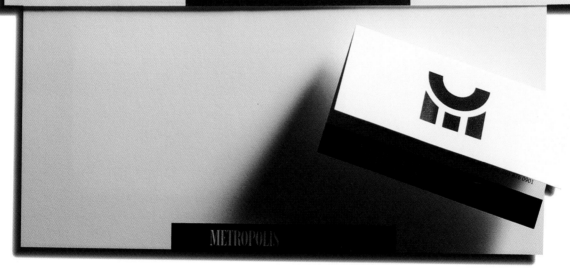

DESIGN FIRM Metropolis Corp.
DESIGNER Denise Davis Mendelsohn
PAPER/PRINTING Cranes Crest
TOOL QuarkXPress

...

The Metropolis logo was traditionally made and the copy was
created in Quark Express. The unique "M" that was produced
is not seen in any typographic font format.

DESIGN FIRM Peterson & Company
ART DIRECTOR/DESIGNER Nhan T. Pham
CLIENT Women's National Book Association
TOOL Adobe Illustrator

Even though the logo was created for WNBA (Dallas Chapter),
the focus was on the association rather than on gender.

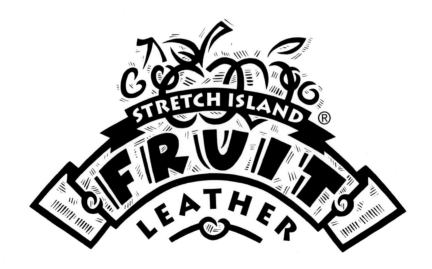

DESIGN FIRM Hornall Anderson Design Works Inc.
ART DIRECTOR Jack Anderson
DESIGNERS Mary Hermes, Jack Anderson, Leo Raymundo
ILLUSTRATOR Fran O'Neill
CLIENT Stretch Island
PAPER/PRINTING Stoneway Carton Co.

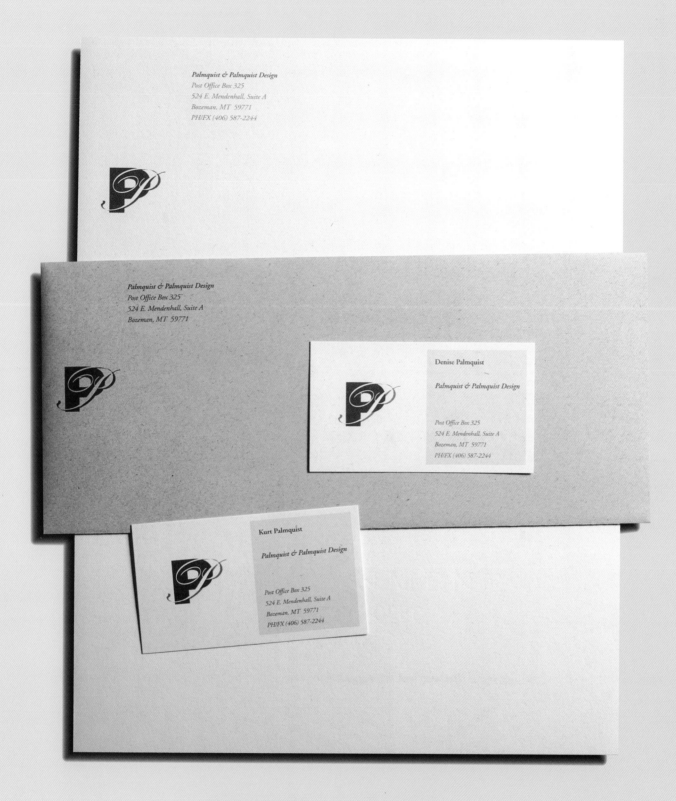

DESIGN FIRM Palmquist & Palmquist Design
ART DIRECTORS/DESIGNERS Kurt and Denise Palmquist
PAPER/PRINTING Environment Moonrock, two PMS colors
TOOL Aldus FreeHand

The masculine "P" and the feminine script "P" reflect different
latitudes in design. The colors are intentionally conservative.
The paper stock reflects nature and the outdoor lifestyle
of the northwest.

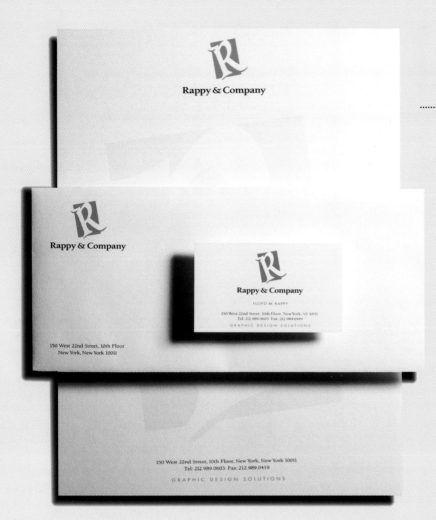

Design Firm Rappy & Company
All Design Floyd Rappy
Client Rappy & Company
Paper/Printing Strathmore Writing Wove
Tools Adobe Illustrator, QuarkXPress

The "R" was hand-lettered, scanned, and brought into
Illustrator and integrated with type.

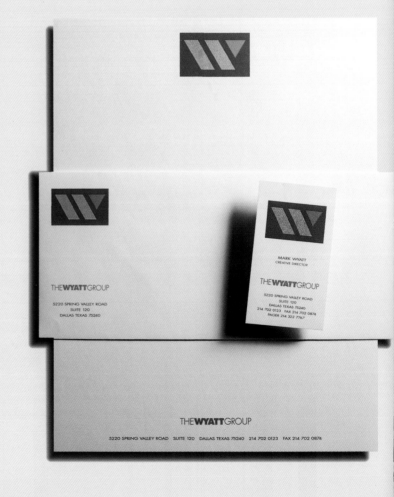

Design Firm The Wyatt Group
All Design Mark Wyatt
Paper/Printing Simpson Starwhite Vicksburg,
three spot metallic inks
Tools Aldus FreeHand, QuarkXPress

Mark Wyatt gave the logo a geometric design in forming the
letter "W." In the printed pieces, metallic inks added a unique
look and feel to the stationery.

Professional Services

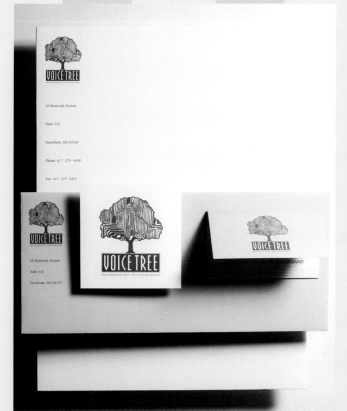

ASSOCIATED PLANNERS INVESTMENT ADVISORY, INC.

A Registered Investment Advisor

Gary E. Roof, CFP

Don H. Eidam, CFP

ASSOCIATED PLANNERS INVESTMENT ADVISORY, INC.

A Registered Investment Advisor

DON H. EIDAM, CFP

One Post Street ▪ Suite 2725
San Francisco ▪ California 94104
415.788.4600 ▪ Fax 415.788.4606

*Securities offered through
Associated Securities Corp.
Member PSE ▪ NASD ▪ SIPC*

ASSOCIATED PLANNERS INVESTMENT ADVISORY, INC.

A Registered Investment Advisor

Securities offered through Associated Securities Corp.▪ Member PSE ▪ NASD ▪ SIPC

One Post Street ▪ Suite 2725 ▪ San Francisco ▪ California 94104

415.788.4600 ▪ Fax 415.788.4606

DESIGN FIRM Clark Design
ART DIRECTOR Annemarie Clark
DESIGNERS Craig Stout, Thurlow Washam
CLIENT Associated Planners Investment Advisory Inc.
PAPER/PRINTING Classic Crest
..
An investment advisory company wanted s look that was
sophisticated but not too expensive. The design used the colors
and a wallpaper pattern from the new office's entrance area.

DESIGN FIRM Toni Schowalter Design
ART DIRECTOR/DESIGNER Toni Schowalter
CLIENT Decisions Strategies International

The mark was used to portray an international strategist corporation.

DESIGN FIRM Greteman Group
ART DIRECTOR Sonia Greteman
DESIGNERS Sonia Greteman, Bill Gardner
CLIENT Colorations

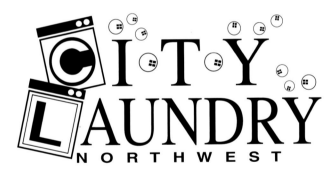

DESIGN FIRM Jeff Fisher Design
ALL DESIGN Jeff Fisher
CLIENT City Laundry Northwest
TOOL Aldus FreeHand

City Laundry's owners wanted a logo that conveyed a fun image of doing your laundry. The business is known as the "dancing washer and dryer" laundry because of the logo.

DESIGN FIRM Greteman Group
ART DIRECTOR/DESIGNER Sonia Greteman
CLIENT Abell Pearson Printing

This is a heroic figure that can handle any job.

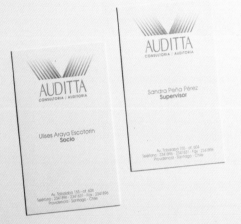

Design Firm Squadra Design Studio
Art Director Guillermo Caceres
Designers Jorge Caceres, Claudia Izquierdo,
Guillermo Caceres
Client Auditta
Paper/Printing Bond 24 lb. Opalina 280 grs, offset 2/0 color

Design Firm Clifford Selbert Design
Art Director Lynn Riddle
Designers Lynn Riddle, Tony Dowers, Mike Balint,
April Skinnard, Bill Crosby
Client Stream International
Paper/Printing Strathmore Ultimate White 24 lb. Wove, offset
Tool Adobe Illustrator

Stream International, a software licensing, packaging, distribution, and support company, is the world's largest software distributor. There is a subtle reference made to water while maintaining a corporate feel.

Stream International Inc.

A merger of Corporate
Software and RR Donnelley
Global Software Services

Stream

Australia
Belgium
Brazil
Canada
China
France
Germany
Hong Kong
Ireland
Japan
Korea
Mexico
The Netherlands
Singapore
Taiwan
United Kingdom
United States

2 Edgewater Drive
Norwood, MA
02062.4637

t 617.440.1000
f 617.440.7070

Stream

2 Edgewater Drive
Norwood, MA 02062.4637

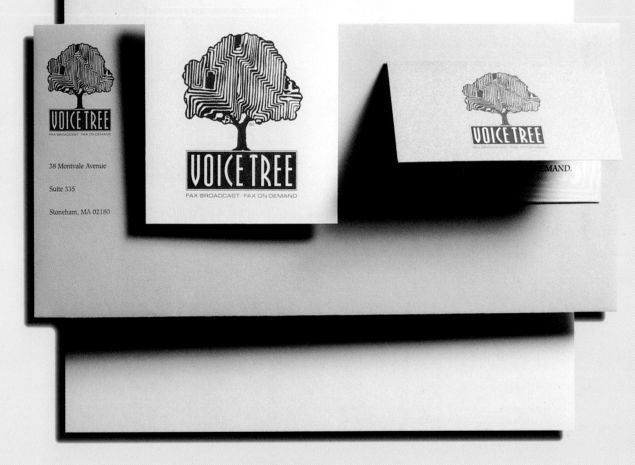

38 Montvale Avenue

Suite 335

Stoneham, MA 02180

Phone 617 · 279 · 4900

Fax 617 · 279 · 4473

38 Montvale Avenue

Suite 335

Stoneham, MA 02180

DESIGN FIRM Carol Lasky Studio
ART DIRECTOR Carol Lasky
DESIGNER/ILLUSTRATOR Erin Donnellan
CLIENT Voice Tree
PAPER/PRINTING Beckett Enhance, Strathmore Writing,
Champion Benefit, Printed at The Ink Spot
TOOLS Aldus FreeHand, QuarkXPress

···

The business card functions as a mini-brochure, making it
stand out—literally. Mixing a variety of papers from different
manufacturers achieved the right blend of stock colors.

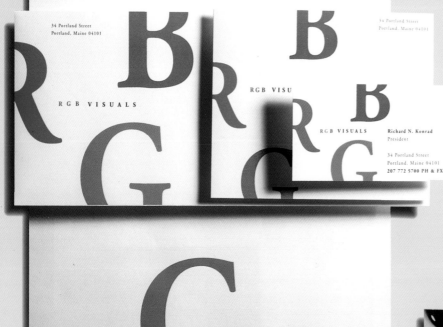

DESIGN FIRM Thomas Hillman Design
ART DIRECTOR/DESIGNER Thomas Hillman
CLIENT RGB Visuals
TOOL Aldus PageMaker

Three letters—RGB—offer the name and color concept in an overstated and dramatic presentation on a white sheet to enhance colors. The final stationery package was assembled in PageMaker.

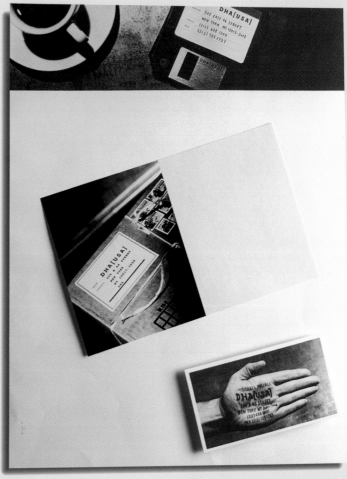

DESIGN FIRM Sagmeister Inc.
ART DIRECTOR/DESIGNER Stefan Sagmeister
PHOTOGRAPHER Tom Schierlitz
CLIENT DHA (USA)
PAPER/PRINTING Strathmore Opaque Bond

DHA (USA) is a consulting company whose services are difficult to pin down. For the identity system, photographs containing all the information demonstrate the services

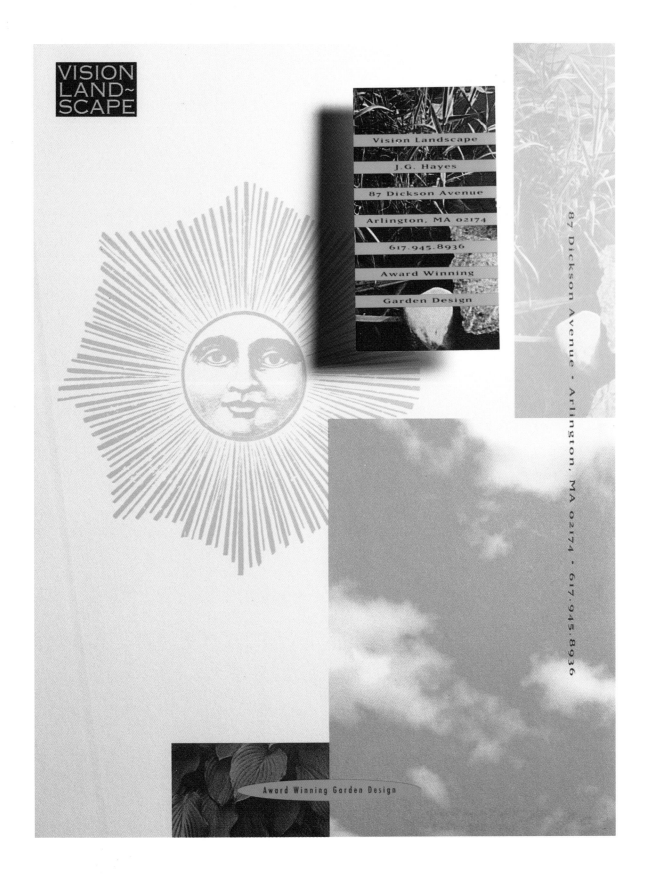

VISION LAND~SCAPE

Vision Landscape

J.G. Hayes

87 Dickson Avenue

Arlington, MA 02174

617.945.8936

Award Winning

Garden Design

87 Dickson Avenue · Arlington, MA 02174 · 617.945.8936

Award Winning Garden Design

DESIGN FIRM The Vision Group
ART DIRECTOR/DESIGNER Gary Ragaglia
CLIENT Vision Landscaping
PAPER/PRINTING Strathmore, 2-color
TOOLS Macromedia FreeHand, Adobe Photoshop

The only design restriction was to create a relationship between
the elements of earth and sky.

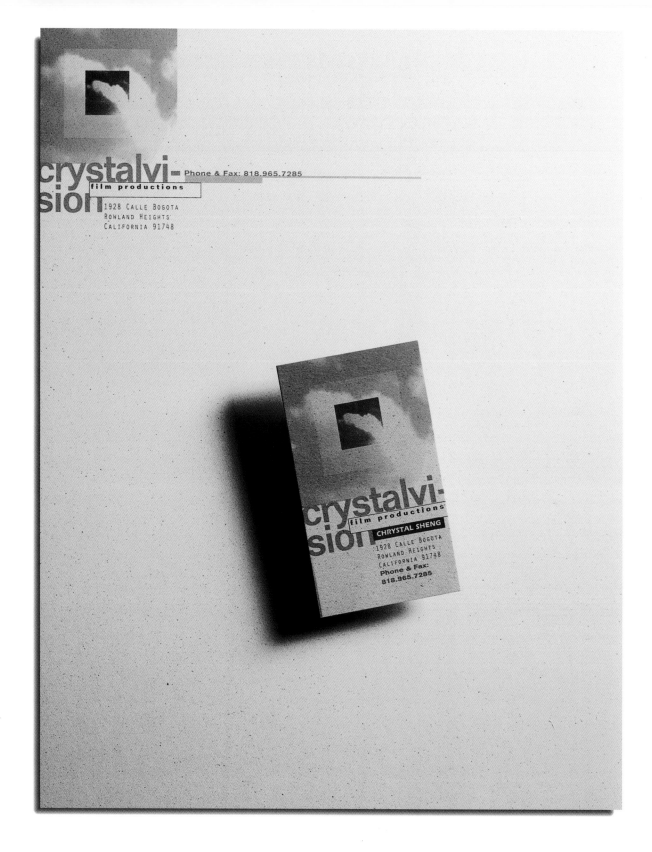

DESIGN FIRM Wonder Studio
ART DIRECTOR Howard Yang
DESIGNER Sherri Yu
CLIENT Crystalvision Film Productions
TOOLS Adobe Photoshop, QuarkXPress
PAPER/PRINTING Simpson Quest, two PMS colors

The sky represents a broad and infinite vision. Using different colors of paper as a single design element accents Crystalvision's free and creative business nature.

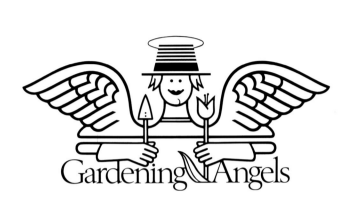

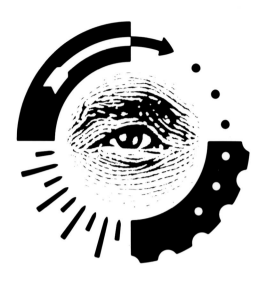

Design Firm Bob Korn Design

All Design Bob Korn

Client Gardening Angels

The mark was created by hand for an urban horticulture firm to reflect the pun in the company's name.

Design Firm Zauhar Design

All Design David Zauhar

Client RPM Video Productions

To depict RPM (revolutions per minute) graphically, there is a cross section of time, movement, and gears rotating around an eye, which represents video. All art was done freehand.

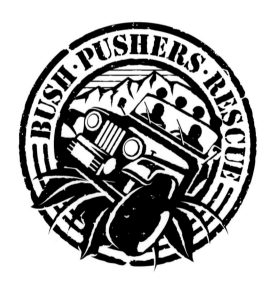

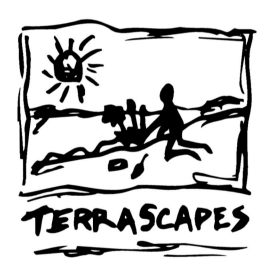

Design Firm Price Learman Associates

All Design Ross West

Client Bush Pushers Rescue

Tools Adobe Photoshop and Streamline, Aldus FreeHand

Bush Pushers Rescue is a group of Jeep enthusiasts that aid in the search and rescue of lost hikers and recreational vehicles. It is a purely volunteer group and receives no compensation.

Design Firm Alfred Design

All Design John Alfred

Client Terrascapes

Tool Adobe Illustrator and Streamline

The thumbnail art was scanned, worked in Streamline, and manipulated in Illustrator. Using the thumbnail as a base maintained the organic feel that the client wanted for its landscaping business.

DESIGN FIRM Elena Design
ALL DESIGN Elena Baca
PAPER Simpson Quest
TOOLS Adobe Illustrator

Some people find it hard to pronounce my name thus the reason
for the treatment on the logo. In designing the letterhead, I
wanted to keep the cost down by using only one color. I opted
for the use of different shades of paper instead.

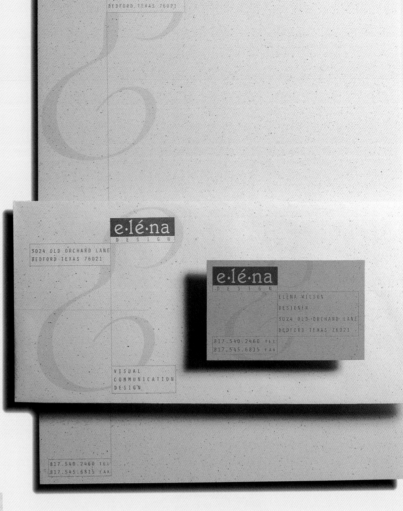

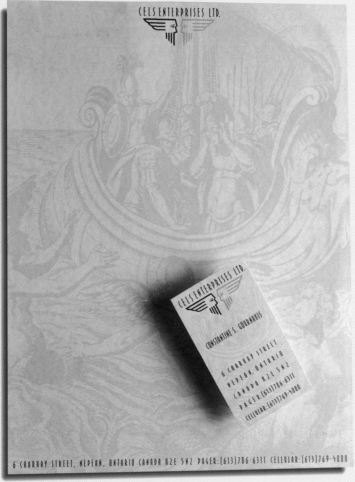

DESIGN FIRM 246 Fifth Design
ART DIRECTOR/DESIGNER Sid Lee
CLIENT Cels Enterprises Ltd.
PAPER/PRINTING Custom Printers of Renfrew

Cels Enterprises wanted to express its Greek roots, so the
"Jason and the Argonauts" imagery also symbolizes a great
adventure or a fantastical voyage which reflects the
company's services.

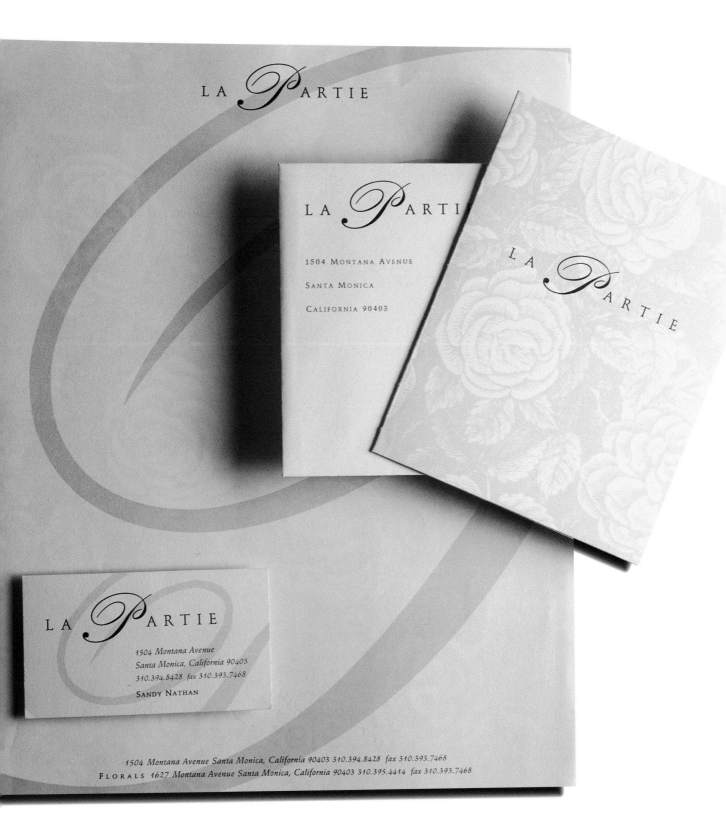

ART DIRECTOR/DESIGNER Christine Cava
CLIENT La Partie; Sandy Nathan
PAPER/PRINTING Circa Select
TOOLS Aldus FreeHand, Adobe Photoshop, QuarkXPress

···

The swirl is the "P" in the La Partie logo modified using
FreeHand; the floral pattern was supposed to be printed in
cream, but a printer's serendipitous error made it green.

KIDS ON THE MOVE
SHUTTLE SERVICE

KIDS ON THE MOVE
SHUTTLE SERVICE

540 N. Santa Cruz Avenue • Suite 257

Los Gatos, California 95030

408.358.8222

540 N. Santa Cruz Avenue • Suite 257 • Los Gatos, California 95030 • 408.358.8222

DESIGN FIRM THARP DID IT
ART DIRECTOR Rick Tharp
DESIGNERS Rick Tharp, Amy Bednarek
CLIENT Kids on the Move Shuttle Service
PAPER/PRINTING Simpson Starwhite Vicksburg, four match
colors, offset lithography
···
The deep yellow traffic sign-shaped logo with red and purple
arrows refers to the client's round- trip service. The hand-drawn
logo was scanned into the computer for composition.

T·H·QUEST

GEOPHYSICAL
CONSULTING

4600 GREENVILLE AVE. SUITE 270
DALLAS, TEXAS 75206

GEOPHYSICAL
CONSULTING

TIMOTHY HEBDEN
PRESIDENT

GEOPHYSICAL
CONSULTING

4600 GREENVILLE AVE. SUITE 270 DALLAS, TEXAS 75206
TEL 214.363.3889 FAX 214.363.9447

T·H·QUEST

4600 GREENVILLE AVE. SUITE 270 DALLAS, TEXAS 75206
TEL 214.363.3889 FAX 214.363.9447

DESIGN FIRM Swieter Design U.S.
ART DIRECTOR John Swieter
DESIGNER Mark Ford
CLIENT T.H. Quest

UNITING OPHTHALMOLOGY AND OPTOMETRY TO BRING YOU COMPREHENSIVE AND CONVENIENT EYE CARE

UNITING OPHTHALMOLOGY AND OPTOMETRY TO BRING YOU COMPREHENSIVE AND CONVENIENT EYE CARE

DESIGN FIRM Incite Design Communications
ALL DESIGN Sherrie and Tracy Holdeman
CLIENT Grene Vision Group
PAPER/PRINTING Classic Crest
TOOL Macromedia FreeHand
..
Grene Vision Group is one of the first total eye care facilities in
the country. The eye icons represent (from left to right) the eye,
glasses, contacts, and radial keratotomy.

DESIGN FIRM Duck Soup Graphics
ALL DESIGN William Doucette
CLIENT Dr. Orsten, dentist
PAPER/PRINTING Classic Crest, two match colors
TOOL Adobe Illustrator

The letterhead and business card fold over to incorporate the two logo variations. The pieces are printed on both sides with gradation tints to emphasize the "From dark to light" slogan.

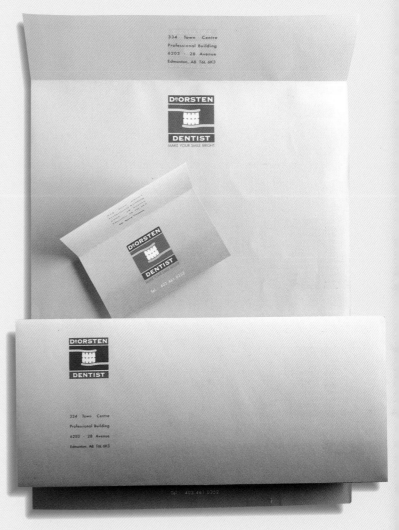

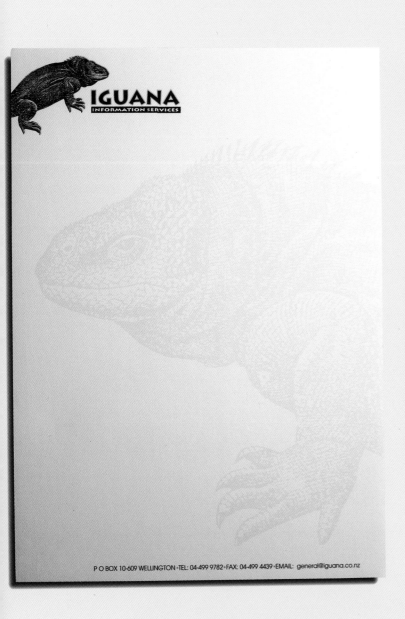

DESIGN FIRM Raven Madd Design
ART DIRECTOR/DESIGNER Mark Curtis
ILLUSTRATOR Copyright-free illustration
CLIENT Iguana Information Services
PAPER/PRINTING Conquer Wove 100 gsm,
Blenheim Print, 2-color
TOOL CorelDRAW

Two TIFFs of a scanned engraving were overlaid and thrown out of alignment to add depth. The illustration was screened back to 5 percent for background effect.

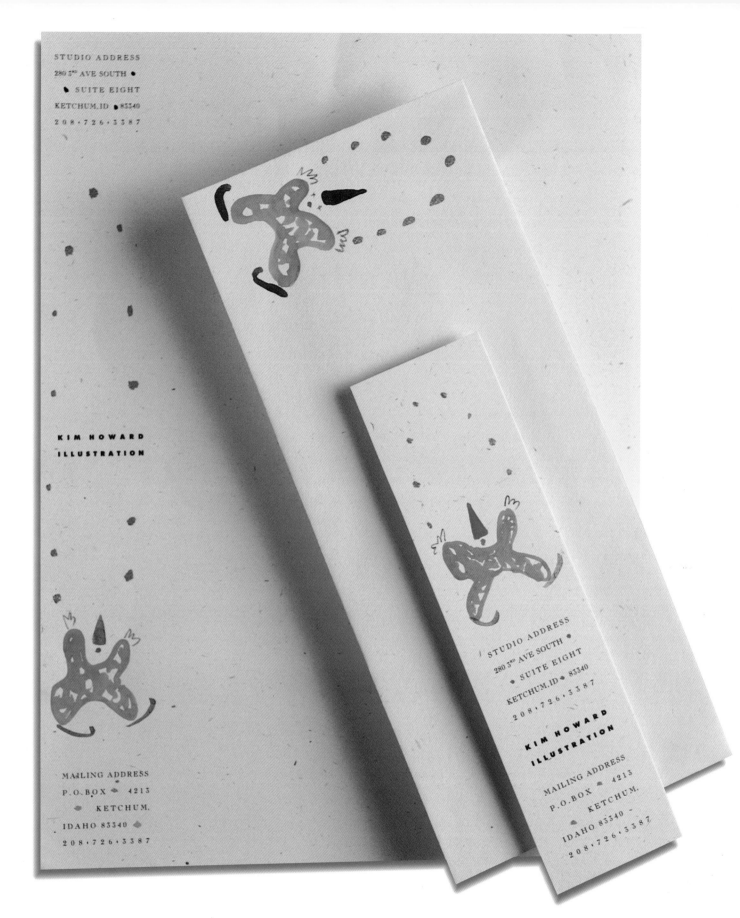

DESIGN FIRM Sackett Design Associates
ART DIRECTOR Mark Sackett
DESIGNERS Mark Sackett, James Sakamoto
ILLUSTRATOR Kim Howard
CLIENT Kim Howard
PAPER/PRINTING Bodoni Speckletone Beach White,
offset litho, black and hand coloring

2551 RIVA ROAD

ANNAPOLIS, MARYLAND 21401-7465

PHONE 410-266-4170

FAX 410-266-2820

2551 RIVA ROAD
ANNAPOLIS, MARYLAND 21401-7465

2551 RIVA ROAD
ANNAPOLIS, MARYLAND 21401-7465

2551 RIVA ROAD
ANNAPOLIS, MARYLAND 21401-7465
PHONE 410-266-4221
FAX 410-266-2820

BRIAN A. KRISAK
SENIOR DIRECTOR, BUSINESS DEVELOPMENT

DESIGN FIRM Kiku Obata & Company
ART DIRECTOR/DESIGNER Rich Nelson
CLIENT Communications by Proxy
PAPER/PRINTING Neenah Classic Crest, Reprox
TOOLS Aldus FreeHand, QuarkXPress

The logo features traditional typography and colors with the
globe as a supporting element, and suggests the technology and
ever-expanding communications network the company provides.

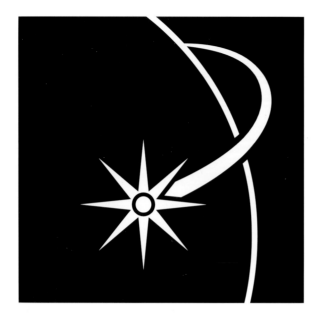

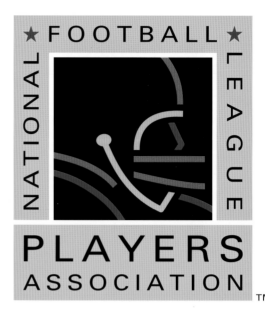

DESIGN FIRM John Evans Design
ART DIRECTORS John Evans, Greg Chapman
DESIGNER Walter Horton
ILLUSTRATOR John Evans
CLIENT Tracy Locke, GTE
TOOL Adobe Illustrator

This mark was drawn by hand then scanned and redrawn in Illustrator. It symbolizes a fiber optic cable encircling the globe.

DESIGN FIRM Grafik Communications Inc.
DESIGNERS David Collins, Judy Kirpich
ILLUSTRATOR David Collins
CLIENT National Football League Players Association
TOOL Adobe Illustrator.

Representing football in a non-cliché way and focusing on the players was a challenge. The logo needed to work on printed material, video, hats, gym bags, T-shirts and banners.

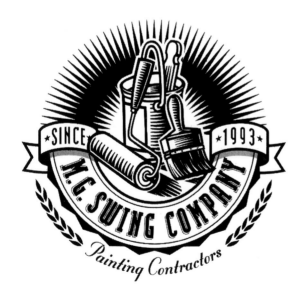

DESIGN FIRM Mires Design Inc.
ART DIRECTOR/DESIGNER Mike Brower
ILLUSTRATOR Tracy Sabin
CLIENT M.G. Swing Company

DESIGN FIRM Lambert Design Studio
ART DIRECTOR/DESIGNER Joy Cathey Price
CLIENT Nature Bound Publishing
PAPER/PRINTING 3-color
TOOL Adobe Illustrator

The client for this logo publishes magazines on outdoor sports, recreation, and conservation. This mark incorporates both a book (or magazine) and the great outdoors.

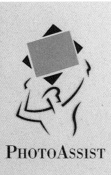

PHOTOASSIST

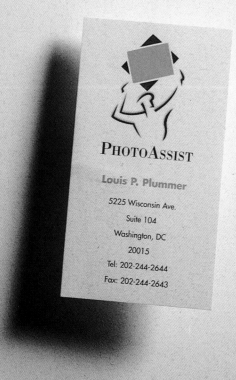

PHOTOASSIST

Louis P. Plummer

5225 Wisconsin Ave.
Suite 104
Washington, DC
20015
Tel: 202-244-2644
Fax: 202-244-2643

5225 Wisconsin Ave.
Suite 104
Washington, DC
20015
Tel: 202-244-2644
Fax: 202-244-2643

DESIGN FIRM Supon Design Group Inc.
ART DIRECTORS Supon Phornirunlit, Andrew Dolan
DESIGNER Eddie Saibua
CLIENT PhotoAssist
PAPER/PRINTING Classic Crest, offset
TOOLS Adobe Photoshop and Illustrator, QuarkXPress

GEOFF REED

PHOTOGRAPHY:

Corporate / Industrial / Editorial

GEOFF REED

PHOTOGRAPHY:

Corporate / Industrial / Editorial

GEOFF REED

PHOTOGRAPHY:

Corporate / Industrial / Editorial

GEOFF REED
29 Prospect Street, Keyport, New Jersey 07735
Tel: (908) 888-7758 Fax: (908) 264-4590

29 Prospect Street, Keyport, NJ 07735

29 Prospect Street, Keyport, New Jersey 07735 Tel: (908) 888-7758 Fax: (908) 264-4590

DESIGN FIRM PM Design
ART DIRECTOR/DESIGNER Philip Marzo
CLIENT Geoff Read Photography
...
The logo is a memorable integration of the photographer's own
initials and the word "photography." The use of a red accent
color for the initials adds contrast and attention to visual integra-
tion.

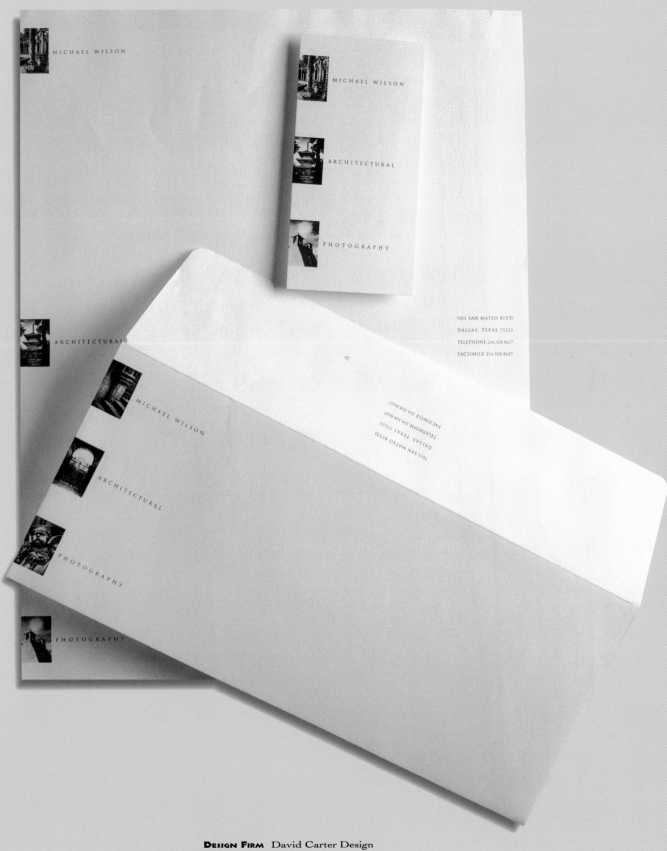

DESIGN FIRM David Carter Design
ART DIRECTOR/DESIGNER Randall Hill
PHOTOGRAPHER Michael Wilson
CLIENT Michael Wilson Architectural Photography
PAPER/PRINTING Simpson Protocol Writing, Padgett Printing

The stationery package was created to highlight the unique
niche this photographer has on the market. Waterless plates
were used in the printing process.

Ground Floor, 15B Yuen Yuen Street, Happy Valley. ● Hong Kong

寵物 PET ● IMAGE 寫眞館

Tel ● 575 3322
Fax ● 574 9393

DESIGN FIRM Camellia Cho Design
ART DIRECTOR/DESIGNER Camellia Cho
CLIENT Pet · Image
PAPER/PRINTING D & P Design & Printing Co.
TOOL QuarkXPress

The most interesting challenge was arranging the pets for the
shooting. During the shooting period, it's really difficult to keep
all the pets in the right position.

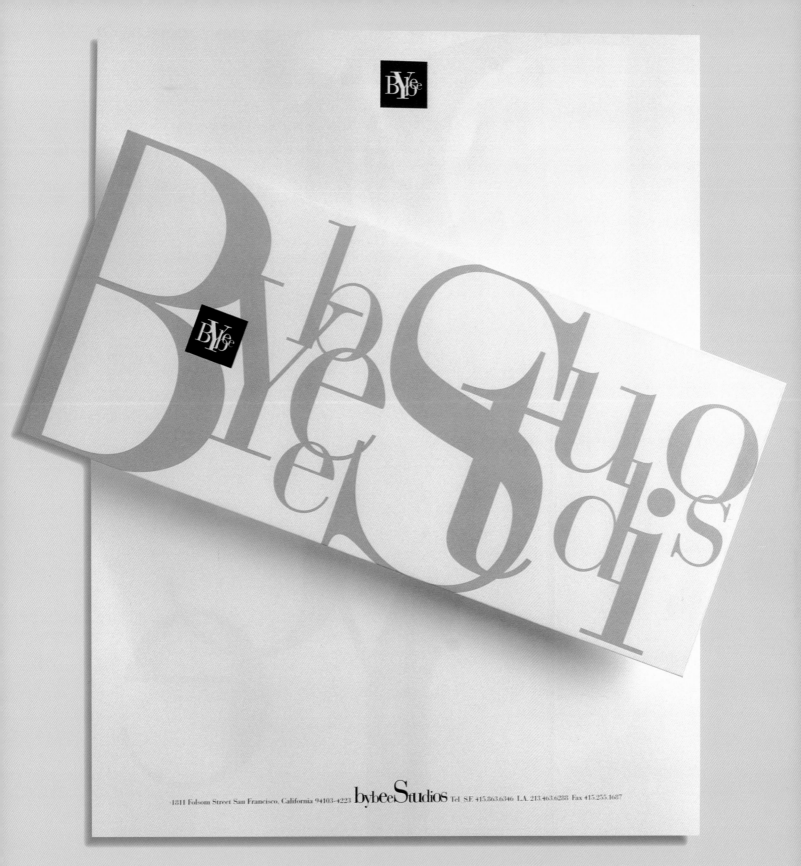

DESIGN FIRM Sackett Design Associates
ART DIRECTOR Mark Sackett
DESIGNERS Mark Sackett, James Sakamoto
CLIENT Bybee Studios
PAPER/PRINTING Simpson Starwhite Vicksburg 80 lb. text,
130 lb. cover, offset litho

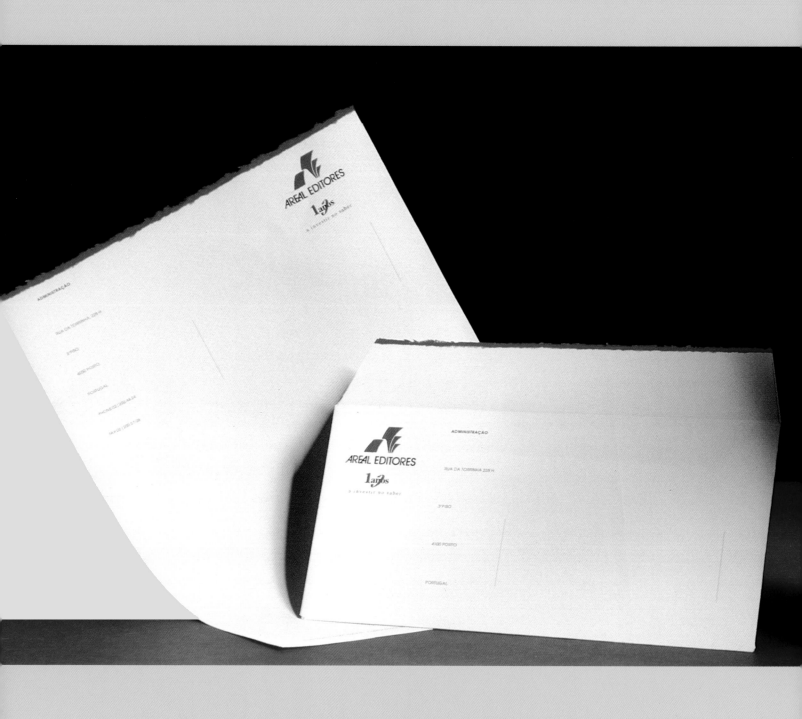

DESIGN FIRM Mário Aurélio & Associados
ART DIRECTOR/DESIGNER Mário Aurélio
CLIENT Areal Edigores
PAPER/PRINTING Strathmore Fiesta, offset
TOOL Aldus FreeHand

PONNY
EXPRESS
CHILE

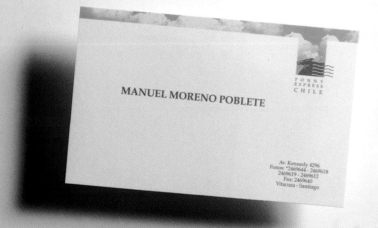

MANUEL MORENO POBLETE

PONNY
EXPRESS
CHILE

Av. Kennedy 4296
Fonos: *2469644 - 2469618
2469619 - 2469612
Fax: 2469640
Vitacura - Santiago

Av. Kennedy 4296
Fonos: *2469644 - 2469618
2469619 - 2469612
Fax: 2469640
Vitacura - Santiago

DESIGN FIRM Squadra Design Studio
ART DIRECTOR Guillermo Caceres B.
DESIGNERS Guillermo Caceres, Claudia Izquierdo
CLIENT Ponny Express Chile
PAPER/PRINTING Bond 24, offset 2/0 color

Design Firm Shields Design
Art Director/Designer Charles Shields
Illustrator Doug Hansen
Client Great Pacific Trading Company
Paper/Printing Classic Crest, City Press
Tools Adobe Photoshop and Illustrator, Altsys Fontographer

"Great Pacific" was scanned from old type books, Streamlined and cleaned up in Illustrator. "Trading Company" was scanned from an old type book, imported into Fontographer to redraw the font.

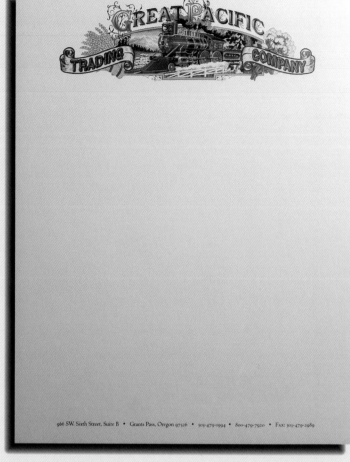

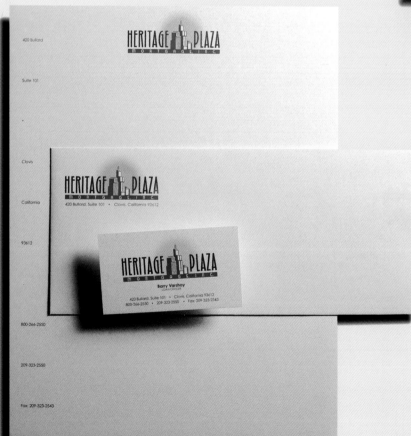

Design Firm Shields Design
Art Director/Designer Charles Shields
Client Heritage Plaza Mortgage Inc.
Paper/Printing Evergreen, Progressive Printing
Tool Adobe Illustrator

The client wanted a friendly and inviting look, so warm colors on a natural stock were chosen. A deco front and image and a warm gradation make the logo accessible.

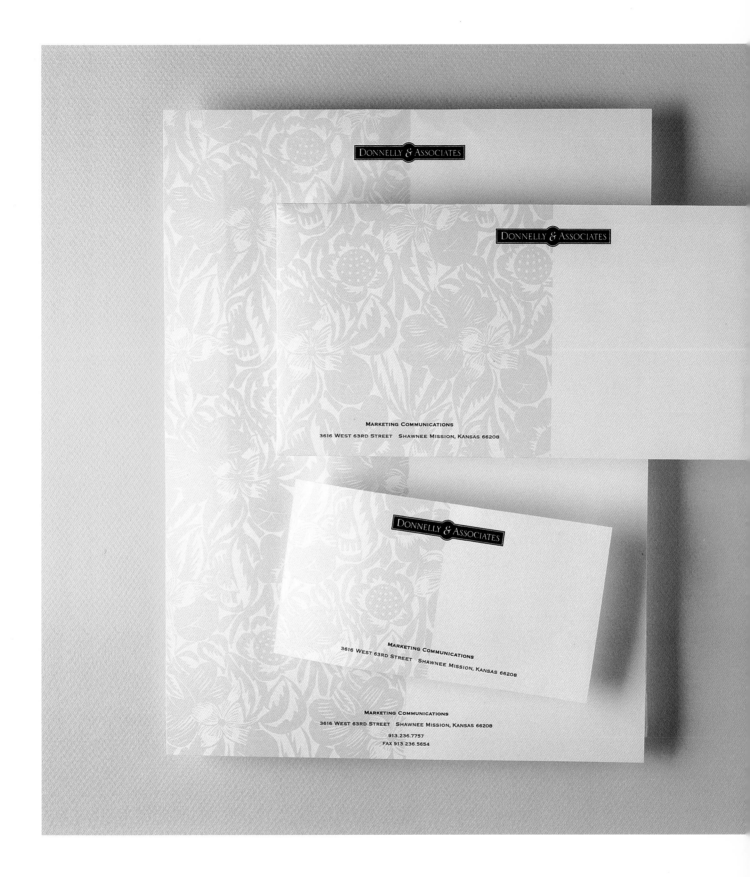

DESIGN FIRM Sackett Design Associates
ART DIRECTOR/DESIGNER Mark Sackett
ILLUSTRATORS Mark Sackett, Wayne Sakamoto
CLIENT Donnelly & Associates
PAPER/PRINTING Neenah Classic Crest Natural White 80 lb.
text, offset lithography, two match colors

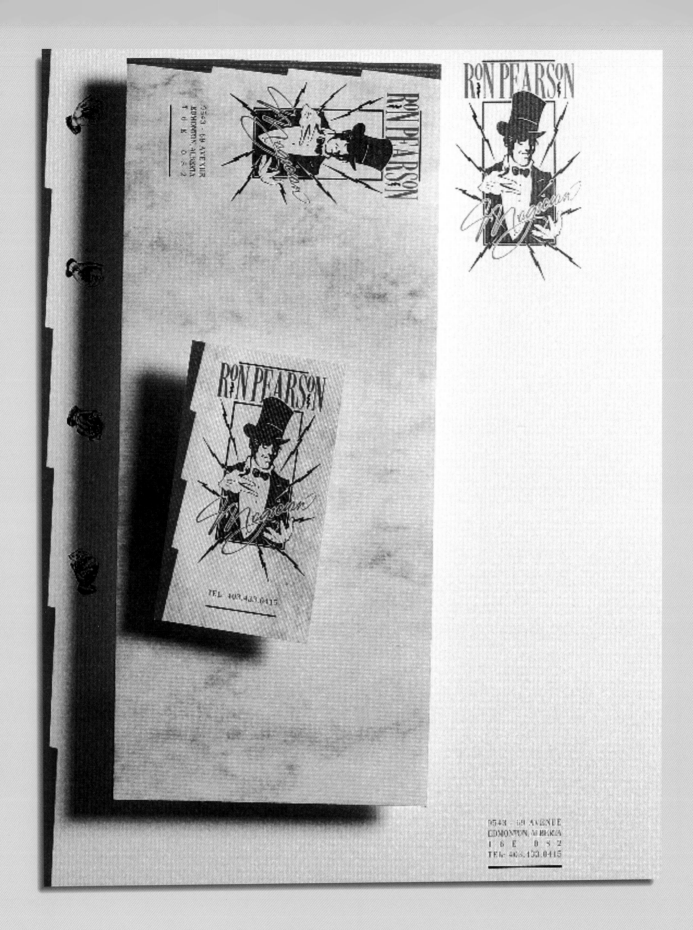

DESIGN FIRM Duck Soup Graphics
ALL DESIGN William Doucette
CLIENT Ron Pearson—Magician
PAPER/PRINTING Beckett Enhance, two match colors

..

The illustration was drawn in pen and ink. The client requested
a logo that offered a visual representation of himself; he per-
forms in a top hat and tuxedo and specializes in close-up magic.

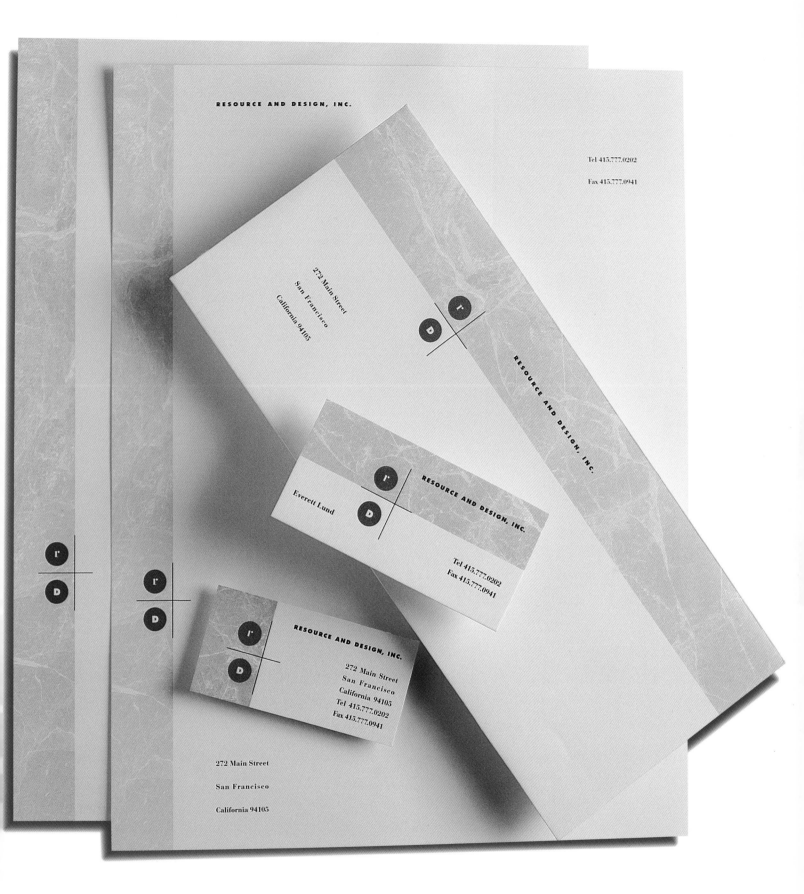

RESOURCE AND DESIGN, INC.

Tel 415.777.0202

Fax 415.777.0941

272 Main Street
San Francisco
California 94105

RESOURCE AND DESIGN, INC.

Everett Lund

RESOURCE AND DESIGN, INC.

Tel 415.777.0202
Fax 415.777.0941

RESOURCE AND DESIGN, INC.

272 Main Street
San Francisco
California 94105
Tel 415.777.0202
Fax 415.777.0941

272 Main Street

San Francisco

California 94105

Design Firm Sackett Design Associates
Art Director/Illustrator Mark Sackett
Designers Mark Sackett, Wayne Sakamoto
Client Resource and Design Inc.
Paper/Printing Neenah Classic Crest Natural 80 lb. text with
110 lb. cover, offset lithography

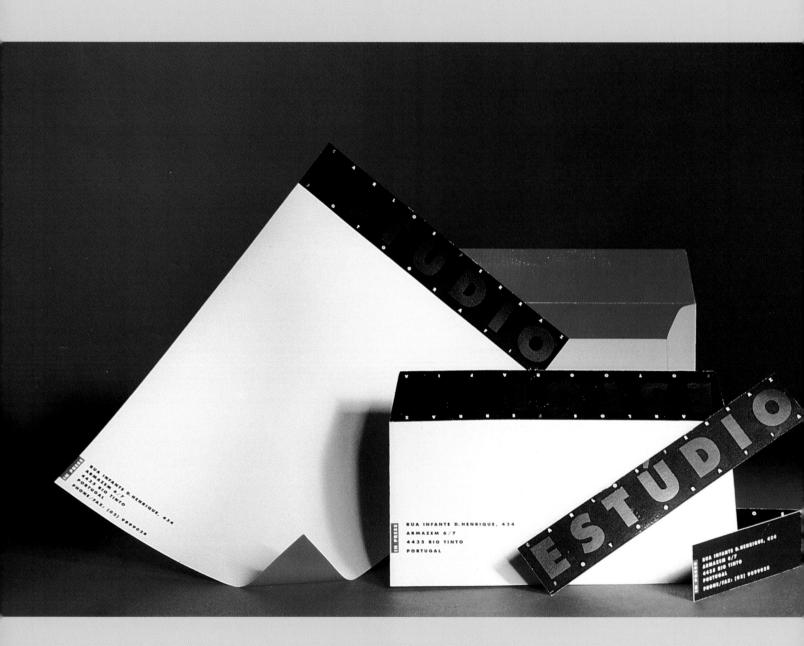

DESIGN FIRM Mário Aurélio & Associados
ART DIRECTOR/DESIGNER Mário Aurélio
CLIENT In Press
PAPER/PRINTING Printomat Paper, offset inks, UV
TOOL Aldus FreeHand

AFFILIATED OFFICES:
*London • Paris • Innsbruck • Rome
Brussels • Shenyang • Dublin • Frankfurt
Auckland • Sydney • Rio de Janerio*

JOERG KRAMER
DIRECTOR ~ EUROPEAN SALES

10224 N. PORT WASHINGTON RD. MEQUON, WISCONSIN 53092-5755
PHONE 414.241.6373 FAX 414.241.6379
TELEX 201.323.YWOTUR NATIONWIDE 1.800.558.8850

10224 N. PORT WASHINGTON RD. MEQUON, WISCONSIN 53092-5755

10224 NORTH PORT WASHINGTON ROAD MEQUON, WISCONSIN 53092-5755
PHONE 414.241.6373 TELEX 201.323.YWOTUR FAX 414.241.6379 NATIONWIDE 1.800.558.8850

DESIGN FIRM Becker Design
ART DIRECTOR/DESIGNER Neil Becker
DESIGNER Neil Becker
CLIENT Value Holidays
PAPER/PRINTING Classic Crest Solar White, 2-color lithography
TOOLS Adobe Illustrator, QuarkXPress

The globe is an appropriate symbol for Value Holidays because
it does only international travel packages.

Design Firm Swieter Design U.S.
Art Director John Swieter
Designer Mark Ford
Client Miller Aviation
Tool Adobe Illustrator

Design Firm Swieter Design U.S.
Art Director John Swieter
Designer Julie Poth
Client Dallas Mavericks
Tool Adobe Illustrator

Design Firm Swieter Design U.S.
Art Director John Swieter
Designer Mark Ford
Client Sports Lab Inc.
Tool Adobe Illustrator

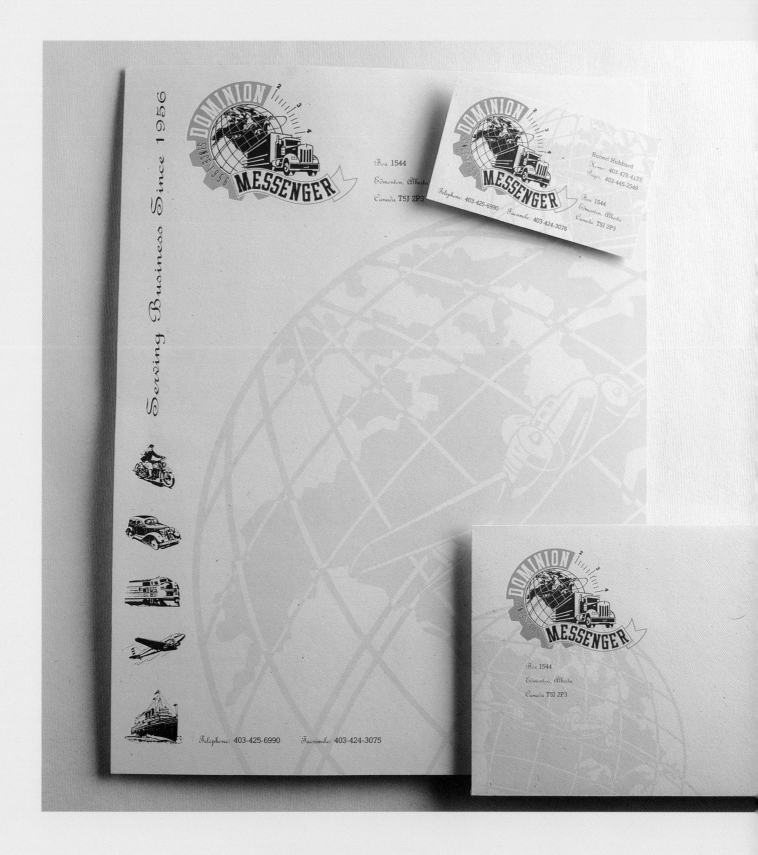

DESIGN FIRM Duck Soup Graphics
ALL DESIGN William Doucette
CLIENT Dominion Messenger Ltd.
PAPER/PRINTING French Speckletone, three match colors

The client is the oldest messenger company in western Canada
and requested a corporate image that would reflect a nostalgic
theme. The illustrations were done in ink.

DESIGN FIRM Ciro Giordano Associates
ART DIRECTOR/DESIGNER Ciro Giordano
ILLUSTRATOR Gary Contic
CLIENT Ciro Giordano Associates
PAPER/PRINTING Strathmore Writing Bright White Wove,
three PMS colors

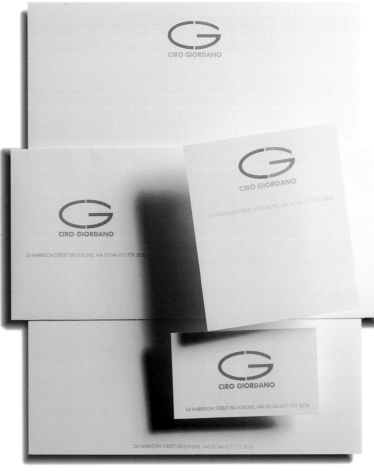

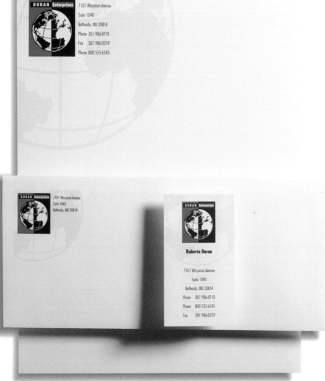

DESIGN FIRM Jill Tanenbaum Graphic Design & Advertising
ART DIRECTOR Jill Tanenbaum
DESIGNER Pat Mulcahy
CLIENT Duran Enterprises
PAPER/PRINTING Strathmore Writing, Westland Printers

The company will be involved in a variety of areas and wanted a
generic, strong, corporate/international look that was not specif-
ic to any one type of business venture.

Real Estate, Properties, and Architecture

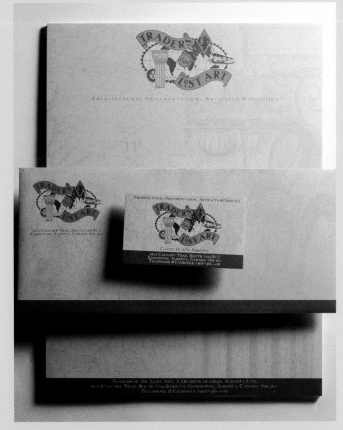

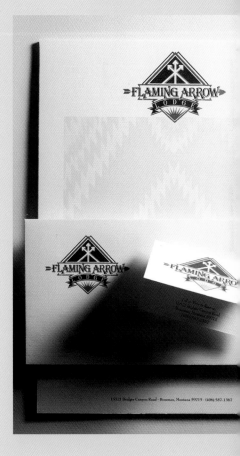

SHELDON E. RODMAN S.I.O.R.
President

758 Eddy Street

Providence, Rhode Island 02903

T: 401/273-2270 F: 401/273-2273

758 Eddy Street

Providence

Rhode Island

02903-4931

758 Eddy Street Providence, RI 02903 Tel (401) 273-2270 Fax (401) 273-2273
··
Individual Membership SOCIETY OF INDUSTRIAL AND OFFICE REALTORS
All information furnished regarding property for sale, rental or financing is from sources deemed reliable. But no warranty or representation is made as to the accuracy
thereof and same is submitted subject to errors, omissions, change of price, rental or other conditions, prior sale, lease or financing or withdrawal without notice.

DESIGN FIRM Providence Creative
ART DIRECTOR Peter Macdonald
DESIGNER Alexis Waldman
CLIENT Rodman Real Estate
PAPER/PRINTING Strathmore Lines
TOOLS Adobe Illustrator, QuarkXPress
···
All stationery elements were printed at once, 1-color, which
kept costs low and to maintain the strong look of elegance. The
type on the bottom is still reasonably legible.

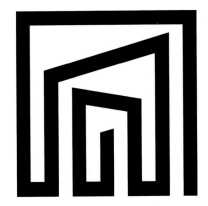

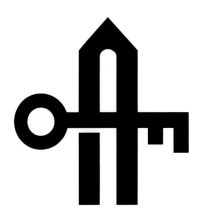

Design Firm Mohr : Design

Art Director/Designer Jack N. Mohr

Client Hoepfner Baukonzept

···

The design of this stationery is still in its early stages.

Design Firm Greteman Group

Art Directors/Designers Sonia Greteman,

James Strange

Client Anita Freg

···

This real estate firm's logo is a combination of house and key.

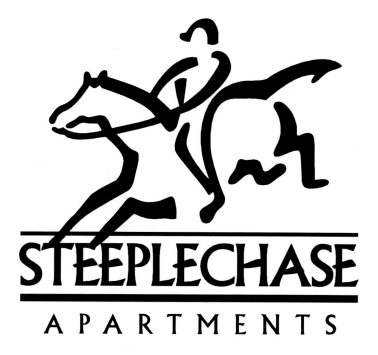

Design Firm Kelly O. Stanley Design

All Design Kelly O'Dell Stanley

Client Sizeler Real Estate Management Company Inc.

···

The image was drawn by hand, then scanned and redrawn in
FreeHand. The typeface was modified so that the horizontal
strokes of the letterforms took on the same energy as the logo.

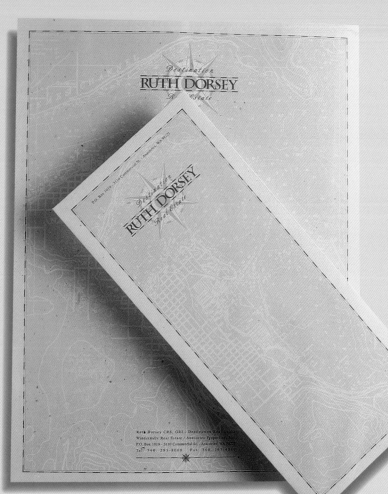

Design Firm Price Learman Associates
All Design Ross West
Client Ruth Dorsey, Realtor
Paper/Printing Classic Crest Peppercorn
Tools Aldus FreeHand, Adobe Photoshop

The background map was scanned into Photoshop, manipulated and imported into FreeHand where it was placed. All other logos and copy were produced in FreeHand and sent directly to film.

Design Firm Price Learman Associates
All Design Ross West
Client Laura Bennett
Paper/Printing Classic Crest Millstone
Tool Aldus FreeHand

The client wanted to portray a vibrant and energetic image. Simple, geometric shapes were used to give a sense of movement and excitement.

Laura Bennett CRS, GRI - Real Estate With A Personal Touch

RE/MAX Eastside Broker's, Inc. • 11711 SE Eighth Street • Bellevue, Washington, 98005 • Office: (206) 450-1644 Residence: (206) 868-9501 Fax: (206) 453-4778

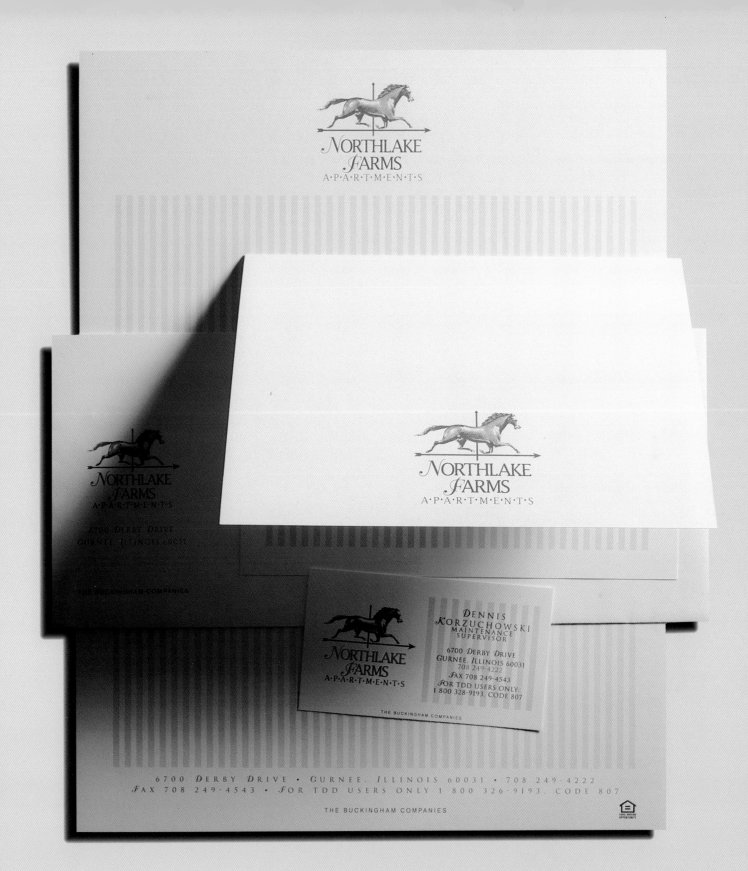

Design Firm Kelly O. Stanley Design
Art Director Kelly O'Dell Stanley
Client The Buckingham Companies
Paper/Printing Classic Crest, 2-color
Tool Aldus FreeHand

Although this logo is for an affordable housing community near Chicago, the client wanted to design something that is comparable in quality to high-class communities.

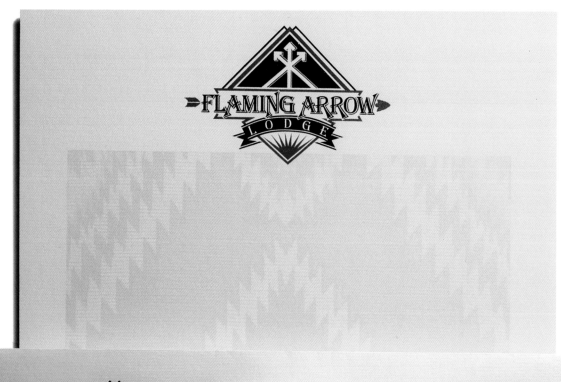

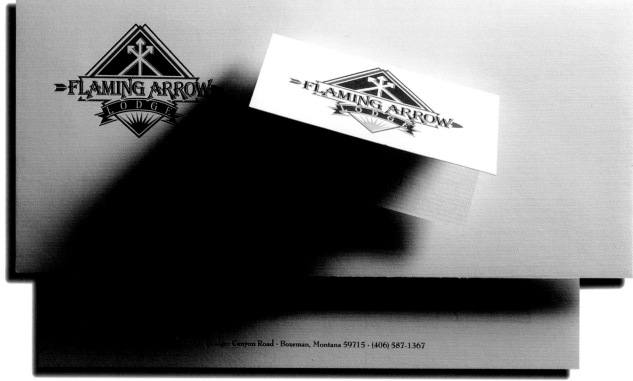

Bridger Canyon Road · Bozeman, Montana 59715 · (406) 587-1367

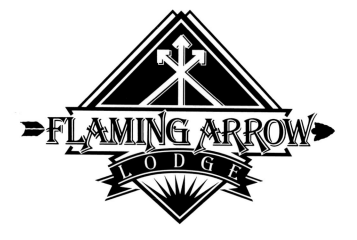

DESIGN FIRM Palmquist & Palmquist Design
ART DIRECTORS/DESIGNERS Kurt and Denise Palmquist
ILLUSTRATOR Kurt Palmquist
CLIENT Flaming Arrow Lodge
PAPER/PRINTING Classic Laid Natural White, 2-color,
embossed (foil stamp on business card)

The logo needed a high-end western look to reflect the lodge's
rugged elegance. The screened pattern on the letterhead and sec-
ond sheet is a swatch of fabric from chairs in the lodge, scanned
and printed as a halftone.

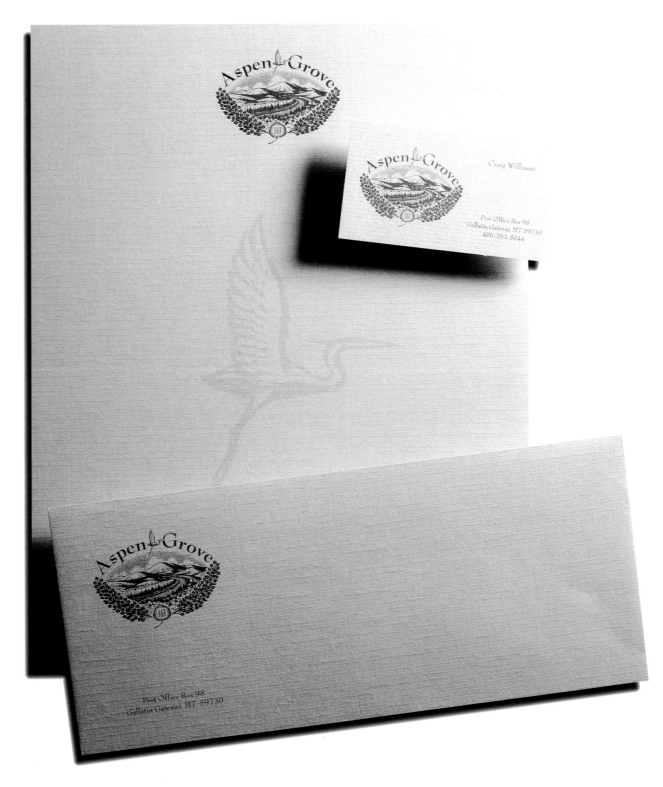

DESIGN FIRM Palmquist & Palmquist Design

ART DIRECTORS AND DESIGNERS Kurt and Denise Palmquist

ILLUSTRATOR James Lindquist

CLIENT Aspen Grove Bed & Breakfast

PAPER/PRINTING Classic Laid Recycled, Brushed Pewter,
1- and 2-color PMS

The logo was designed to reflect the quaint and quiet ambience
of this bed-and-breakfast and to provide an idea of the sur-
rounding geography. The logo was created on scratchboard.

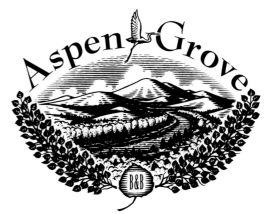

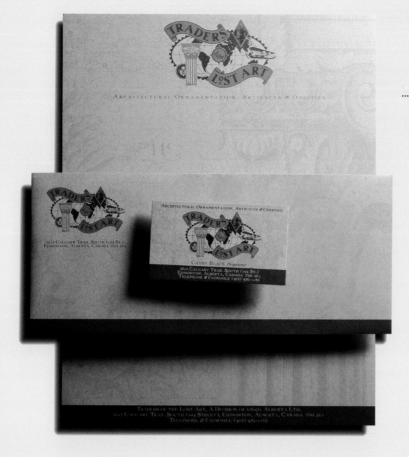

DESIGN FIRM Duck Soup Graphics

ALL DESIGN William Doucette

CLIENT Traders of the Lost Art

PAPER/PRINTING Hopper Proterra, three match colors

TOOL Adobe Illustrator

The stationery features a subtle background screen of an old map and a Roman column to represent the company's origins. Envelopes were printed in two passes on a 2-color press.

DESIGN FIRM Laurie Bish

ALL DESIGN Laurie Bish

CLIENT MVA

PAPER/PRINTING Classic Columns, lithography, 2-color

The color was inspired by architectural paper used by architects. The design was illustrated by hand, and finished art was done by typesetter on computer program.

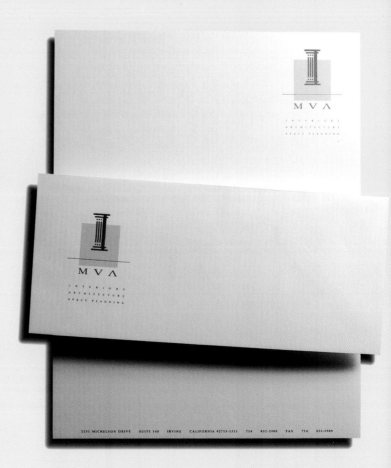

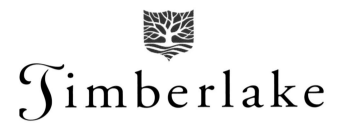

Timberlake

DESIGN FIRM Plaid Cat Design
ALL DESIGN Eric Scott Stevens
CLIENT Timberlake, Powell Construction

The logo for the Timberlake community features a shield, which incorporates images that describe Timberlake. The shield and rest of the logo were created in FreeHand.

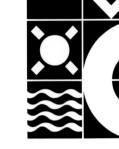

DESIGN FIRM Harrisberger Creative
ART DIRECTOR/DESIGNER Lynn Harrisberger
CLIENT Glenn & Sadler
TOOL Macromedia FreeHand

Glenn & Sadler specializes in land and water construction, and this is reflected in the logo.

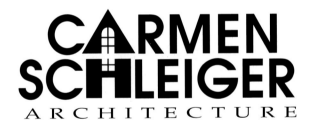

CARMEN SCHLEIGER
ARCHITECTURE

DESIGN FIRM Jeff Fisher Design
ALL DESIGN Jeff Fisher
CLIENT Carmen Schleiger

Carmen Schleiger is an architect who designs residences. The logo was designed in FreeHand, with Avant Garde and Palatino. Stacking the text elements permitted using a house as a graphic.

Westwood CoHousing Community

DESIGN FIRM Plaid Cat Design
ALL DESIGN Eric Scott Stevens
CLIENT Westwood CoHousing Community
TOOL Macromedia FreeHand

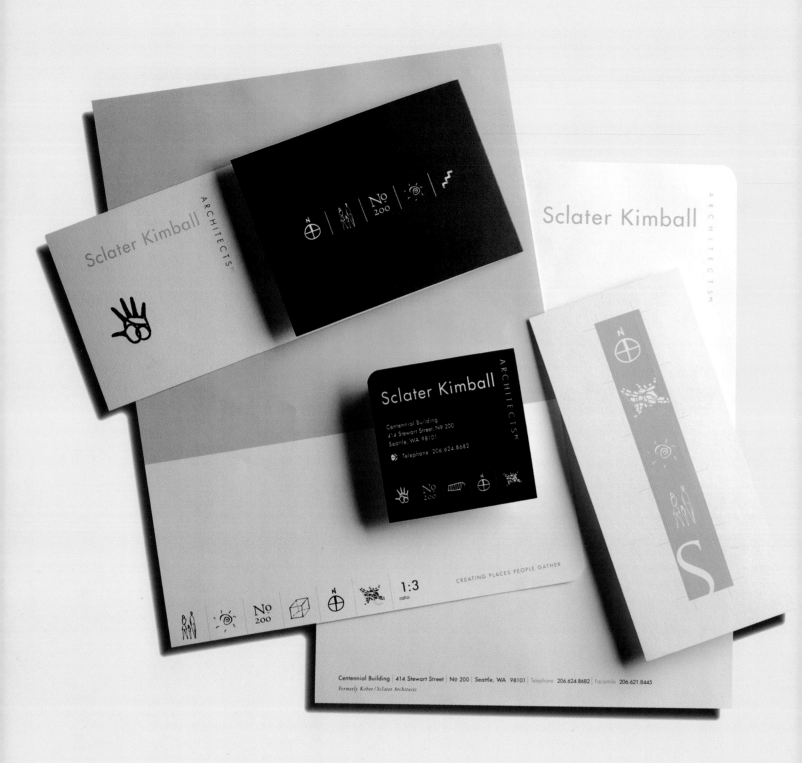

DESIGN FIRM The Leonhardt Group
DESIGNERS Ray Ueno, Jon Cannell
CLIENT Sclater Kimball Architects
PAPER/PRINTING Classic Crest Natural White, three PMS colors

This corporate identity is a complete system that allows for
flexibility. The various icons were created to show the many
characteristics of architecture.

Health Care, Education, and Nonprofit

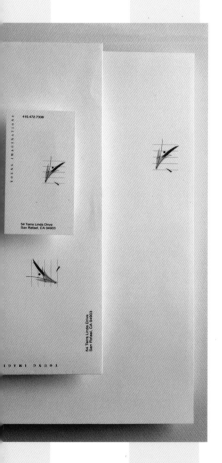

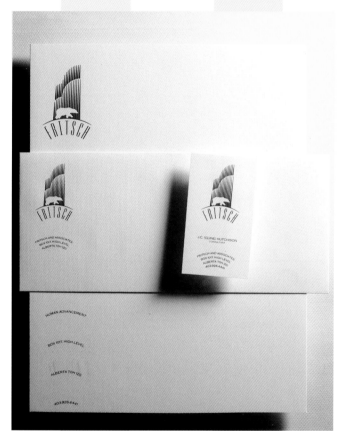

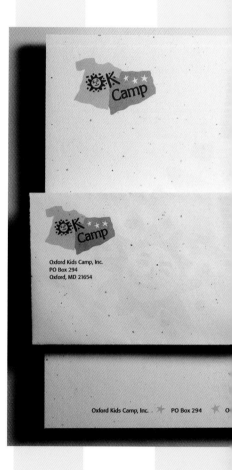

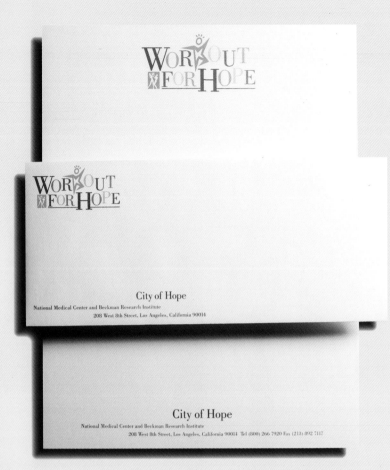

DESIGN FIRM Clifford Selbert Design
ART DIRECTOR Brian Lane
DESIGNERS Brian Lane, Heather Watson, Tracey Lane
CLIENT City of Hope Hospital
TOOL Adobe Illustrator, QuarkXPress
PAPER/PRINTING Classic Crest, Avon Brilliant White

The person depicted in the letter "K" is used to represent aspects of Workout for Hope: running, aerobics, cycling, swimming, and basketball.

DESIGN FIRMS [Metal]/Peat Jariya Design
ART DIRECTOR/DESIGNER Peat Jariya
CLIENT Hermann's Women's Center
PAPER/PRINTING Classic Crest, 2-color

National **Design** Museum

Cooper-Hewitt

Smithsonian Institution

nal **Design** Mu

2 EAST 91 STREET NEW YORK NY 10128-0669 | TEL 212 860 6868 | FAX 212 860 6909

DESIGN FIRM Drenttel Doyle Partners
ART DIRECTOR Stephen Doyle
DESIGNERS Terry Mastin, Rosemarie Turk
CLIENT National Design Museum
PAPER/PRINTING Benefit Waylaid
TOOL QuarkXPress

This corporate I.D. emphasizes the word "design" and pays
homage to the museum's mission.

DESIGN FIRM Greteman Group
ART DIRECTORS/DESIGNERS Sonia Greteman,
James Strange
CLIENT City of Wichita

The logo for Wichita's Fair + Festival used a festive character
to capture the feeling of the event.

DESIGN FIRM Sibley/Peteet Design
ART DIRECTOR/DESIGNER David Beck
ILLUSTRATORS David Beck, Mike Broshous
CLIENT Charles James
TOOL Adobe Illustrator

The final design was done in Illustrator from a scan from a
pencil drawing. Crack-and-peel stickers were created to give
to Charles James's clients.

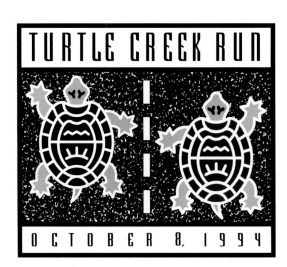

DESIGN FIRM Sibley/Peteet Design
ART DIRECTOR Donna Aldridge
DESIGNER Donna Aldridge
CLIENT American Heart Association
TOOL Adobe Illustrator and Photoshop

The background texture for the pavement began as a photo-
copy from an old schoolbook, which was then manipulated on
the photocopier and by hand, then scanned into Photoshop.

DESIGN FIRM Greteman Group
ART DIRECTORS/DESIGNERS Sonia Greteman,
James Strange
CLIENT Our Lady of Lourdes

This logo is for a rehabilitation hospital representing the Patron
Saint of Our Lady of Lourdes and her healing attributes.

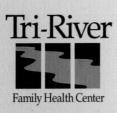

Tri-River
Family Health Center

*A Division of the
University of Massachusetts
Medical Center*

Tri-River
Family Health Center

*A Division of the University
of Massachusetts Medical Center*

281 East Hartford Avenue
Uxbridge, MA 01569

Tri-River
Family Health Center

David P. Tapscott, M.D.

*A Division of the University
of Massachusetts Medical Center*

281 East Hartford Avenue
Uxbridge, MA 01569
Tel: (508) 278-5573
Fax: (508) 278-7142

281 East Hartford Avenue
Uxbridge, MA 01569
Tel: (508) 278-5573
Fax: (508) 278-7142

Caring for Our Community Since 1978

DESIGN FIRM Smith Korch Daly
ART DIRECTOR Patricia B. Korch
DESIGNER/ILLUSTRATOR Barbara A. Truell
CLIENT Tri-River Family Health Center
PAPER/PRINTING Strathmore Script Pinstripe Bright White,
Image Press
TOOLS Aldus FreeHand, QuarkXPress

The Tri-River logo was created by hand, scanned and placed
into FreeHand, where type was added before placing into
QuarkXPress for layout.

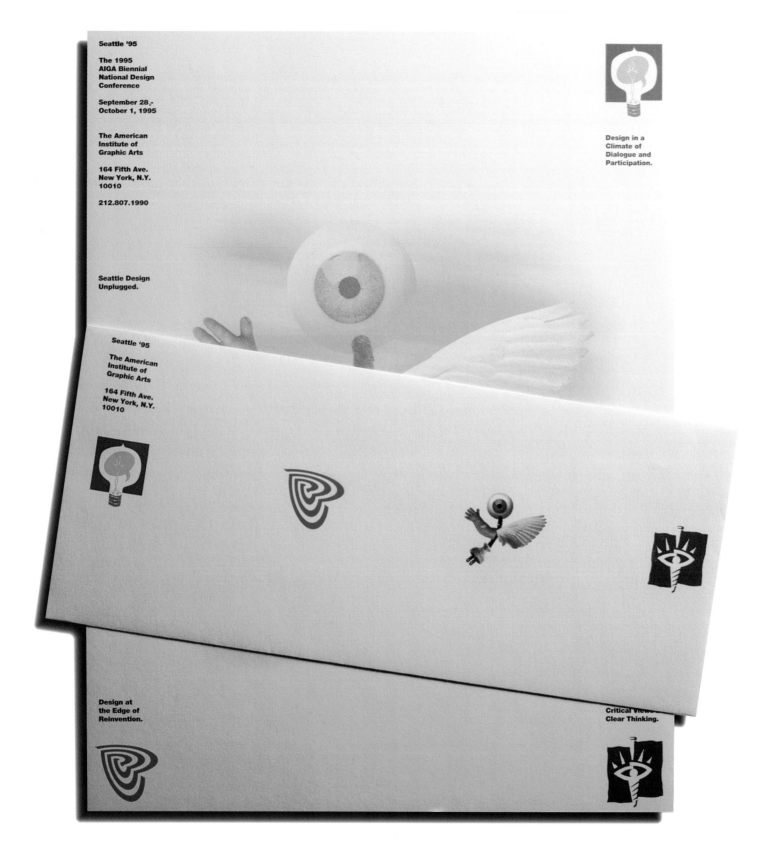

Seattle '95

The 1995
AIGA Biennial
National Design
Conference

September 28 -
October 1, 1995

The American
Institute of
Graphic Arts

164 Fifth Ave.
New York, N.Y.
10010

212.807.1990

Seattle Design
Unplugged.

Design in a
Climate of
Dialogue and
Participation.

Seattle '95

The American
Institute of
Graphic Arts

164 Fifth Ave.
New York, N.Y.
10010

Design at
the Edge of
Reinvention.

Critical Views
Clear Thinking.

Design Firm Rick Eiber Design (RED)
Art Director/Designer Rick Eiber
Illustrators Studio MD, Werkhaus, Hornall Anderson,
Ed Fotheringham
Client American Institute of Graphic Arts
Paper/Printing Classic Crest Writing 24 lb. Bisque, The Press

This was designed for the 1995 National Design Conference. It
was printed using the 4-color process, two colors were printed
at a time with density reduction.

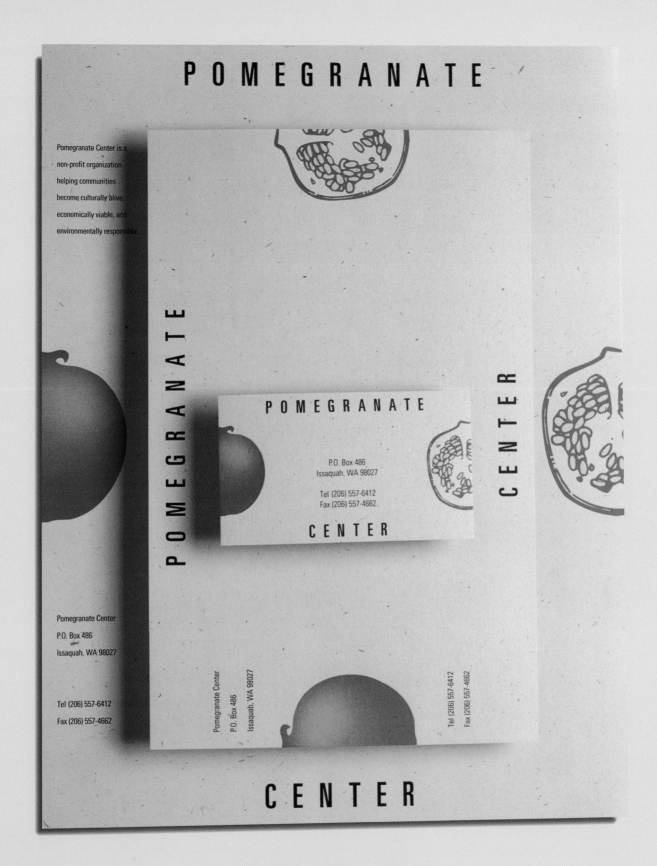

DESIGN FIRM Rick Eiber Design (RED)

ART DIRECTOR/DESIGNER Rick Eiber

ILLUSTRATOR David Verwolf

CLIENT Pomegranate Center

PAPER/PRINTING French Speckletone Natural text

Stationery uses a redundant verbal and visual form which says
the name Pomegranate Center.

DESIGN FIRM Jeff Fisher Design
ALL DESIGN Jeff Fisher
CLIENT Laugh Line Productions
TOOL Aldus FreeHand

Laugh Line Productions presents stand-up comedy to raise funds for AIDS. Using the traditional comedy mask as the "U" in the word laugh gives the logo a strong visual.

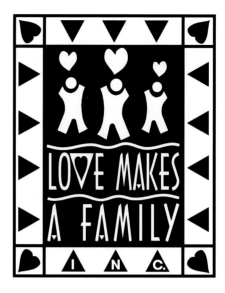

DESIGN FIRM Jeff Fisher Design
ALL DESIGN Jeff Fisher
CLIENT Love Makes A Family Inc.
TOOL Aldus FreeHand

The logo was created in FreeHand and is the combination of two designs. The heart symbolizes love, and the triangle is an adopted gay-rights symbol.

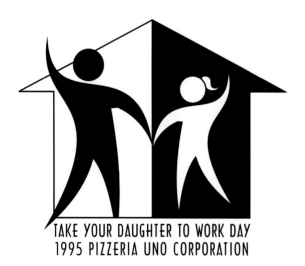

DESIGN FIRM Pizzeria Uno Corp. In-House Art Department
ART DIRECTOR/DESIGNER Christopher Consullo
CLIENT Pizzeria Uno, Human Resources Dept.
TOOL Macromedia FreeHand

This logo was for materials promoting "Take Your Daughter to Work Day". It appeared on items given to the girls on that day, like gift certificates and name badges.

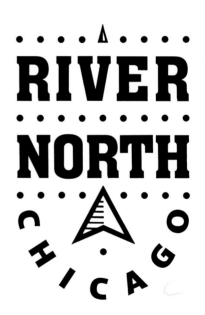

DESIGN FIRM Bullet Communications Inc.
ALL DESIGN Tim Scott
CLIENT River North Association
TOOL QuarkXPress

The River North Association logo was created using both QuarkXPress and conventional production techniques. The logo was created to promote the River North area in Chicago.

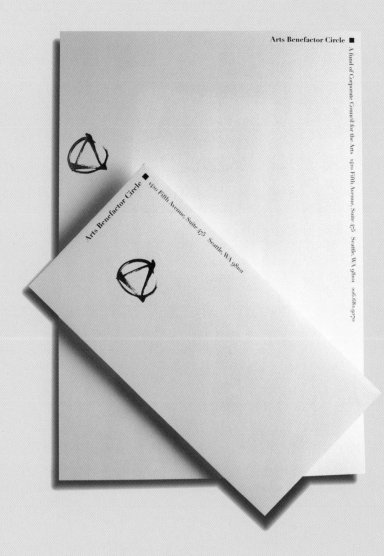

DESIGN FIRM Rick Eiber Design (RED)
ART DIRECTOR/DESIGNER Rick Eiber
CLIENT Corporate Council for the Arts
PAPER/PRINTING Classic Crest

DESIGN FIRM McCullough Creative Group Inc.
ART DIRECTOR/DESIGNER Mike Schmalz
CLIENT Dubuque Council for Diversity
PAPER/PRINTING Classic Crest, Union-Hoermann Press
TOOL Aldus FreeHand

This identity is based on the universal and elementary idea that
we as people should work at getting along. Dubuque is a river
town so the sun and water are fitting.

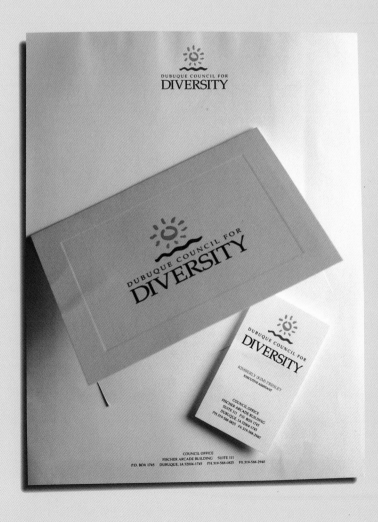

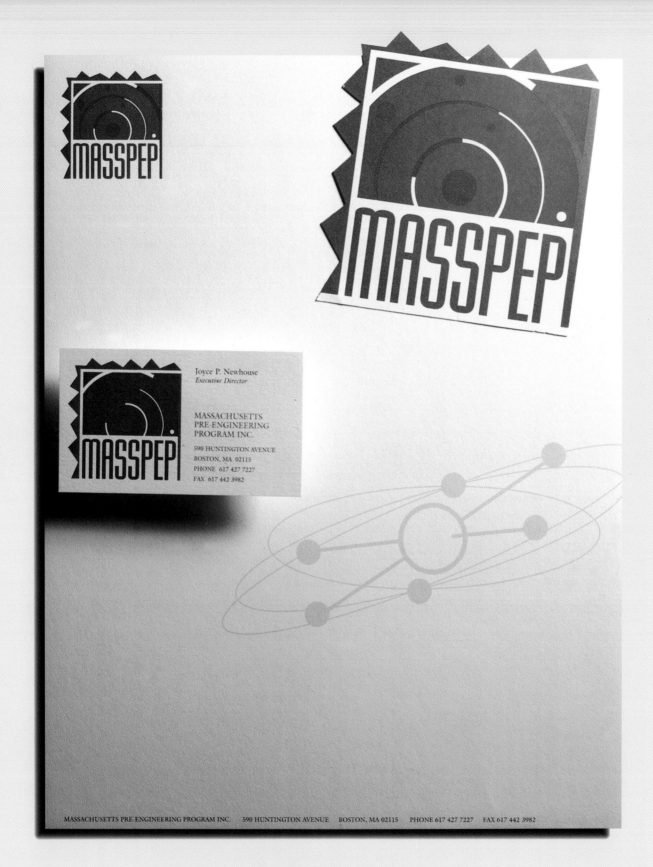

DESIGN FIRM Carol Lasky Studio

ART DIRECTOR Carol Lasky

DESIGNER/ILLUSTRATOR Erin Donnellan

CLIENT MassPep

PAPER/PRINTING Strathmore Renewal, Ink Spot

TOOL Aldus FreeHand, QuarkXPress

The Massachusetts Pre-Engineering Program takes urban kids
and teaches them math, science, and technology. The shapes are
open-ended and the two-sided border is playful.

COMPUTER
SYSTEMS
INSTITUTE

ELLA ZIBITSKER
DIRECTOR OF EDUCATION

405 LAKE COOK PLAZA
SUITE A205
DEERFIELD, ILLINOIS 60015
TEL: 708/291-7030
FAX: 708/291-0741
E-mail: 72204.2132 @ Compuserve.com

405 LAKE COOK PLAZA
SUITE A205
DEERFIELD, ILLINOIS 60015

405 LAKE COOK PLAZA
SUITE A205
DEERFIELD, ILLINOIS 60015
TEL: 708/291-7030
FAX: 708/291-0741
E-mail: 72204.2132 @ Compuserve.com

Design Firm Bullet Communications Inc.
All Design Tim Scott
Client Computer Systems Institute
Paper/Printing Neenah Classic Crest, PMS 3145 and black ink
Tool QuarkXPress

Computer Systems Institute provides computer training.
The symbol artwork was designed and rendered by hand, then
scanned into a Macintosh system. The logo unit and stationery
were designed in QuarkXPress.

Oxford Kids Camp, Inc.
PO Box 294
Oxford, MD 21654

Oxford Kids Camp, Inc. ★ PO Box 294 ★ Oxford, Maryland 21654

DESIGN FIRM Whitney Edwards Design
ART DIRECTOR/DESIGNER Charlene Whitney Edwards
CLIENT Oxford Kids Camp Inc.
PAPER/PRINTING Fox River Confetti, two Pantone colors
TOOLS Adobe Illustrator, QuarkXPress

The client requested the three stars and the sun. The shirt and flag represent what the kids make at camp. The letterhead was created in Adobe Illustrator, separated in QuarkXPress.

the merrill c. berman collection
twentieth century modernist art and graphic design
international corporate center
555 theodore fremd avenue, suite b203
rye, new york 10580 usa
tel 914.967.8200
fax 914.967.8252

the merrill c. berman collection
twentieth century modernist art and graphic design
international corporate center
555 theodore fremd avenue, suite b203
rye, new york 10580 usa

DESIGN FIRM Matsumoto Incorporated
ART DIRECTOR/DESIGNER Takaaki Matsumoto
CLIENT The Merrill C. Berman Collection
PAPER/PRINTING Crane's Crest Antique White Wove,
Letterpress, two colors
TOOLS Adobe Illustrator, QuarkXPress
...
Because the Berman Collection is a modern art collection, the
Futura type family was used. The stationery system, composed
of letterhead, envelope, and mailing label, was printed using
a letterpress.

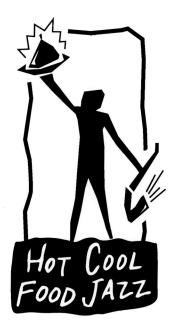

Design Firm Delmarva Power Corporate Comm.
All Design John Alfred
Client Meals on Wheels
Tools Adobe Illustrator and Streamline

..

This logo for Hot Food, Cool Jazz, a non-profit fund-raiser, was created by scanning a thumbnail sketch, Streamlining it, and manipulating it in Illustrator.

Design Firm Swieter Design U.S.
Art Director John Swieter
Designer Jenice Heo
Client Arlington Museum of Art

..

This logo was created for the museum's "Raise the Roof Fun Run."

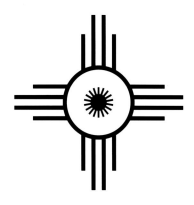

SEE YOU IN SANTA FE

Design Firm Dept. of Art as Applied to Medicine, Johns Hopkins University
Art Director/Designer Joseph M. Dieter, Jr.
Client The Wilmer Eye Institute, The Johns Hopkins Hospital
Tool Adobe Illustrator

..

This logo was developed for a professional meeting for ophthalmologists held in Santa Fe, New Mexico. The familiar symbol used by New Mexico was appropriately turned into an eyeball.

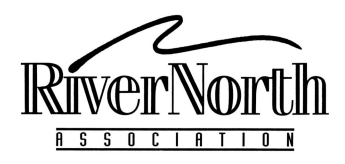

Design Firm Bullet Communications Inc.
All Design Tim Scott
Client River North Association
Tool QuarkXPress

..

The graphic swash was drawn then scanned into a Macintosh system. The swash was then combined with type, which was set and customized in QuarkXPress.

C O M M U N I T Y

R E H A B I L I T A T I O N

C E N T E R S , I N C .

C O M M U N I T Y

R E H A B I L I T A T I O N

C E N T E R S , I N C .

C O M M U N I T Y
R E H A B I L I T A T I O N
C E N T E R S , I N C .

Debbie Angle
Vice President

6001 Indian School Rd. NE

Albuquerque, New Mexico 87110

505 • 881 • 4961

FAX 505 • 881 • 5097

22 West Monument Avenue, Suite 3 • Kissimmee, Florida 34741 • 407·847·6003 • FAX 407·847·6290

DESIGN FIRM Vaughn Wedeen Creative
ART DIRECTORS Steve Wedeen, Dan Flynn
DESIGNER/ILLUSTRATOR Dan Flynn
CLIENT Horizon Health Care
PAPER/PRINTING Classic Crest, Prisma Graphics
TOOL Adobe Illustrator

The client, a therapy organization, wanted the logo to look hand-
done. After the initial illustration was finished, it was then
scanned in and cleaned up in Illustrator.

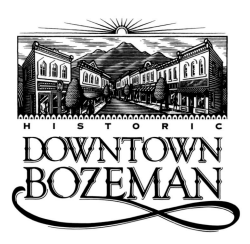

DESIGN FIRM Palmquist & Palmquist Design
ART DIRECTORS/DESIGNERS Kurt and Denise Palmquist
ILLUSTRATORS James Lindquist, Denise Palmquist
CLIENT Downtown Bozeman Association

..

This logo could not focus on one specific building or street because of politics. The illustration was done on scratchboard and the type was a combination of computer- and hand-rendering.

DESIGN FIRM Palmquist & Palmquist Design
ART DIRECTORS/DESIGNERS Kurt and Denise Palmquist
ILLUSTRATOR Kurt Palmquist
CLIENT Coalition for Montanans Concerned with Disabilities
TOOL Aldus FreeHand

..

The logo design focused on the objectives the organization was trying to accomplish: To help disabled persons while educating politicians and professionals about the concerns and goals of the disabled.

DESIGN FIRM Mires Design Inc.
ART DIRECTOR/DESIGNER José Serrano
ILLUSTRATOR Tracy Sabin
CLIENT Harcourt Brace & Co.

..

This logo is for a children's fantasy book series.

DESIGN FIRM Mires Design Inc.
ART DIRECTOR Mike Brower
DESIGNER Mike Brower
CLIENT Bod-E

..

The client is a personal health trainer.

DESIGN FIRM Misha Design Studio
ALL DESIGN Michael Lenn
CLIENT Combined Jewish Philanthropies General Assembly '95

..

The '95 Convention for CJP being held in Boston must demonstrate beauty and excitement. This logo shows the significant landmarks in Boston and invites a participant to the assembly.

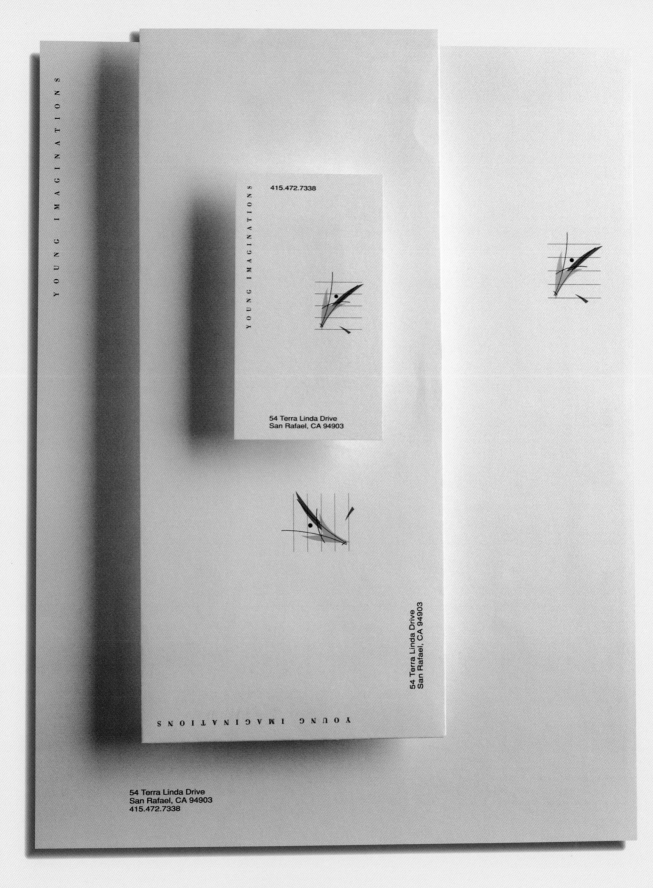

DESIGN FIRM Sackett Design Associates

ART DIRECTOR/DESIGNER Mark Sackett

DESIGNER Mark Sackett

ILLUSTRATOR Wayne Sakamoto

CLIENT Young Imaginations

PAPER/PRINTING Simpson Coronado SST Recycled 80 lb. text,
offset lithography, two match colors and black

Children's Health Care Minneapolis
2525 Chicago Avenue South
Minneapolis, Minnesota 55404
(612) 863-6100

DESIGN FIRM Larsen Design Office Inc.

ART DIRECTOR Tim Larsen

DESIGNERS Nancy Whittlesey, Kristine Thayer

CLIENT Children's Health Care

TOOL Aldus FreeHand

Since the name, Children's Health Care, is very straightforward,
the warmth and professional care of the organization needed to
be communicated through its colorful and playful logo design.

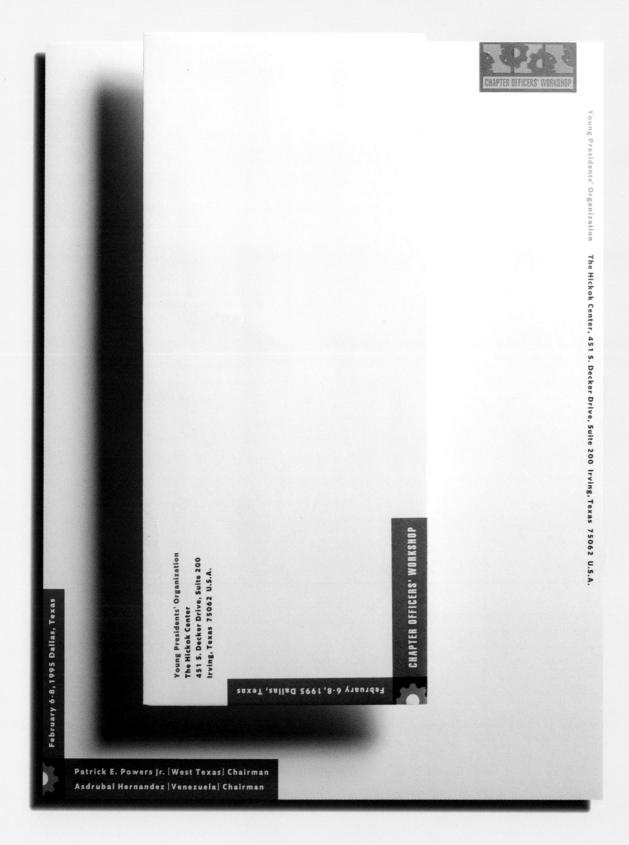

Design Firm Swieter Design U.S.
Art Director John Swieter
Designer Mark Ford
Client Young Presidents' Organization Chapter Officers'
Workshop
Tool Adobe Illustrator

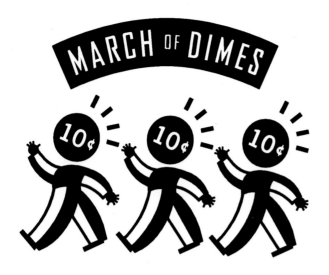

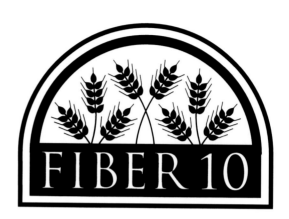

Design Firm Jon Flaming Design
All Design Jon Flaming
Client March of Dimes
Paper/Printing T-shirts
Tool Adobe Illustrator

This is a logo that was produced for the March of Dimes
walk-a-thon. It was used on T-shirts.

Design Firm Anderson Hanson & Company
Art Director/Designer Raul Varela
Client AdvoCare International Fiber 10
Tool Adobe Illustrator

The logo's appeal is due in part to the pleasing-to-the-eye design
of the wheat stalks, which are used to convey Fiber 10's
purpose: to cleanse the stomach.

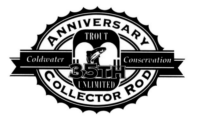

Design Firm Palmquist & Palmquist
Design
Art Directors/Designers Kurt and
Denise Palmquist
Illustrator Kurt Palmquist
Client National Chapter of Trout
Unlimited

The bottom line of type is dropped in
to double as the logo for a commemora-
tive rod (limited edition), produced to
celebrate Trout Unlimited's 35th
anniversary.

Design Firm Swieter Design U.S.
Art Director John Swieter
Designer Jenice Heo
Client ASICS

This logo was designed for the ASICS
Tiger Corporation and the 1994 New
York City Marathon commemorating
the Marathon's 25th Anniversary.
The design was applied to everything
from posters, to in-store merchandising
displays, to tattoos and lapel pins.

Design Firm Swieter Design U.S.
Art Director John Swieter
Designer Julie Poth
Client Young Presidents' Organization
Tool Adobe Illustrator

This icon was created for the Global
Masters Program.

DESIGN FIRM Jon Wells Associates
ART DIRECTOR/DESIGNER Jon Wells
ILLUSTRATOR Michael Schwab
TOOL Adobe Illustrator
CLIENT The Corporation for Cultural Literacy

"America's Family Books" feature children's stories which chronicle America's racial history. The logo highlights this heritage. The image was hand drawn and then it was combined with the type in Illustrator.

DESIGN FIRM Swieter Design U.S.
ART DIRECTOR John Swieter
DESIGNER Mark Ford
CLIENT Young Presidents' Organization
TOOL Adobe Illustrator

DESIGN FIRM Swieter Design U.S.
ART DIRECTOR/DESIGNER John Swieter
CLIENT Young Presidents' Organization
TOOL Adobe Illustrator

DESIGN FIRM Swieter Design
ART DIRECTOR John Swieter
DESIGNERS John Swieter, Mark Ford, Paul Munsterman
CLIENT Young Presidents' Organization
TOOL Adobe Illustrator

DESIGN FIRM Swieter Design U.S.
ART DIRECTOR John Swieter
DESIGNER Mark Ford
CLIENT Young Presidents' Organization
TOOL Adobe Illustrator

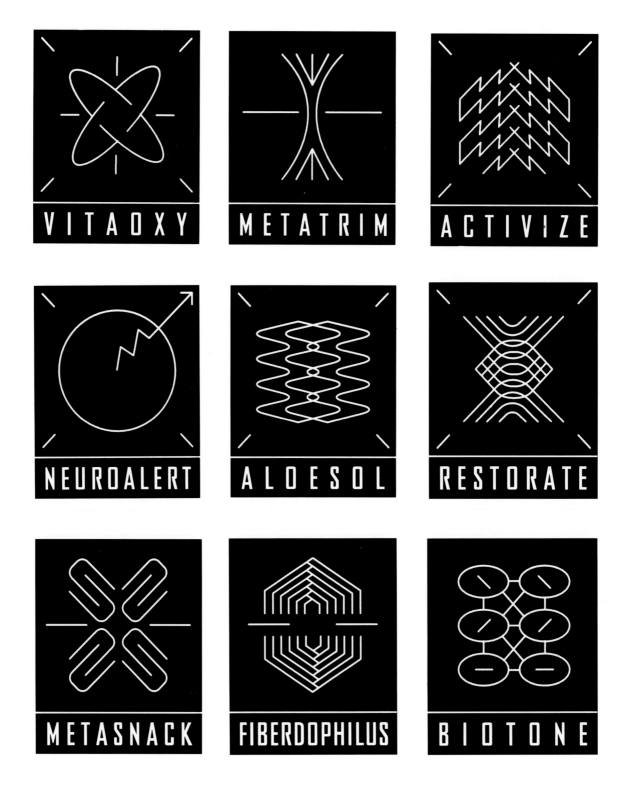

DESIGN FIRM Anderson Hanson & Company

ART DIRECTOR/DESIGNER Raul Varela

CLIENT LifeTronix product packaging logos (Vitaoxy, Metatrim, Activize, Neuroalert, Aloesol, Restorate, Metasnack, Fiberdophilus, Biotone)

TOOL Adobe Illustrator

Each logo was created to give a subconscious reference to the products. The company wanted to convey sophistication and let the logo designs build themselves with product usage.

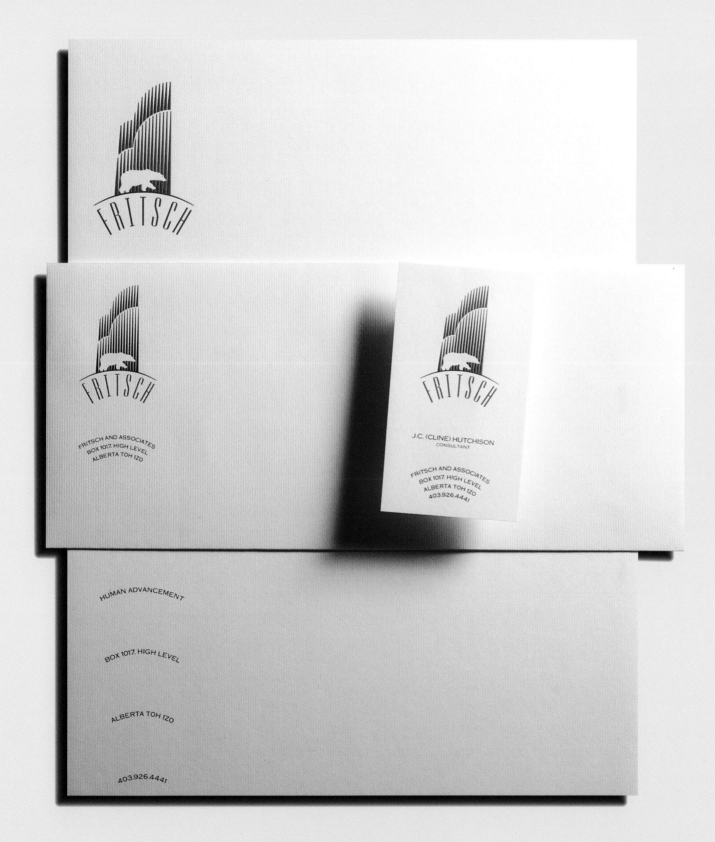

DESIGN FIRM Duck Soup Graphics
ALL DESIGN William Doucette
CLIENT Fritsch and Associates
PAPER/PRINTING James River Graphika, 2-color,
logo is embossed
TOOL Adobe Illustrator

The logo is embossed on all pieces for subtle tactile sensation.
Client requested a mark that would appeal to the Eskimo
population of Canada's Arctic regions.

FLORENCE

OCTOBER 6-12, 1995

YOUNG
PRESIDENTS'
ORGANIZATION

THE HICKOK CENTER
451 SOUTH DECKER DRIVE
SUITE 200
IRVING, TEXAS
75062 U.S.A.
TEL 214.650.4600
FAX 214.650.4777

UNIVERSITY CHAIRMAN
PAOLO AND ROSSELLA FANTACCI
(FLORENCE)

EDUCATION
MARK AND HELEN BLODGETT
(NEW ENGLAND)

OFF-SITE EDUCATION
EDGAR AND ELISSA CULLMAN
(METRO NEW YORK)

HOSPITALITY/SALES
OMAR AND PAULA AL ASKARI
(EMIRATES)

SOCIAL
SIMONETTA AND GIROLAMO
BRANDOLINI D'ADDA
(FLORENCE)

ACADEMIES
ROBERT AND LESLEY HIPPENMEYER
(ALPINE)

TRANSPORTATION
GUISEPPE AND LAURA MAZZINI
(FLORENCE)

ADVISORS
TIMOTHY AND CAROL HOLMES
(WESTERN AUSTRALIA)

FLORENCE

OCTOBER 6-12, 1995

YOUNG
PRESIDENTS'
ORGANIZATION

THE HICKOK CENTER
451 SOUTH DECKER DRIVE
SUITE 200
IRVING, TEXAS
75062 U.S.A.

DESIGN FIRM Swieter Design U.S.

ART DIRECTOR John Swieter

DESIGNERS Mark Ford, Jenice Heo

CLIENT Young Presidents' Organization Florence University

Industrial and Manufacturing

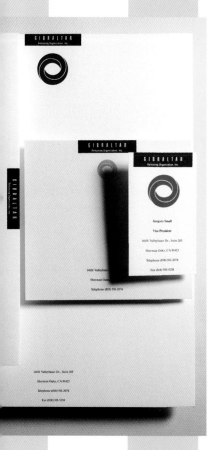

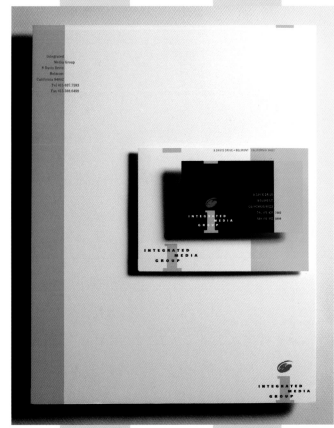

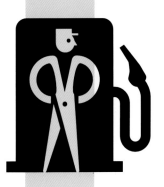

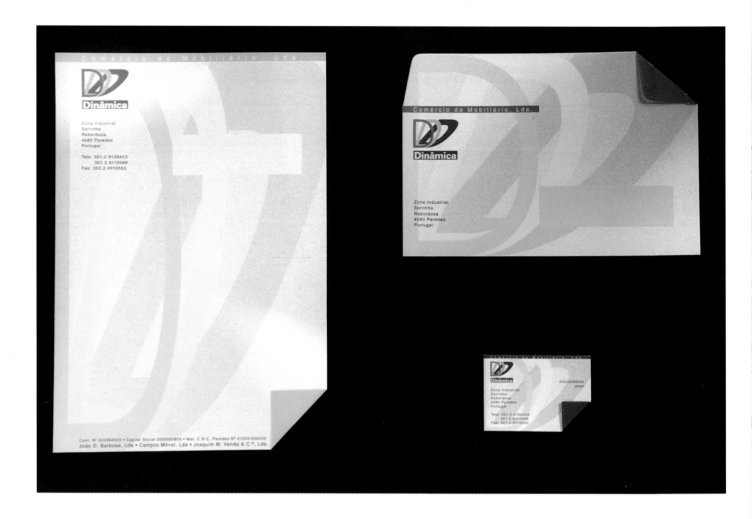

DESIGN FIRM Mário Aurélio & Associados
ART DIRECTOR/DESIGNER Mário Aurélio
CLIENT Dinamica Furniture
PAPER/PRINTING Flannel Paper, offset
TOOL Aldus FreeHand

Design Firm John Evans Design
All Design John Evans
Illustrator John Evans
Client Mary Kay Cosmetics
Tool Adobe Illustrator

These icons were originally drawn with marker then scanned and redrawn in Illustrator. They were used in a line of packaging for Mary Kay Cosmetics.

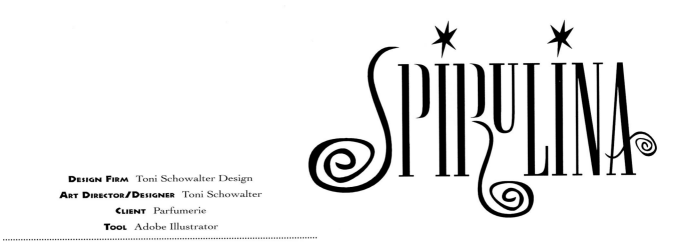

Design Firm Toni Schowalter Design
Art Director/Designer Toni Schowalter
Client Parfumerie
Tool Adobe Illustrator

The font was manipulated to create the swirling effect for a natural cosmetic line from Hawaii.

DESIGN FIRM John Evans Design
ALL DESIGN John Evans
CLIENT Milton Bradley
TOOL Adobe Illustrator

These icons are just a few of about 50 created for the game of *Life Jr.* Originally done in pencil, they were faxed to the client for approval, then redrawn in Illustrator.

DESIGN FIRM Toni Schowalter Design
ART DIRECTOR/DESIGNER Toni Schowalter
CLIENT Tri Mark
TOOL Aldus FreeHand

This logo was used to portray a furniture designer and manufacturer.

DESIGN FIRM Toni Schowalter Design
ART DIRECTOR/DESIGNER Toni Schowalter
DESIGNER Toni Schowalter
CLIENT Johnson & Johnson
TOOL Adobe Illustrator

This mark was used to differentiate the research and development department in a large health product manufacturer.

Darlington China, Inc.

P.O. Box 410 ▪ *127 Cannelton Road* ▪ *Darlington, PA 16115*
Phone 412-827-8141 ▪ *FAX 412-827-2001*

Design Firm Ara Corporation
Designer William Tittiger
Client Darlington China
Paper/Printing Mystique Laid 24 lb. Soft White, offset,
one PMS ink, foil stamped gold

This logo was created freehand. The customer wanted a design
for stationery, and to use as a seal on china plates. The customer
chose gold foil stamping for an elegant look.

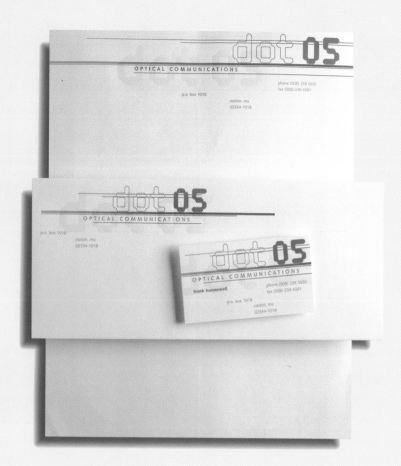

DESIGN FIRM Marc English : Design
ART DIRECTOR/DESIGNER Marc English
CLIENT DOT 05 Optical Communications
PAPER/PRINTING Neenah Classic, split-fountain with fluorescent inks; silver; transparent foil stamp

The logotype, Interact, was opened in Photoshop to create outline and solid versions. Fluorescent and metallic inks, the split-fountain, and a transparent foil stamp conveys speed, depth, and light.

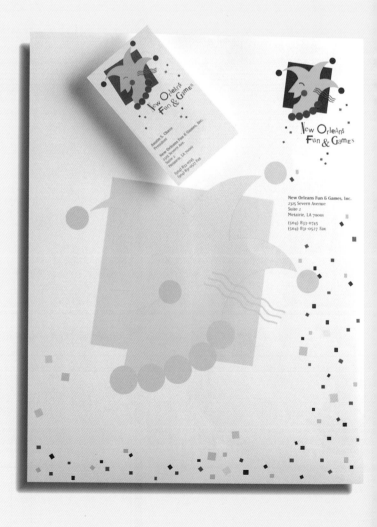

DESIGN FIRM Degnen Associates Inc.
ART DIRECTOR Steve Degnen
DESIGNERS Neil Motts, Dave Fowler
CLIENT New Orleans Fun & Games
PAPER/PRINTING Gilbert, offset using five spot colors
TOOL Aldus FreeHand

The company wanted a logo to capture the fun and excitement of its products. The five spot colors reinforce the color and pageantry of New Orleans, especially during Mardi Gras.

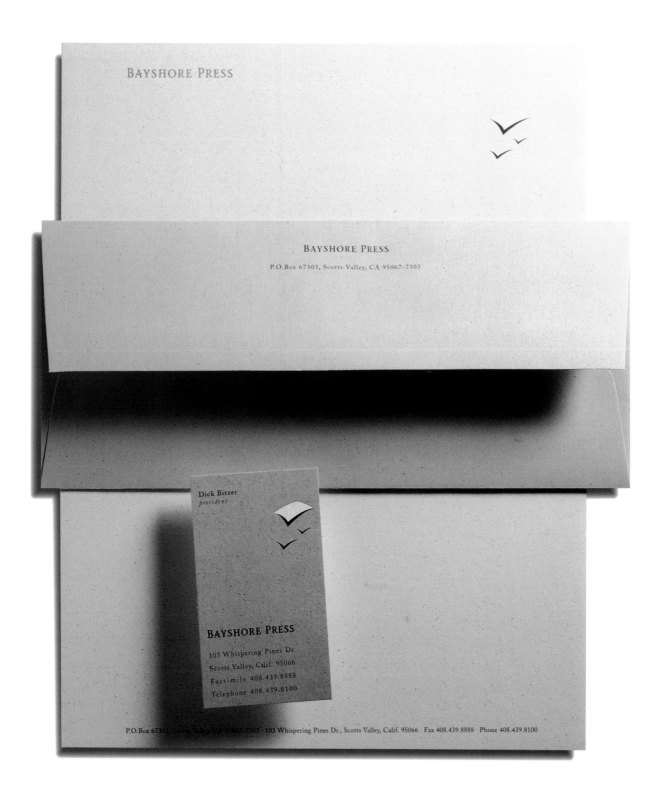

Design Firm THARP DID IT

Art Director Rick Tharp

Designers Rick Tharp, Jana Heer, Laurie Carberry,
Amy Bednarek

Client Bayshore Press

Paper/Printing Simpson Quest Recycled, offset lithography

Tool Adobe Illustrator

The logo was rendered by hand and scanned into the computer.
The custom logotype was created in Illustrator and traditional
art board mechanicals were produced for all print materials.

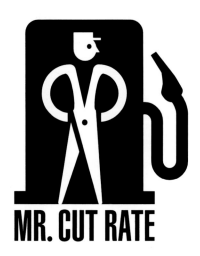

MR. CUT RATE

DESIGN FIRM Witherspoon Advertising
ART DIRECTOR/DESIGNER Rishi Seth
CLIENT FFP Partners
TOOL Adobe Illustrator

This logo was intended for displays at gasoline outlets. The client insisted that a gas pump and scissors be included. The "scissors guy" came from bringing these diverse elements together.

DESIGN FIRM Fernandez Vs. Miller Design
ART DIRECTOR/DESIGNER Bryan M. Miller
CLIENT A Tile Store
TOOL Adobe Illustrator

A Tile Store, in Seattle, Washington specializes in custom handcrafted and specialty tiles. The client's favorite tiles were charcoal rubbed for the logo. A little stylizing in Illustrator and the rest is history.

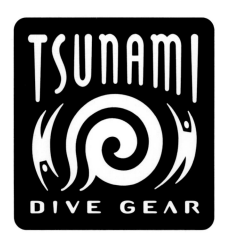

DESIGN FIRM Mires Design Inc.
ART DIRECTOR/DESIGNER John Ball
CLIENT Tsunami Dive Gear, underwater communication equipment

DESIGN FIRM Félix Beltrán + Asociados
ART DIRECTOR/DESIGNER Félix Beltrán
CLIENT Novum, Mexico
TOOL CorelDRAW

In the creation of this logo for a videocassette factory, CorelDRAW was used for printing the initial sketches. The logo was silk-screened to improve the color.

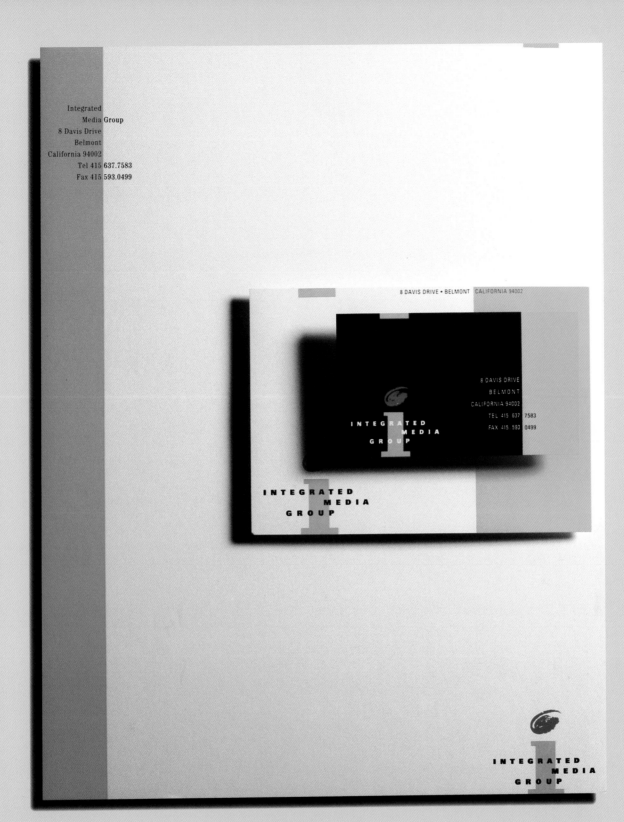

Integrated
Media Group
8 Davis Drive
Belmont
California 94002
Tel 415 637.7583
Fax 415 593.0499

8 DAVIS DRIVE • BELMONT CALIFORNIA 94002

8 DAVIS DRIVE
BELMONT
CALIFORNIA 94002
TEL 415 637 7583
FAX 415 593 0499

INTEGRATED
MEDIA
GROUP

INTEGRATED
MEDIA
GROUP

INTEGRATED
MEDIA
GROUP

Design Firm THARP DID IT
Art Director Rick Tharp
Designers Rick Tharp, Colleen Sullivan
Illustrator Georgia Deaver
Client Integrated Media Group
Paper/Printing Simpson Starwhite Vicksburg, three match
colors, offset lithography

...

This logo was created for a publisher of interactive multimedia
teaching programs. It includes a graphic style guide. Art was
rendered by hand, scanned into the computer, and composed in
Illustrator.

maharam

86 Legault Crescent
Cambridge, Ontario
N3C 3T4 Canada
Telephone 519.658.6108
Telefax 519.658.1303

maharam

86 Legault Crescent
Cambridge, Ontario
N3C 3T4 Canada

maharam

86 Legault Crescent
Cambridge, Ontario
N3C 3T4 Canada

Donald Maharam

2212 Gladwin Creascent Unit A-5
Ottawa, Ontario K18 5N1
Telephone 519.658.6108
800.321.5619 (New York)
Telefax 519.658.1303
516.562.1026 (New York)

maharam

DESIGN FIRM Matsumoto Incorporated
ART DIRECTOR/DESIGNER Takaaki Matsumoto
CLIENT Maharam
PAPER/PRINTING Cranes Crest Fluorescent White,
3-color engraved
TOOLS Adobe Illustrator, QuarkXPress

The vertical elements in the design are an abstract suggestion of
threads of fabric. The components of the stationery system were
engraved using three colors.

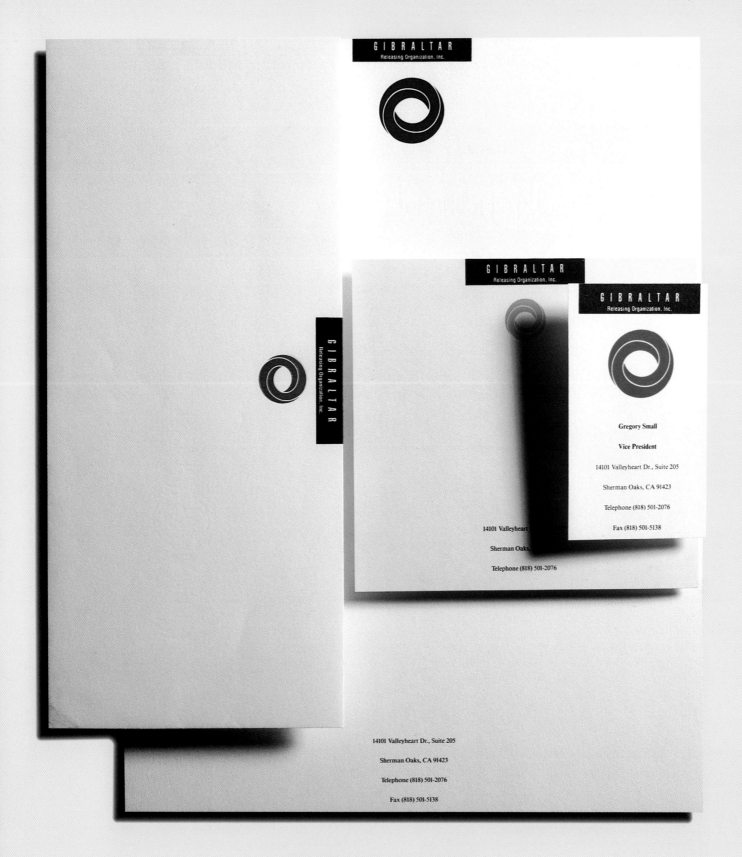

DESIGN FIRM Melissa Passehl Design

ART DIRECTOR/DESIGNER Melissa Passehl

CLIENT Gibraltar Releasing Organization Inc.

··

This identity system and logo were designed to reflect the creative, thought provoking, and interactive films produced by this movie company.

DESIGN FIRM Becker Design
ART DIRECTOR/DESIGNER Neil Becker
ILLUSTRATOR Drew Dallet
CLIENT Rite Hite
PAPER/PRINTING Classic Crest, Solar White, 4-color lithography
TOOLS Adobe Illustrator, QuarkXPress

..

Rite Hite, a loading dock/industrial safety system company, needed a logo for an incentive program, a trip to St. Thomas.

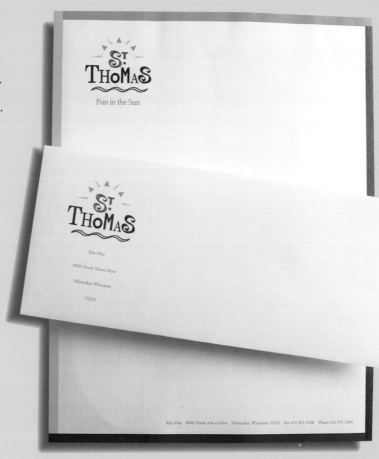

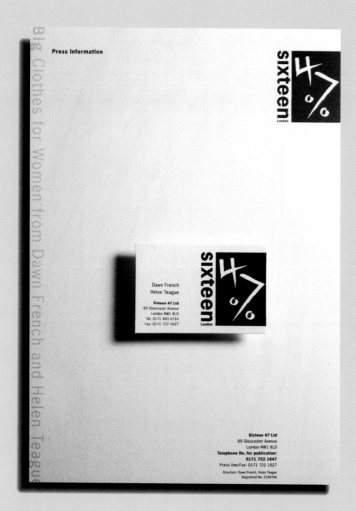

DESIGN FIRM The Green House
ART DIRECTOR Judi Green
DESIGNER James Bell
CLIENT 1647 Ltd.
PAPER/PRINTING Rives Tradition White, Arjo Wiggins

..

The logo has to convey the notion that 47 percent of all British women are size 16 and higher. The logo required flexibility for application in a variety of uses.

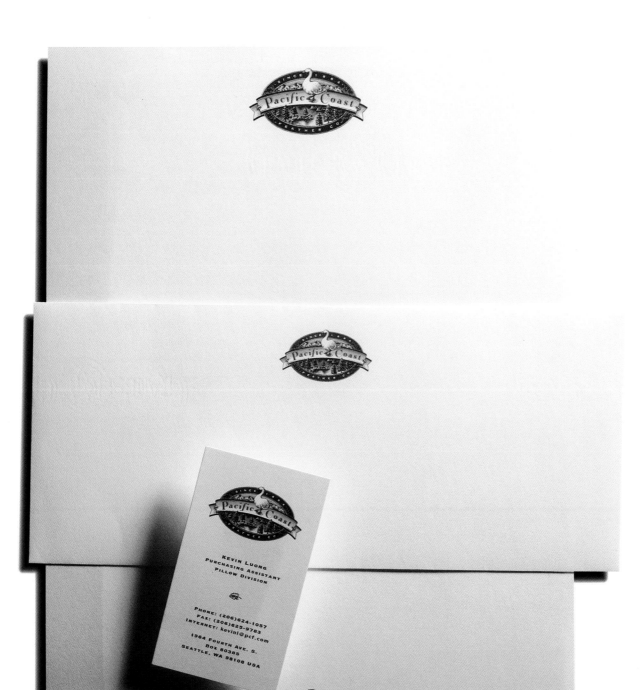

DESIGN FIRM Hornall Anderson Design Works Inc.

ART DIRECTOR Jack Anderson

DESIGNERS Jack Anderson, Julie Lock, Heidi Favour,
Leo Raymundo

ILLUSTRATOR Carolyn Vibbert

CLIENT Pacific Coast Feather Company

PAPER/PRINTING Cranes Crest

TOOLS Adobe Photoshop, Aldus FreeHand

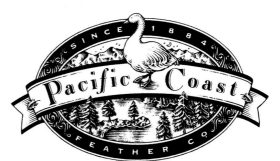

This letterhead needed to reflect the outdoors of the American
Northwest and the company's longtime establishment in the area.

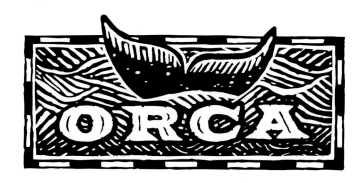

DESIGN FIRM Mires Design Inc.
ART DIRECTOR José Serrano
DESIGNER José Serrano
ILLUSTRATOR Tracy Sabin
CLIENT Found Stuff Paperworks
PAPER/PRINTER Terra Sketch—100% recycled organic
sketch paper.

DESIGN FIRM Mires Design Inc.
ART DIRECTOR/DESIGNER John Ball
ILLUSTRATOR Tracy Sabin
CLIENT S.D. Johnson Co.

ORCA fishing products

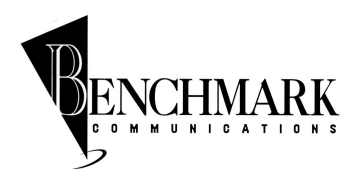

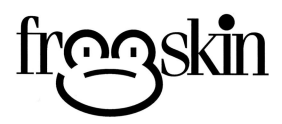

DESIGN FIRM MacVicar Design & Communications
ART DIRECTOR John Vance
DESIGNER William A. Gordon
CLIENT Benchmark Communications
TOOL Adobe Illustrator

Logo was developed for use as the corporate identity of a radio-
industry management/promotions firm.

DESIGN FIRM Caldera Design
ILLUSTRATORS Dave Kottler, Paul Caldera,
Doreen Caldera, Bart Welch
CLIENT Frogskins

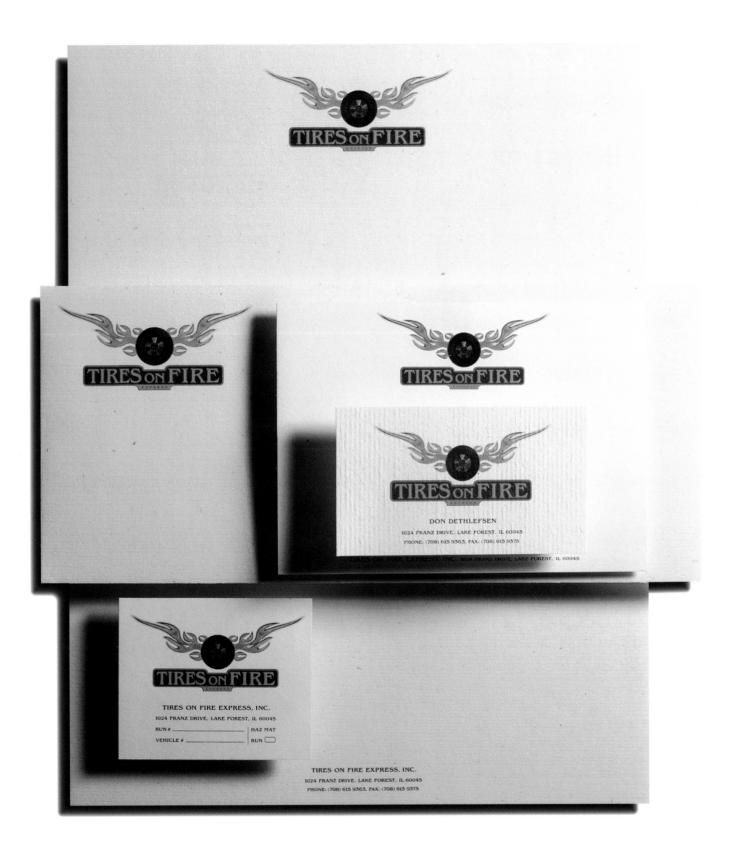

DESIGN FIRM Segura Inc.

ART DIRECTOR Carlos Segura

DESIGNER Carlos Segura, Laura Alberts

ILLUSTRATOR Tony Klassen

CLIENT Tires on Fire

PAPER/PRINTING Argus Press, 4-color

TOOLS Adobe Illustrator and Photoshop, QuarkXPress

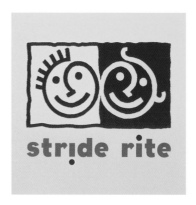

DESIGN FIRM Clifford Selbert Design
ART DIRECTORS Clifford Selbert, Robin Perkins
DESIGNERS Robin Perkins, Julia Daggett, Michele Phelan,
Kamren Colson, Kim Reese, John Lutz
ILLUSTRATOR Gerald Bustamante
CLIENT Stride Rite Inc.

The concept focused on "the joy of growing up." The color
palette has three simple, vibrant colors, and Stride Rite's "i's"
reflect a youthful energy and spirit.

DESIGN FIRM The Kamber Group
ART DIRECTOR Dennis Walston
DESIGNER Page Miller
CLIENT Montague Branch

Montague Branch crafts fine cabinetry and outfits entire
kitchens for its clients.

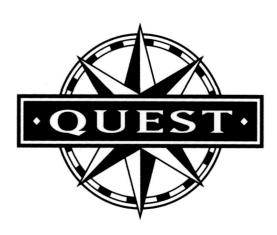

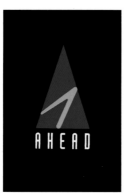

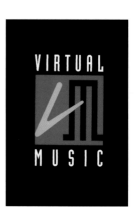

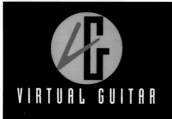

DESIGN FIRM Sackett Design Associates
ART DIRECTOR/DESIGNER Mark Sackett
ILLUSTRATOR Wayne Sakamoto
CLIENT Quest

DESIGN FIRM Clifford Selbert Design
ART DIRECTOR Robin Perkins
DESIGNERS Robin Perkins, Jeff Breidenbach
CLIENT Ahead Inc.
TOOL Aldus FreeHand

The fonts used in these pieces were Industrial, Template
Gothic, and Oblong. The three logos used a common element
— the V— in a variety of ways.

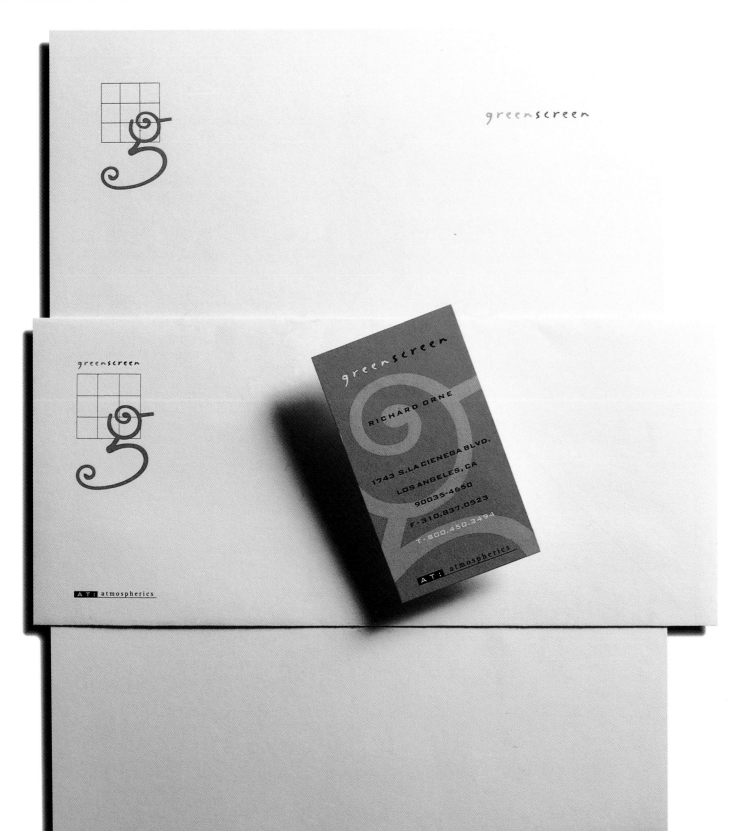

Design Firm Clifford Selbert Design
Art Director Robin Perkins
Designer Heather Watson
Client Atmospherics
Paper/Printing Genesis Cross Point 80 lb. text, offset
Tools Adobe Illustrator, QuarkXPress

This logo is for a landscaping system called "green screen."
The fonts used are Remedy and Letters Ecletes and the color
is Birch.

TELEVISION MALDIVES

DESIGN FIRM Incite Design
Communications
ALL DESIGN Sherrie and
Tracy Holdeman
CLIENT Tom Arpky
TOOL Macromedia FreeHand
...
Using two P's to create a package
seemed to be the ideal solution. I tried to
make it equally easy to discern the two
P's versus the package and vice versa.

DESIGN FIRM Swieter Design U.S.
ART DIRECTOR/DESIGNER John Swieter
CLIENT Hexagraph Fly Rods Co.

DESIGN FIRM Group X Graphics &
Design Associates
ART DIRECTOR/DESIGNER Mohamed
Shafeeq
CLIENT Television Maldives
TOOL CorelDRAW
...
This logo for Television Maldives uses
the letters TVM, with the television col-
ors of blue, green and red splash, across
the first triangle of the two that make up
V and M.

COLORSELECT
SYSTEM

DESIGN FIRM John Evans Design
ALL DESIGN John Evans
CLIENT Milton Bradley
TOOL Adobe Illustrator
...
This symbol was created for a fast-action
game by Milton Bradley. It was drawn
by hand then scanned and redrawn
in Illustrator.

DESIGN FIRM Lambert Design Studio
ART DIRECTOR/DESIGNER Christie Lambert
CLIENT Mary Kay Cosmetics
TOOL Adobe Illustrator
...
The CS brushstroke was printed in a pastel rainbow with the type in a warm gray.
The brushstroke and rainbow were created by hand, then the printer merged the two.

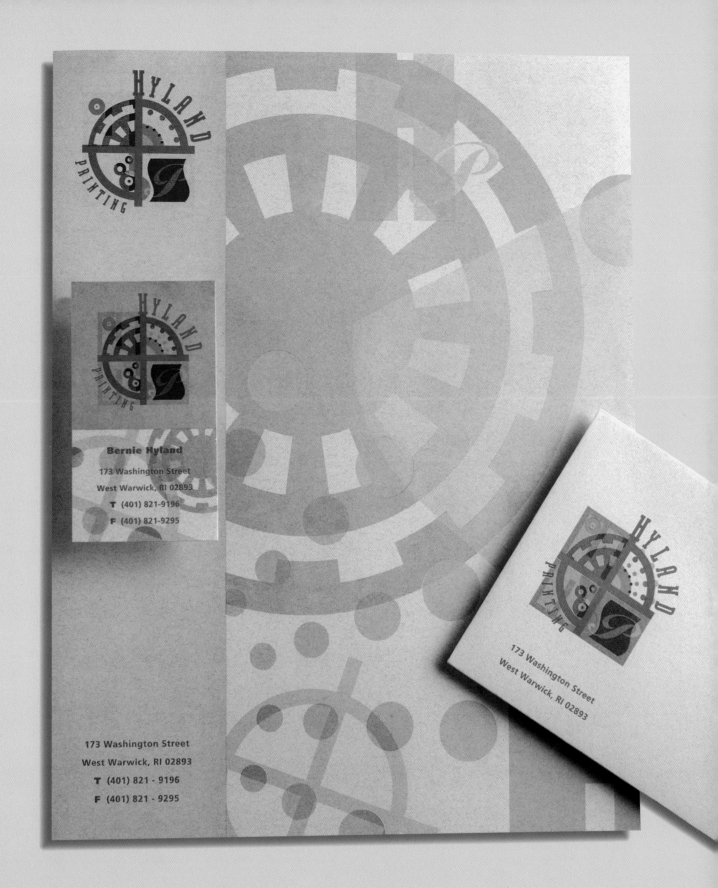

DESIGN FIRM Adkins/Balchunas
ART DIRECTOR Jerry Balchunas
DESIGNER Dan Stebbings
CLIENT Hyland Printing
PAPER/PRINTING Neenah Environment, Hyland Printing

This stationery was printed in four spot colors, three of which
were metallic.

DESIGN FIRM Supon Design Group Inc.
ART DIRECTORS Supon Phornirunlit, Andrew Dolan
DESIGNER Eddie Saibua
CLIENT Discovery Communications
PAPER/PRINTING Strathmore Renewal, offset
TOOLS Adobe Photoshop, QuarkXPress

The client wanted something different, and the online address needed to be "screaming."

DESIGN FIRM Supon Design Group Inc.
ART DIRECTORS Supon Phornirunlit, Andrew Dolan
DESIGNER Andrew Dolan
CLIENT Discovery Communications
PAPER/PRINTING Strathmore Writing
TOOLS Adobe Illustrator, QuarkXPress

KNOW-TV wants to communicate to audience that they are changing ways for people to watch cable.

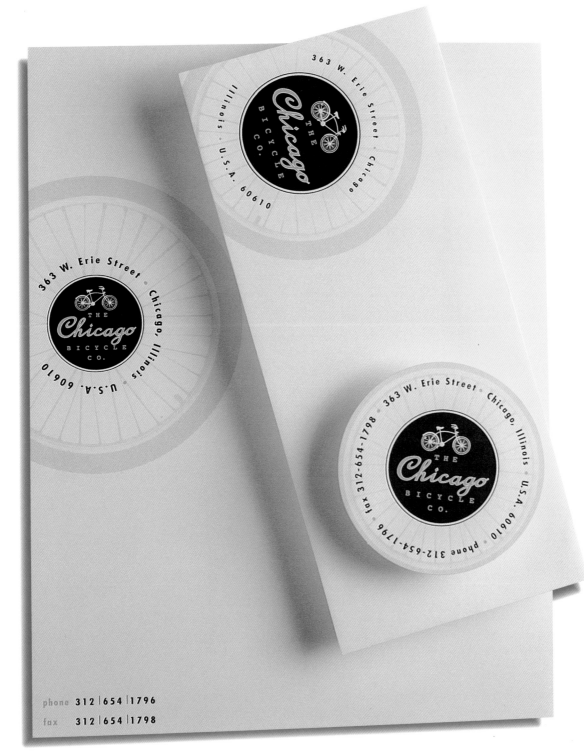

DESIGN FIRM Maximum Marketing
ART DIRECTOR Ed Han
DESIGNER/ILLUSTRATOR Deirdre Boland
CLIENT The Chicago Bicycle Co.
TOOLS Adobe Illustrator, QuarkXPress

The warm-toned paper along with the beige and blue inks enhance the retro feel. It is used on signage, printed materials, apparel, and advertising. The red and yellow version is used on all store signage.

DESIGN FIRM Swieter Design U.S.
ART DIRECTOR John Swieter
DESIGNER Mark Ford
CLIENT Street Savage Roller Blade Gear
TOOL Adobe Illustrator

This icon was developed for a company that manufactures street hockey equipment.

DESIGN FIRM Swieter Design U.S.
ART DIRECTOR John Swieter
DESIGNER Mark Ford
CLIENT ASICS
TOOL Adobe Illustrator

This icon was created for the "Sound Mind Sound Body" series.

DESIGN FIRM Swieter Design U.S.
ART DIRECTOR John Swieter
DESIGNER Paul Munsterman
CLIENT Converse Basketball
TOOL Adobe Illustrator

This product icon was developed for a line of basketballs featuring the highest grade synthetic leather which is durable on all court surfaces.

DESIGN FIRM Swieter Design U.S.
ART DIRECTOR/DESIGNER John Swieter
CLIENT Converse Basketball
TOOL Adobe Illustrator

This product icon features a global rendition of the traditional seams on a basketball and is targeted as the first genuine leather ball sold internationally for Converse.

DESIGN FIRM Swieter Design U.S.
ART DIRECTOR John Swieter
DESIGNER Mark Ford
CLIENT Fujitsu
TOOL Adobe Illustrator

This logo was created for **Envoy,** Fujitsu's Quarterly Technical Journal.

DESIGN FIRM Swieter Design U.S.
ART DIRECTOR John Swieter
DESIGNER Kevin Flatt
CLIENT Converse Basketball
TOOL Adobe Illustrator

This product icon, created for Converse Inc., symbolizes the use of this product as an indoor and outdoor basketball.

DESIGN FIRM Design One
ALL DESIGN David Guinn
CLIENT Handmade in America
TOOL Aldus FreeHand
PAPER/PRINTING Confetti Tan, Offset White, copper metallic
PMS on uncoated sheet

This logo captures a handmade feel and used a loose rendition of
a hand and letters "H," "M," and "A." It was drawn in
FreeHand with tablet pen.

DESIGN FIRM Swieter Design U.S.
ART DIRECTOR John Swieter
DESIGNER Kevin Flatt
CLIENT Pet Rite
TOOL Adobe Illustrator

This identity was created for dog shampoo and conditioner.

DESIGN FIRM Swieter Design U.S.
ART DIRECTOR/DESIGNER John Swieter
CLIENT Timberform Builders
TOOL Adobe Illustrator

DESIGN FIRM Go Media Inc.
ALL DESIGN Sonya Cohen
CLIENT Active Paper
TOOL Adobe Illustrator

After many drawings of "active" paper and information in motion, the elements and the quirky drawing style were honed.

DESIGN FIRM Cato Design Inc.
DESIGNER Ken Cato
CLIENT Poppy Industries
TOOL Adobe Illustrator

The logo was hand drawn but put together in Illustrator. The packaging symbol was derived from the name of the company's founder, Poppy King.

DESIGN FIRM Swieter Design U.S.
ART DIRECTOR John Swieter
DESIGNER Kevin Flatt
CLIENT Converse Basketball
TOOL Adobe Illustrator

The title "Security Panel" refers to a signature strip on the basketball itself. The Converse "Security Panel" ball was the first basketball designed with a debossed panel for personalizing each ball.

DESIGN FIRM Rousso+Associates Inc.
ART DIRECTOR/DESIGNER Steve Rousso
CLIENT Harbinger Corporation

This logo suggests the interchange flow of information with the arrows traveling vertically through the bold "H" shape. The curved sides added dynamism to the otherwise solid, stable shape.

Design Firm JiWon Shin
Art Director/Designer JiWon Shin
Client Color Kit
Paper/Printing Tracing (Transparent) paper

Overlapping rotating Modulars produce changing color and
shape combinations. There are six colored Modulars in acrylic
and hardboard. Transparent paper was used for the stationery
because the clock parts are transparent.

Design Firm 13TH FLOOR
Art Director/Designer Eric Ruffing
Client Frank + Frisch
Tool Aldus FreeHand
Paper/Printing Neenah Environment, Circle Printing Co.

The "+" element is based on the bold, simple style of the client's work, and the loose layout of the type was based on the chaos of the shop.

Food and Beverage

DESIGN FIRM John Evans Design
ART DIRECTORS John Evans, Michael Reyes
DESIGNER/ILLUSTRATOR John Evans
CLIENT Quaker Oats, Berry Brown Advertising
TOOL Adobe Streamline

This mark was done with traditional scratchboard, then it was scanned and Streamlined to create the final logo.

DESIGN FIRM Robert Bailey Incorporated
ART DIRECTOR Robert Bailey
DESIGNER/ILLUSTRATOR Dan Franklin
CLIENT CA One Services Inc.
TOOL Macromedia FreeHand

This logo is for a proposed lounge for Los Angeles International Airport. It is based on the architecture of Greene & Greene, the well-known "bungalow" architects of southern California.

DESIGN FIRM Robert Bailey Incorporated
ART DIRECTOR Robert Bailey
DESIGNER Ellen Bednarek
CLIENT CA One Services Inc.
TOOL Macromedia FreeHand

This logo is for a proposed delicatessen for Los Angeles International Airport. The theme is based on the old-fashioned, friendly, full-service Jewish delicatessen.

DESIGN FIRM Kelly O. Stanley Design
ALL DESIGN Kelly O'Dell Stanley
CLIENT Caffé di Cielo
TOOL Aldus FreeHand

This logo needed to represent quality since many coffee shops are trendy. The logo was drawn in FreeHand and the typeface used for Cielo was created specifically for this logo.

ARMENO
COFFEE
ROASTERS
LTD

ARMENO
COFFEE
ROASTERS
LTD

▲

75 Otis Street, Northborough
Massachusetts 01532

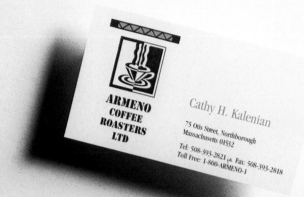

ARMENO
COFFEE
ROASTERS
LTD

Cathy H. Kalenian

75 Otis Street, Northborough
Massachusetts 01532

Tel: 508-393-2821 ▲ Fax: 508-393-2818
Toll Free: 1-800-ARMENO-1

75 Otis Street
Northborough
Massachusetts 01532

▲

Tel: 508-393-2821
Fax: 508-393-2818
Toll Free:
1-800-ARMENO-1

Design Firm Smith Korch Daly
Art Director Patricia B. Korch
Designer Barbara A. Truell
Illustrator Linda Rice
Client Armeno Coffee Roasters Ltd.
Paper/Printing Classic Crest Earthstone, Image Press
Tools Aldus FreeHand, QuarkXPress

...

This logo needed to be a contemporary and easily recognizable
symbol that would work well with the old stencil font. The
blend of old and new complemented the client's business.

Design Firm Robert Bailey Incorporated
Art Director Robert Bailey
Designer/Illustrator Dan Franklin
Client CA One Services Inc.
Tool Macromedia FreeHand

This logo is for a proposed lounge for Los Angeles International Airport. The theme is based on the Italian countryside, to relate to the adjoining local restaurant, Rosti.

Design Firm Mind's Eye Design
All Design Stephen Brown
Client Main Street Grind
Tools Adobe Photoshop and Streamline, Macromedia FreeHand

The client wanted a logo to convey the impression of a well-established business. They wanted it to be easily adaptable for T-shirts, coffee mugs, and shopping bags.

Design Firm Sibley/Peteet Design
Art Director Rex Peteet
Designer Tom Hough
Client Shawnee Milling Company
Tool Adobe Illustrator

The logo's curves have to be exactly right in relation to each other. It took much longer on the computer than it would have drawing it by hand with French curves.

Design Firm Greteman Group
Art Director/Designer Sonia Greteman
Client Green Acres

The logo is rough and natural. It represents a homey, family feeling.

Design Firm Incite Design Communications
All Design Sherrie and Tracy Holdeman
Client Jitters All Night Coffee House
Tool Macromedia FreeHand

Jitters was hand drawn, scanned and opened in Streamline to convert it into vector lines. It was opened into FreeHand to modify the line work to give it the extra jitters.

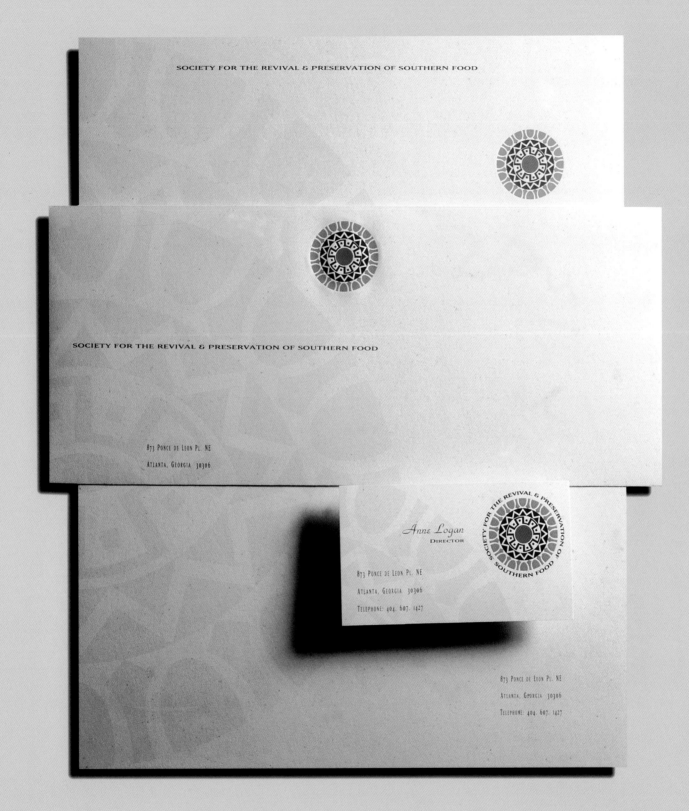

SOCIETY FOR THE REVIVAL & PRESERVATION OF SOUTHERN FOOD

SOCIETY FOR THE REVIVAL & PRESERVATION OF SOUTHERN FOOD

873 Ponce de Leon Pl. NE
Atlanta, Georgia 30306

Anne Logan
DIRECTOR

873 Ponce de Leon Pl. NE
Atlanta, Georgia 30306
Telephone: 404. 607. 1427

873 Ponce de Leon Pl. NE
Atlanta, Georgia 30306
Telephone: 404. 607. 1427

DESIGN FIRM Rousso+Associates, Inc.
ART DIRECTOR/DESIGNER Steve Rousso
CLIENT Society for the Revival & Preservation of Southern Food
..
The society, trying to bring back the heritage and appreciation
of American Southern cuisine, wanted an image that was upscale
and did not convey the typical thinking about Southern food.

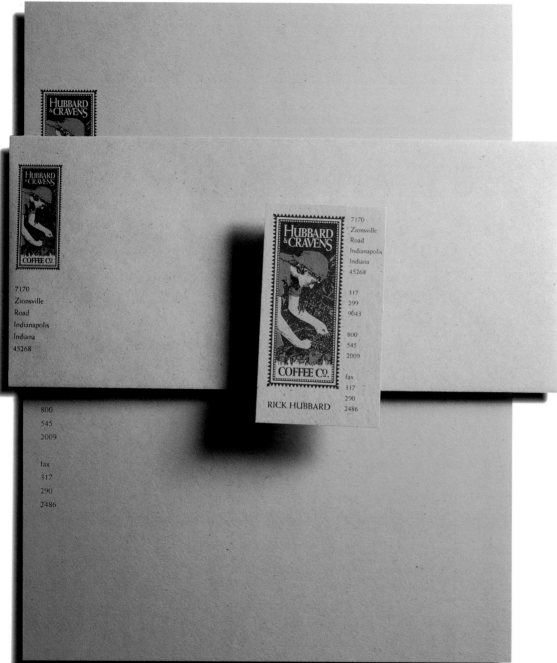

Design Firm Kelly O. Stanley Design
All Design Kelly O'Dell Stanley
Client Hubbard & Cravens Coffee Co.
Paper/Printing Champion Benefit
Tool Aldus FreeHand

The logo and illustration are based on a photo of women
picking coffee beans. It was illustrated by hand and the frame
and typography were created in FreeHand.

David's

restaurant

123 Stuart Street

Boston, MA 02116

617•367•8405

123 Stuart Street

Boston, MA 02116

617•367•8405

DESIGN FIRM Brenner Design
ALL DESIGN Martha B. Slone
CLIENT David's Restaurant
PAPER/PRINTING Strathmore Renewal Recycled Text, 2-color
TOOL Aldus FreeHand

The design was created by drawing quick sketches of vegetables
and wheat and adjusting the line width. Palatino was chosen for
its versatility, and paper was chosen to complement ink.

DESIGN FIRM Riechesbaird Advertising
ALL DESIGN Masa Lau
CLIENT Suzanne's Catering
PRINTING Printers Litho
TOOL Adobe Photoshop, Aldus FreeHand

The illustration was done in FreeHand and brought into Photoshop, where it was manipulated. The client wanted the logo to give the feeling that catering is an art.

DESIGN FIRM Peter Galperin Design
DESIGNER Peter Galperin
CLIENT Vince & Linda at One Fifth

The identity was meant to give a slightly updated antique feel. The ivory Quest paper stock and the unusual green accent color helped modernize the design.

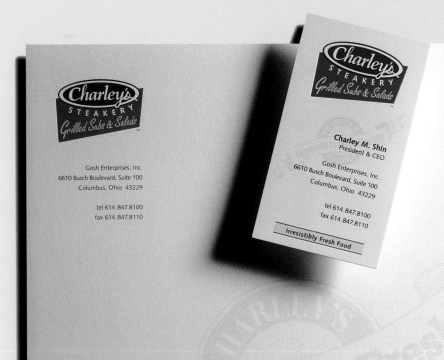

Grilled Sandwiches Salads Gourmet Fries Fresh Lemonade Grilled Sandwiches Salads Gourmet Fries Fresh Lemonade

DESIGN FIRM Degnen Associates Inc.

ART DIRECTOR Steve Degnen

DESIGNER Stephanie Henry

CLIENT Gosh Enterprises Inc.

PAPER/PRINTING Strathmore Writing, offset (stationery: three spot colors; folder: four spot colors)

TOOL Aldus FreeHand

··

The screened back image was created and applied to stationery stating "Charley's pledge for only Irresistibly Fresh Ingredients." The logo was created on Macintosh using Aldus FreeHand.

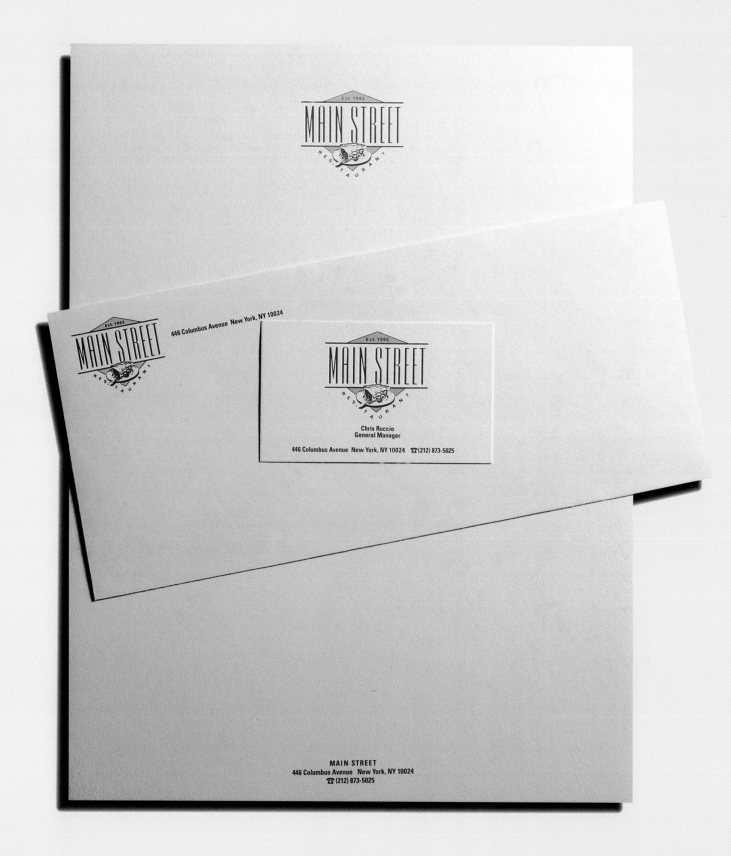

DESIGN FIRM PM Design
ART DIRECTOR/DESIGNER Philip Marzo
CLIENT Main Street Restaurant

..

This restaurant needed a strong logo to give it an established
feel. The traditional apple pie, classic type selection, and rustic
color scheme gave an immediate familiar and comfortable feeling.

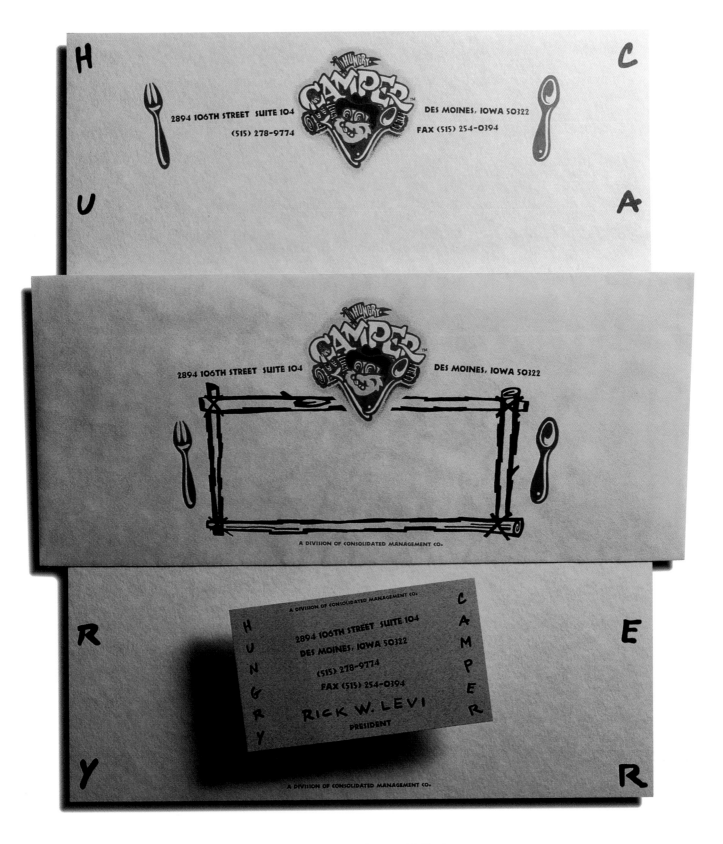

DESIGN FIRM Sayles Graphic Design
ALL DESIGN John Sayles
CLIENT The Hungry Camper
PAPER/PRINTING Hopper Parchment, Acme Printing

..

The logo evokes images of fun at summer camp. A smiling animal
in a forest ranger hat with a big fork and spoon is the dominant
visual element.

DESIGN FIRM PM Design
ART DIRECTOR/DESIGNER Philip Marzo
ILLUSTRATOR Calligrapher—Iskra Johnson
CLIENT Rain Restaurant

The combination of vibrant oriental calligraphy, hand-tied
bead string, and custom jade ink on two paper stocks—rice
paper and bamboo paper—creates a handcrafted stationery
and menu program.

DESIGN FIRM Love Packaging Group
ALL DESIGN Tracy Holdeman
CLIENT Tortilla Factory
TOOL Adobe Photoshop

The logo is drawn in pencil, then the white space is traced
with a black marker. This reverse image is scanned into
Photoshop and inverted to create a wood-cut effect.

DESIGN FIRM Witherspoon Advertising
ALL DESIGN Randy Padorr-Black
CLIENT Jose's Mexican Bakery

The client wanted a logo with a hint of South of the Border
that would not alienate predominantly Anglo customers. The
client uses this logo on signage, letterhead, bags, and cups.

DESIGN FIRM Bullet Communications Inc.
ALL DESIGN Tim Scott
CLIENT Stella d'Italia Restaurant
TOOL QuarkXPress

Stella d'Italia was designed to have a sophisticated, contempo-
rary look. The Stella lettering was hand drawn and combined
with typography using QuarkXPress. The logo prints gold on
dark green.

Ronald W. Haveman
Controller

North Star Cold Storage, Inc.
27100 Pioneer Highway
P. O. Box 1359
Stanwood, WA 98292

(360) 629-9591
Fax: (206) 778-8440
Seattle Direct:
(206) 778-8189

North Star Cold Storage, Inc.

27100 Pioneer Highway • P. O. Box 1359 • Stanwood, WA 98292
(360) 629–9591 • Fax: (206) 778-8440 • Seattle Direct: (206) 778-8189

Design Firm Walsh and Associates Inc.
Art Director Miriam Lisco
Designer Katie Dolejsi
Illustrator Larry Jost
Client Northstar Cold Storage
Paper/Printing Classic Crest, 2-color
Tool Adobe Illustrator

...

An illustrator drew the polar bear, while the logo was designed
in Illustrator for corporate identity. The pieces were printed in
2-color, maintaining quality and dimension.

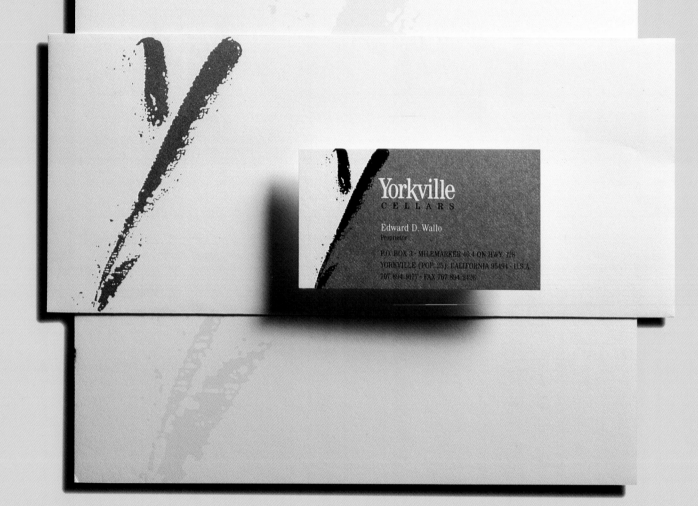

Yorkville
C E L L A R S

P.O. BOX 3
YORKVILLE (POP. 25)
CALIFORNIA 95494 · U.S.A.
FAX 707.894.2426
PHONE 707.894.9177

Yorkville
C E L L A R S

Edward D. Wallo
Proprietor

P.O. BOX 3 · MILEMARKER 40.4 ON HWY. 128
YORKVILLE (POP. 25), CALIFORNIA 95494 · U.S.A.
707.894.9177 · FAX 707.894.2426

DESIGN FIRM THARP DID IT
ART DIRECTOR Rick Tharp
DESIGNERS Rick Tharp, Jana Heer
ILLUSTRATOR Georgia Deaver
CLIENT Yorkville Cellars
PAPER/PRINTING Simpson Evergreen Recycled, offset
lithography; wine labels are foil stamped
..
For European traditionalism and Japanese extempora-
neous simplicity, a calligrapher created the letter Y,
and a typographer set the text. The labels are printed
in two match colors and foil stamped.

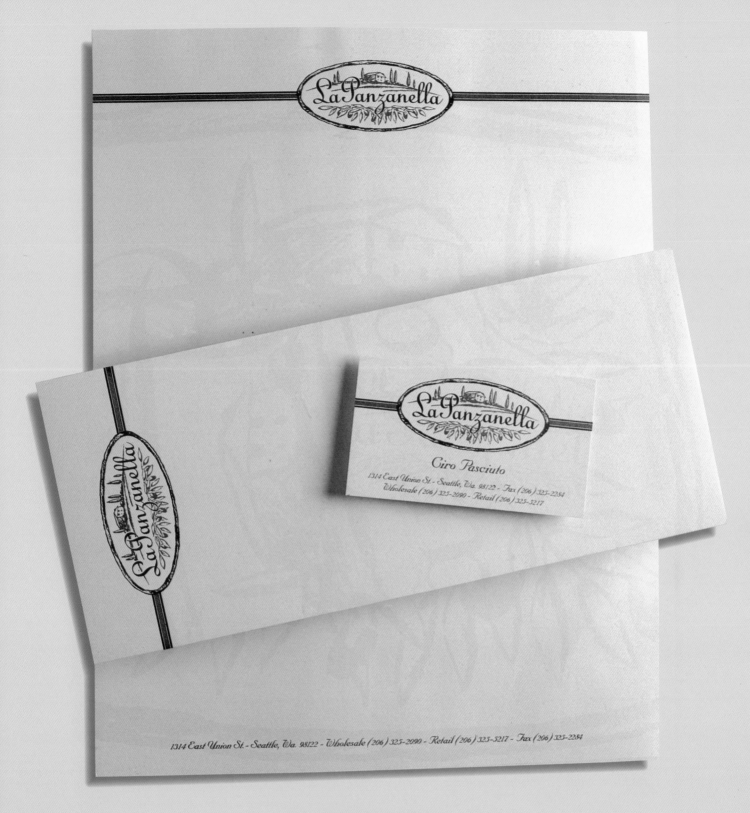

Design Firm Price Learman Associates

All Design Ross West

Client La Panzanella

Paper/Printing Classic Crest Peppercorn

Tools Adobe FreeHand, Aldus FreeHand

La Panzanella is a small bakery that specializes in authentic breads made in the tradition of old Italy. The logo needed a warm, old-world Italian feel without showing bread.

LA · TAVOLATA

A GATHERING OF FRIENDS AND NEIGHBORS FOR CHARITY

DESIGN FIRM Price Learman Associates
ALL DESIGN Ross West
CLIENT La Tavolata
TOOLS Adobe Photoshop, Aldus FreeHand

"La Tavolata" has many meanings: family, community, caring, giving. The challenge was to convey this message without straying from the table. This was accepted into the 1995 *Print Regional Design Annual.*

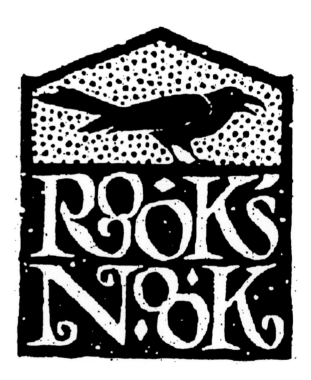

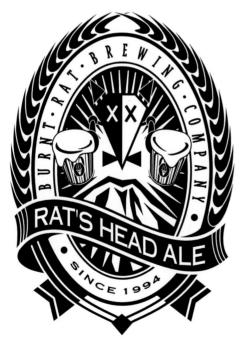

DESIGN FIRM Plaid Cat Design
ALL DESIGN Eric Scott Stevens
CLIENT Rook's Nook Coffeehouse

The logo uses a hand lettering style that works well with the antiquated feel. Since a rook is a crow-like bird, black lends itself to the design quite nicely.

DESIGN FIRM Price Learman Associates
ALL DESIGN Ross West
CLIENT Burnt Rat Brewing Co.
TOOLS Adobe Photoshop, Aldus FreeHand

Burnt Rat Brewing Co. is a start-up home microbrewery that makes batches of hand crafted brew. The rat imagery refers to stories of the origins of beer.

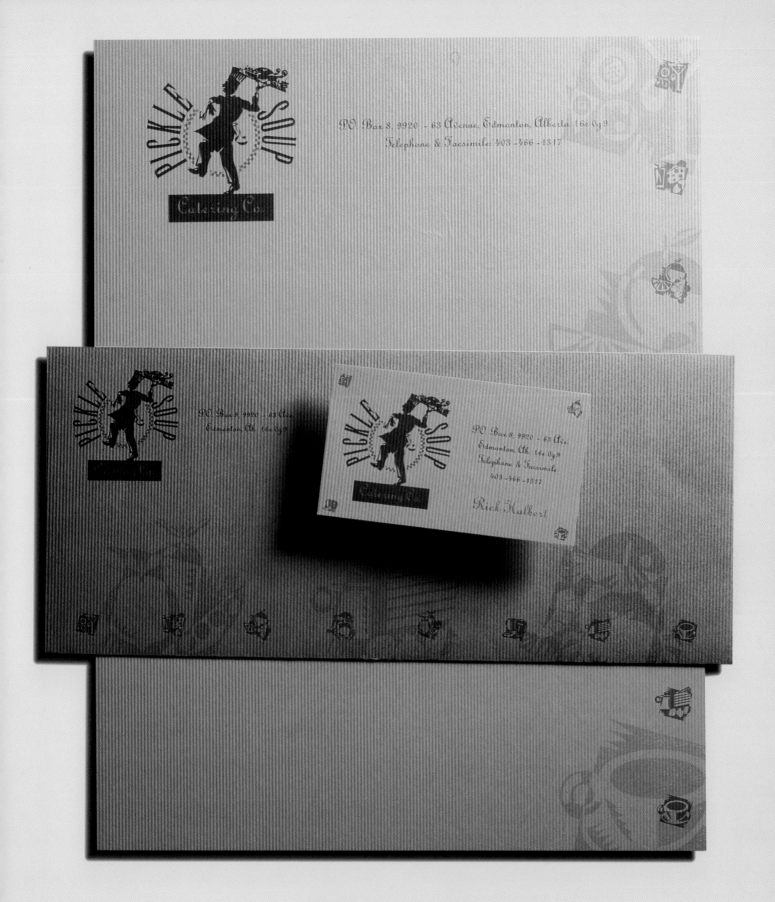

DESIGN FIRM Duck Soup Graphics
ALL DESIGN William Doucette
CLIENT Pickle Soup Catering Co.
PAPER/PRINTING Domtar Naturals, two match colors

Two colors of the same paper stock were used for a visual contrast. The hand-drawn logo represents the chef/president who had built a reputation before starting the catering division.

REGIONAL
ITALIAN
CUISINE

REGIONAL
ITALIAN
CUISINE

14 North Street, Hingham, MA 02043 617·740·0080

Design Firm Adkins/Balchunas
Art Director/Designer Jerry Balchunas
Client Tosca
Paper/Printing Fox River Confetti, Village Press,
Universal Printing

36 EXCHANGE TERRACE
PROVIDENCE, RHODE ISLAND 02903

MARK HAMON
BREWER

36 EXCHANGE TERRACE
PROVIDENCE, RHODE ISLAND 02903
401-274-BREW, FAX 401-831-2120

36 EXCHANGE TERRACE
PROVIDENCE, RHODE ISLAND 02903
401-274-BREW, FAX 401-831-2120

DESIGN FIRM Adkins/Balchunas
ART DIRECTOR/DESIGNER Jerry Balchunas
CLIENT Union Station Brewery
PAPER/PRINTING Cross Pointe, Genesis Village Press

Box 2144, Banff, Alberta T0L 0C0

David J. Simard

Box 2144, Banff, Alberta T0L 0C0
(403) 762-3408, in Edmonton (403) 476-1387

Box 2144, Banff, Alberta T0L 0C0
(403) 762-3408, in Edmonton (403) 476-1387

DESIGN FIRM Duck Soup Graphics
ALL DESIGN William Doucette
CLIENT The Ice Age Co.
PAPER/PRINTING Classic Laid, two match colors

This client was the first company in Canada to offer 100 percent
pure, prehistoric glacier ice to the consumer as gourmet ice. The
logo was hand drawn in ink.

DESIGN FIRM Swieter Design U.S.
ART DIRECTOR John Swieter
DESIGNER Jim Vogel
CLIENT Lunar Lodge Night Club
TOOL Adobe Illustrator

DESIGN FIRM Walsh and Associates
ART DIRECTOR/DESIGNER Miriam Lisco
ILLUSTRATOR Jim Hays
CLIENT Chukar Cherries
TOOL Adobe Illustrator

An illustrator drew the Chukar bird, and the design was created in Illustrator. The logo needed to be used in 1-color, 2-color, and 4-color applications.

DESIGN FIRM Swieter Design U.S.
ART DIRECTOR John Swieter
DESIGNER Mark Ford
CLIENT Eclipse Restaurant
TOOL Adobe Illustrator

DESIGN FIRM Hornall Anderson Design Works Inc.
ART DIRECTOR Jack Anderson
DESIGNERS Jack Anderson, Julia LaPine, Jill Bustamante
ILLUSTRATOR Julia LaPine
CLIENT Talking Rain

Tower

District

936

East

Olive

Avenue

Fresno

CA

93729

Phone

266-

2739

DESIGN FIRM Shields Design
ART DIRECTOR/DESIGNER Charles Shields
CLIENT Apex Restaurant
PAPER/PRINTING Quest, Progressive Printing
TOOL Adobe Illustrator

One printed piece serves several purposes: A legal-size sheet has
menu information on the bottom. For letterhead, the sheet is
trimmed to eleven inches.

Other

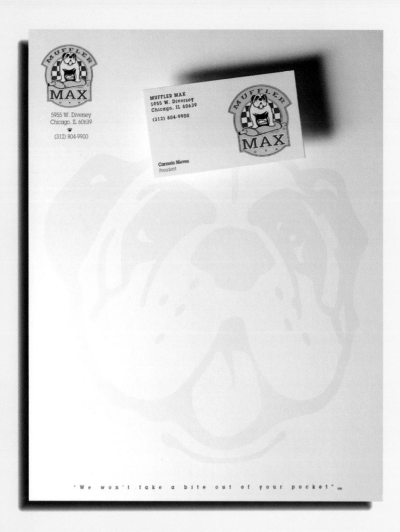

DESIGN FIRM ZGraphics Ltd.
ART DIRECTOR Joe Zeller
DESIGNER Eric Halloran
CLIENT Muffler Max USA
PAPER/PRINTING Strathmore Writing Bright White Wove

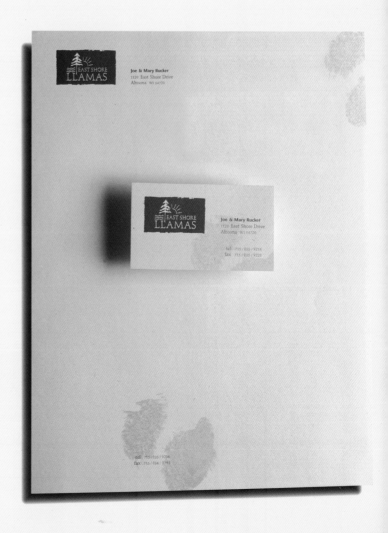

DESIGN FIRM Corridor Design
ALL DESIGN Ejaz Saifullah
CLIENT East Shore Llamas
PAPER/PRINTING French True White, Rooney Printing Co.
TOOLS Adobe Illustrator, QuarkXPress

All logo components, except type, were drawn on paper and fine tuned in Illustrator. Footprints were taken using mud and paper and were later scanned. The stationery was typeset in QuarkXPress.

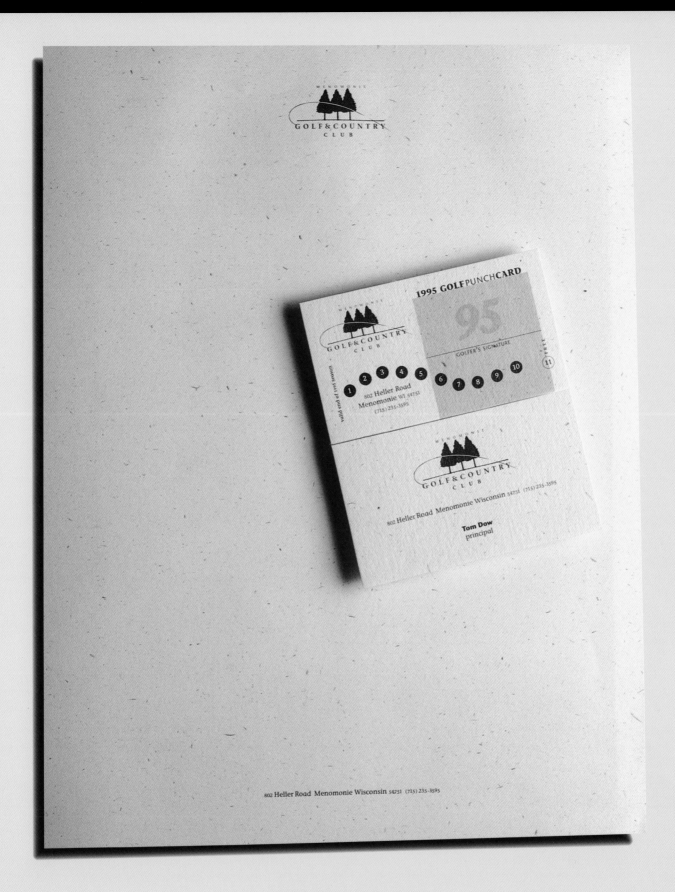

Design Firm Corridor Design

All Design Ejaz Saifullah

Client Menomonie Golf & Country Club

Paper/Printing French True White Speckletone,
Rooney Printing Co.

Tools Adobe Illustrator, QuarkXPress

All logo components, except type, were drawn on paper
and fine tuned in Illustrator. The stationery was typeset
in QuarkXPress.

DESIGN FIRM Plaid Cat Design
DESIGNER/ILLUSTRATOR Eric Scott Stevens
CLIENT Fish Camp Jam, Gaston Festivals

Since fish is the main focus of Fish Camp Jam, fish forms part of the logo. The logo and type were created by hand and then later taken into the computer to add coloration.

DESIGN FIRM Price Learman Associates
ALL DESIGN Ross West
CLIENT Kirkland Chamber of Commerce
TOOL Aldus FreeHand

Taste! Kirkland is an annual summer event that features local restaurants and their assortment of foods and beverages. The shoreline community of Kirkland is situated on Lake Washington.

DESIGN FIRM Love Packaging Group
ALL DESIGN Brian Miller
CLIENT Adaptive Athletics
TOOL Macromedia FreeHand

This is a proposed logo for an annual race for wheelchair athletes. It started as a pencil sketch, was scanned into the computer and traced/refined in FreeHand.

DESIGN FIRM John Reynolds Design
ART DIRECTOR/DESIGNER John Reynolds
CLIENT Katama Bay Croquet + Racquet Society
PAPER/PRINTING Apple Laserwriter Pro 600
TOOLS Adobe Illustrator, QuarkXPress

The racquet was scanned and the mallets were drawn in Illustrator. The "Croquet" font modified in Fontographer; the "Katama" font was created in Illustrator. The logo was assembled in QuarkXPress.

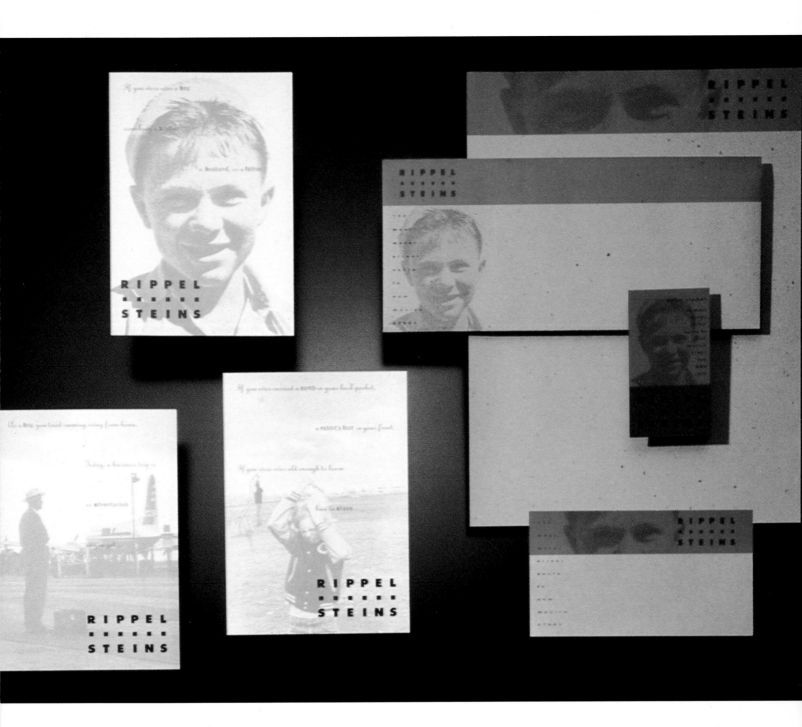

DESIGN FIRM Vaughn Wedeen Creative
ART DIRECTOR/DESIGNER Rick Vaughn
CLIENT Rippelstein's
PAPER/PRINTING Confetti, Academy Printing
TOOLS Aldus FreeHand, QuarkXPress

The '50s photo of a small, freckle-faced boy represents the little
boy in everyone. The photo was scanned, retouched in
Photoshop, and screened back using a large dot pattern.

DESIGN FIRM Incite Design Communications
ALL DESIGN Sherrie and Tracy Holdeman
CLIENT Big Dog Custom Motorcycles
PAPER/PRINTING Classic Crest
TOOL Macromedia FreeHand

Tests were run to determine the exact screen percentage of the ghosted back logos. To achieve the contrast on each piece, the yellow was screened black 70 percent, the blue 85 percent, and the orange 80 percent.

DESIGN FIRM Sackett Design Associates
ART DIRECTOR/DESIGNER Mark Sackett
ILLUSTRATOR Chris Yaryan
CLIENT The AART Group
PAPER/PRINTING Simpson Starwhite Vicksburg 80 lb. text,
offset lithography, black and one match color

Design Firm I.E. Mitchell Design
All Design Ina Mitchell
Client Mundy Park Christian Fellowship
Paper/Printing Cambric Text New Ash, PMS 187, 3285, black, block printing by Stan Potma M.P.C.F.

This logo, created from a freehand drawing, incorporates the "reformed" tradition in a modern, inviting style. Teal color represents the neighboring woodlands and red is symbolic of the blood of Christ.

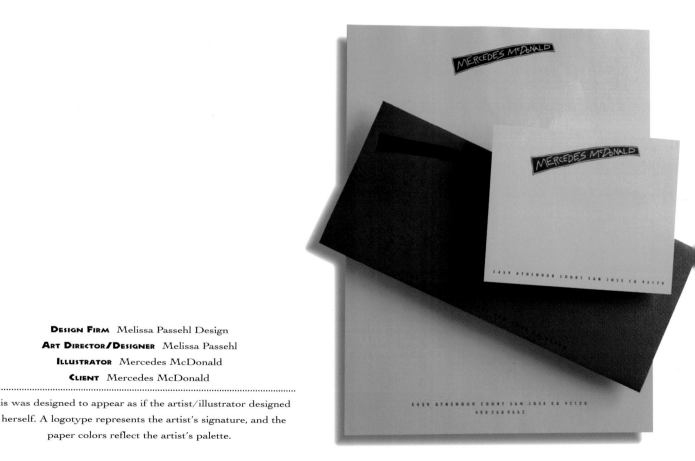

Design Firm Melissa Passehl Design
Art Director/Designer Melissa Passehl
Illustrator Mercedes McDonald
Client Mercedes McDonald

This was designed to appear as if the artist/illustrator designed it herself. A logotype represents the artist's signature, and the paper colors reflect the artist's palette.

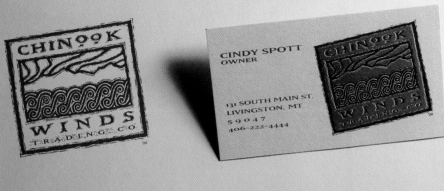

DESIGN FIRM Palmquist & Palmquist Design
ART DIRECTORS Kurt and Denise Palmquist
ALL DESIGN Kurt Palmquist
CLIENT Chinook Winds Trading Co.
PAPER/PRINTING Evergreen hickory, 1 PMS to 2 PMS and black
TOOL Aldus FreeHand

..

The objective was to design a logo with a western that was not "Cowboys & Indians." The entire logo was hand illustrated on scratchboard.

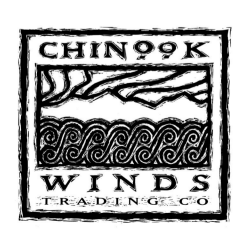

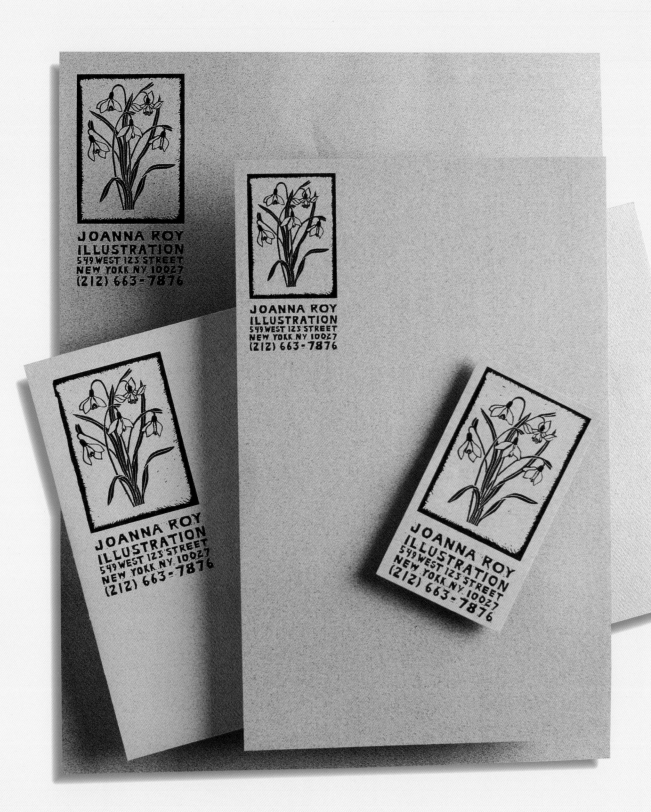

DESIGN FIRM Joanna Roy Illustration

ALL DESIGN Joanna Roy

PAPER/PRINTING Jam Paper, offset printing

..

An existing scratchboard flower illustration was used. The
type was created by hand in scratchboard. Earthy colors
were chosen. All these elements combine to give a natural,
handmade, non-tech feeling.

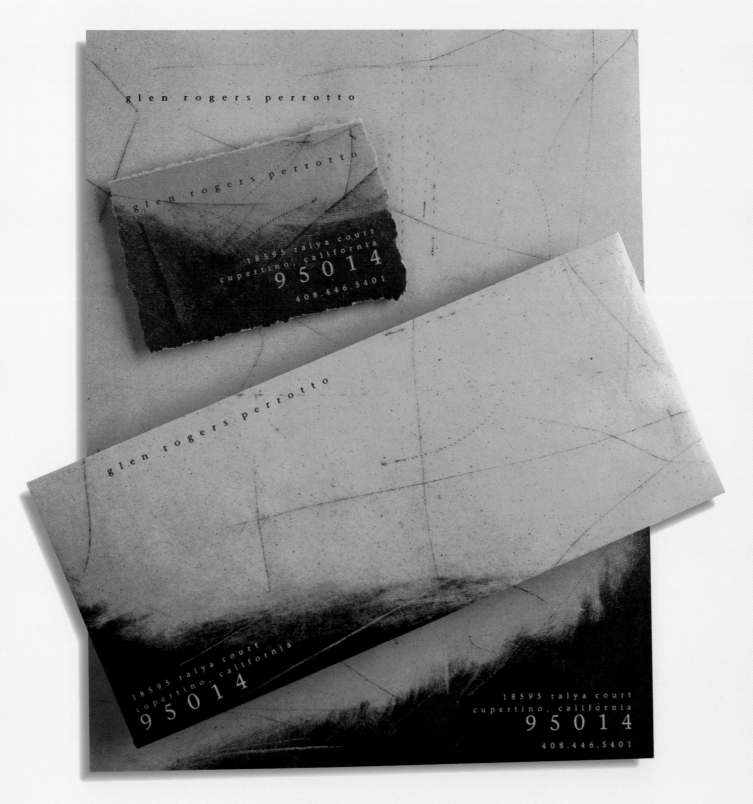

Design Firm Melissa Passehl Design
Art Director/Designer Melissa Passehl
Artist Glen Rogers Perrotto
Client Glen Rogers Perrotto

The artist created background art that was reproduced as
line art. The business cards are hand-torn to reinforce the
handmade element.

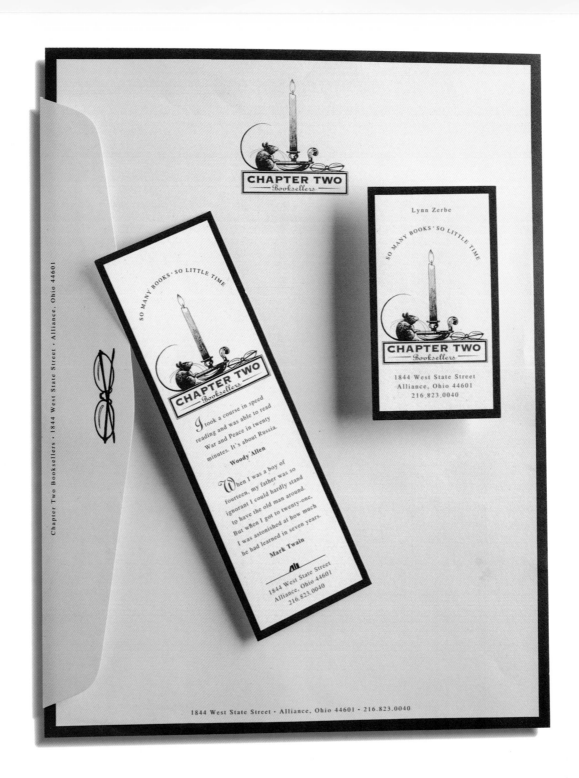

DESIGN FIRM THARP DID IT

ART DIRECTOR Rick Tharp

DESIGNERS Rick Tharp, Laurie Carberry

ILLUSTRATOR Susan Jaekel

CLIENT Chapter Two Booksellers

PAPER/PRINTING Simpson Evergreen Recycled, two match colors, offset lithography

The illustration was rendered by hand and scanned into the computer. The art and type was lino output, and traditional mechanicals were produced for all print materials.

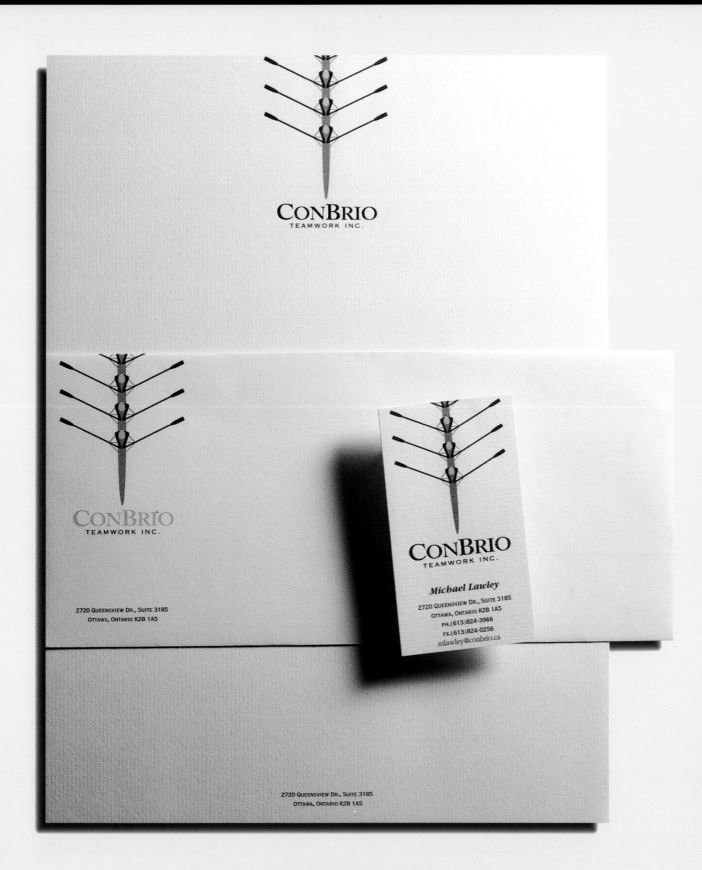

DESIGN FIRM S.A. Design Group

ALL DESIGN Daniel Rogall

CLIENT ConBrio Teamwork Inc.

PAPER/PRINTING Circa '83 Nantucket Grey, one PMS color
and silver foil

This client wanted a memorable image representing teamwork.
Since the client was concerned about the cost of a foil stamp, the
silver foil was reproduced using a tint of the PMS color.

B.D.A
INTERNATIONAL

212 251 8712 TEL 212 889 1595 FAX

BDA INTERNATIONAL, INC. 470 PARK AVENUE SOUTH 9TH FLOOR NEW YORK, NY 10016-6819

470 PARK AVENUE SOUTH 9TH FLOOR NEW YORK, NY 10016-6819

B.D.A
INTERNATIONAL

LYNNE M. GRASZ
EXECUTIVE DIRECTOR

212 251 8712 TEL

212 889 1595 FAX

B.D.A
INTERNATIONAL

470 PARK AVENUE SOUTH 9TH FLOOR NEW YORK, NY 10016-6819

DESIGN FIRM Supon Design Group Inc.

ART DIRECTOR Supon Phornirunlit

DESIGNER David Carroll

CLIENT Broadcast Designers Association

PAPER/PRINTING Environment, offset

TOOLS Adobe Illustrator and Photoshop, QuarkXPress

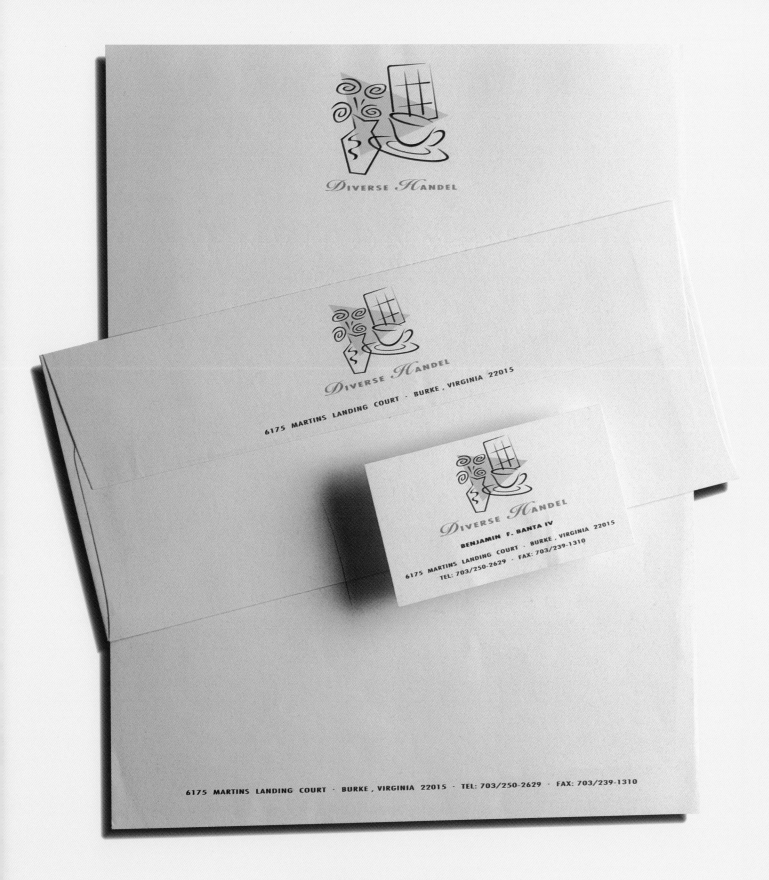

DESIGN FIRM Supon Design Group Inc.
ART DIRECTOR Supon Phornirunlit
DESIGNER/ILLUSTRATOR Richard Lee Heffner
CLIENT Diverse Handel
PAPER/PRINTING Environment, offset
TOOLS Adobe Illustrator, QuarkXPress

...

The playful illustration reflects European style.

EUGENE MAILLARD
Chairman

GARY VOIGHT
Vice Chairman
Chief Financial Officer

JUDITH LUHR
Chief Executive Officer

NANCY LESOFSKY
President

3112 M Street, N.W.

GEORGETOWN

Washington, D.C. 20007

Judith Luhr
Chief Executive Officer

29 Morgan Hollow Way
Landenberg, PA 19350
Tel 610-255-5825
Fax 610-255-5825

3112 M Street, N.W.
Washington, D.C. 20007
Tel 202-337-8915
Fax 202-342-7428

3112 M Street, N.W. • GEORGETOWN • Washington, D.C. 20007 • Tel 202-337-8915

DESIGN FIRM Natsuko
ALL DESIGN Laura Natsuko Symanski
CLIENT Renaissance Gallery
PAPER/PRINTING Classic Natural (envelope, letterhead);
Mohawk Natural Vellum (business card); PMS 876 and black
TOOLS Aldus FreeHand, QuarkXPress

..

The client wanted a logo design with a column. A standard col-
umn icon evolved into the abstract spiral. The logo was created
in FreeHand; all collateral materials created in QuarkXPress.

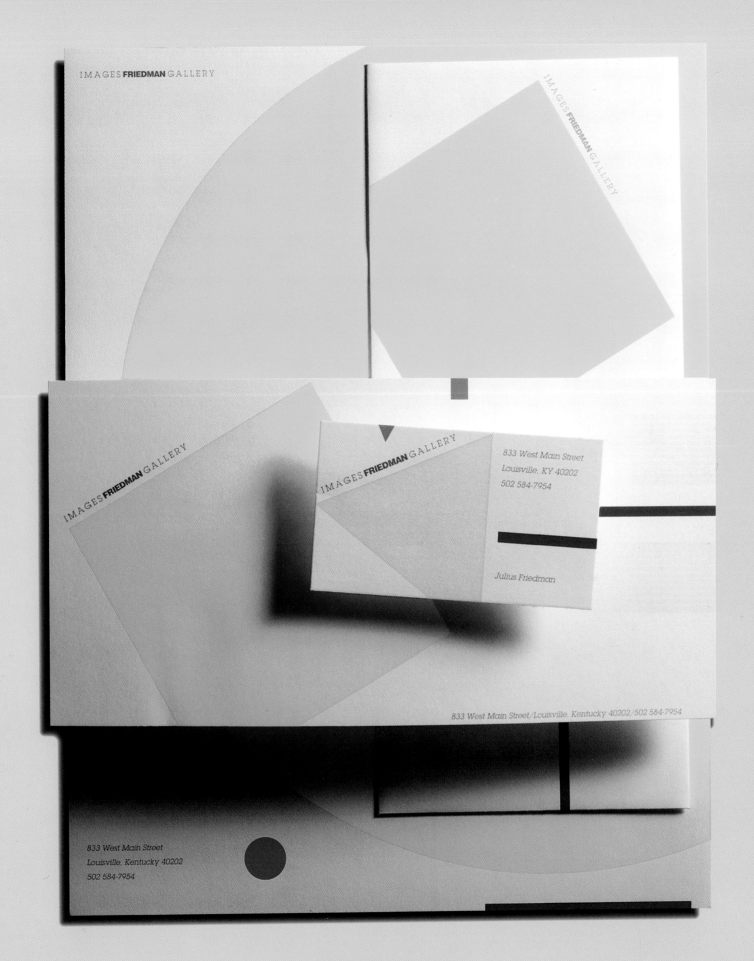

DESIGN FIRM Images
ART DIRECTOR/DESIGNER Julius Friedman
CLIENT Images Friedman Gallery
PAPER/PRINTING Simpson Vicksburg Star White, offset

DESIGN FIRM Greteman Group
ART DIRECTOR/DESIGNER Sonia Greteman
CLIENT City of Wichita

This logo is for a community program. The lion with wing represents community courage with leadership.

DESIGN FIRM John Evans Design
ALL DESIGN John Evans
CLIENT N.E. Waz
TOOL Adobe Illustrator

This series of symbols was developed for a line of T-shirts produced by a new clothing manufacturer. The themes were golf, fishing, basketball, and Americana.

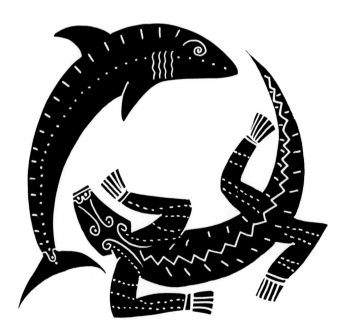

DESIGN FIRM Cato Design Inc.
DESIGNER Cato Design Inc.
CLIENT Hyatt Regency Surabaya

This Indonesian hotel was conceived as a "wealthy western mansion" that displayed national artifacts. The identity had to appeal to local residents and tourists. The final logo was hand drawn.

'NiGHT LOUIE

DESIGN FIRM Swieter Design U.S.
ART DIRECTOR John Swieter
DESIGNER Kevin Flatt
CLIENT Night Louie Jazz Band
TOOL Adobe Illustrator

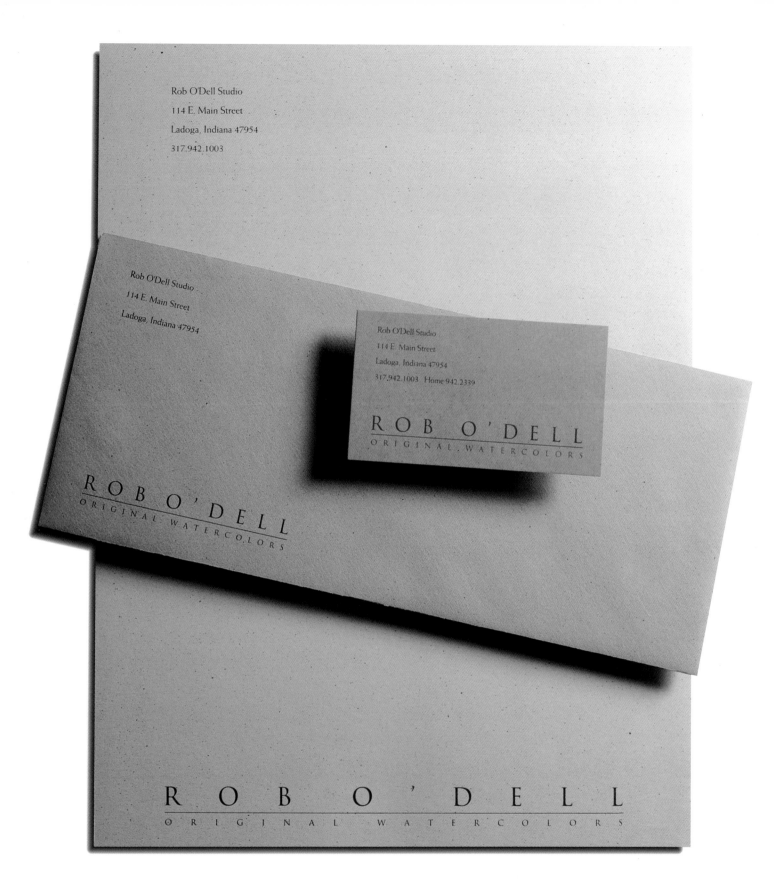

DESIGN FIRM Kelly O. Stanley Design
ART DIRECTOR/DESIGNER Kelly O'Dell Stanley
CLIENT Rob O'Dell
PAPER/PRINTING Simpson Quest
TOOL QuarkXPress

Since the project was limited to 1-color, color was brought into
the identity pieces by using three different colors of paper—col-
ors found throughout the client's work.

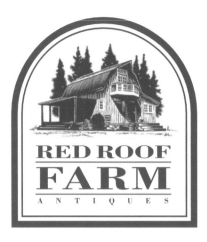

DESIGN FIRM Eskind Waddell
ART DIRECTOR Malcolm Waddell
DESIGNER Maggi Cash
CLIENT The Aradia Ensemble

The logo was conveys tone and rhythm through an orderly laying of rules and screens at different angles. The 1-color logo can appear in newspapers; 2-color versions reflect individual concerts.

DESIGN FIRM Swieter Design U.S.
ART DIRECTOR/DESIGNER John Swieter
ILLUSTRATOR Paul Munsterman
CLIENT Red Roof Farm Antiques
TOOL Adobe Illustrator and Photoshop

DESIGN FIRM Félix Beltrán + Asociados
ART DIRECTOR/DESIGNER Félix Beltrán
CLIENT Trade Center, New York
TOOL CorelDRAW

This logo is to promote a big apple sculpture for the Trade Center. CorelDRAW was used for printing the initial sketches. The final logo was silk-screened to improve the color.

DESIGN FIRM Swieter Design U.S.
ART DIRECTOR John Swieter
DESIGNER Mark Ford
CLIENT Virtual Integration
TOOL Adobe Illustrator

DESIGN FIRM Swieter Design U.S.
ART DIRECTOR John Swieter
DESIGNER Paul Munsterman
CLIENT Shower Head Shampoo
TOOL Adobe Illustrator

DESIGN FIRM Swieter Design U.S.
ART DIRECTOR John Swieter
DESIGNER Mark Ford
CLIENT Connectware Inc.
TOOL Adobe Illustrator

Kemma RPS is a product icon.